FROM A BASEMENT IN SEATTLE
THE POSTER ART OF BRAD KLAUSEN

AKASHIC BOOKS

Published by Akashic Books
©2010 by Brad Klausen

Book design by Brad Klausen
Design assistance by Aaron Petrovich
Oversized sketch photos by Ric Peterson

ISBN-13: 978-1-936070-67-1
Library of Congress Control Number: 2010922714

First Printing

Akashic Books
PO Box 1456
New York, NY 10009
info@akashicbooks.com
www.akashicbooks.com

Printed in China

ACKNOWLEDGMENTS

There are a lot of folks without whom this book wouldn't exist. First there's my mom. If not for her, I would not be here. Not only in the obvious fact that she gave birth to me, but she raised me and has been continually supportive of anything and everything I've attempted to do throughout my whole life. I cannot thank her enough for everything she's done for me. My sister Lauren made a simple, yet sagely suggestion one day that I should take a class. That suggestion forever changed the direction of my life on multiple levels. My girlfriend Kristin is the most amazing muse anyone could ever ask for. She not only inspires me to be a better artist, but more importantly she inspires me to be a better person. She is an overwhelmingly bright light that has allowed me to see the world in ways I never have before. My dog Zoe has been a tremendous guide, taking me out into the world and keeping me connected with nature and the stars, reintroducing me to the wondrous mysteries of the universe.

I thank Jeff Ament, Matt Cameron, Stone Gossard, Mike McCready, and Eddie Vedder, along with everyone in the Pearl Jam organization, for the opportunity to create art for their musical endeavors. I am forever in debt to them for not only introducing me to the Pacific Northwest and all the people I have met here, but for making me fall in love with art. Music opened the door to the art world for me. My whole life I've been interested in art and enjoyed creating it, but it wasn't until I moved to Seattle that I became infatuated with it.

I would not have been able to do any of the things I've done if the Ames Bros hadn't already established a poster-collecting cult through years of innovative, clever, colorful poster designs. Barry and Coby cleared the path and built the road, leaving a massive shadow in their wake, setting the bar astronomically high. I am beyond grateful for their hard work, their creativity, and all the inspiration they've provided me over the years.

Huge thanks to Jay Ryan and Johnny Temple. Jay has been a major source of inspiration and advice over the years, and he is also the reason you are holding this book. I was picking Jay's brain one day about how to get a book made, and unbeknownst to me, after our conversation he reached out to Johnny Temple at Akashic Books and put in a good word for me. Next thing I know, I'm talking with Johnny about putting out a book. I cannot thank Johnny and the folks at Akashic Books enough for helping me put this book out, and for being so unbelievably patient and understanding with me throughout the whole process.

And last but most certainly not least, I would like to thank all of you out there who have supported my work over the years. You have all granted me the privilege to continue doing what I love doing. That is a gift which I can never repay.

From every ounce of my heart, thank you.

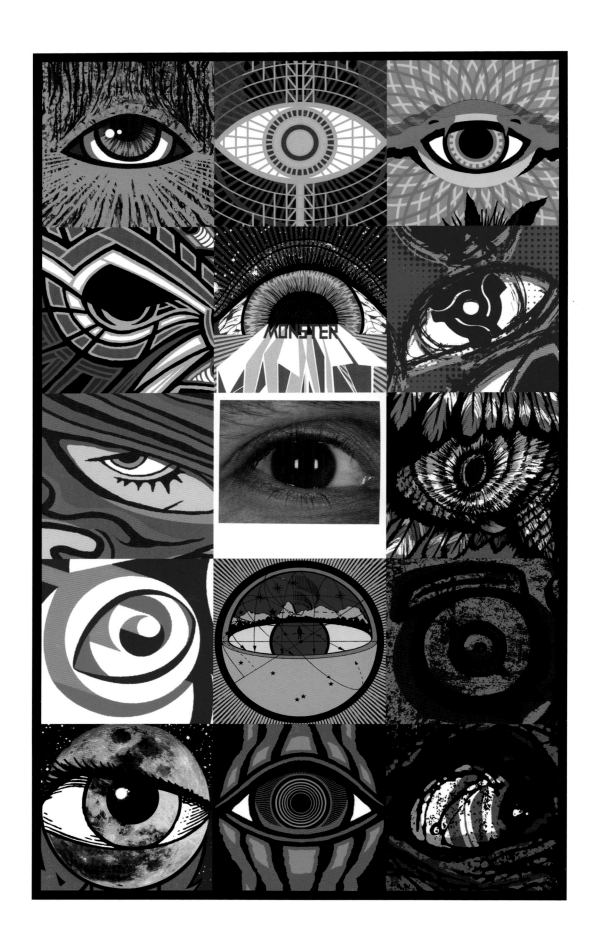

TABLE OF CONTENTS

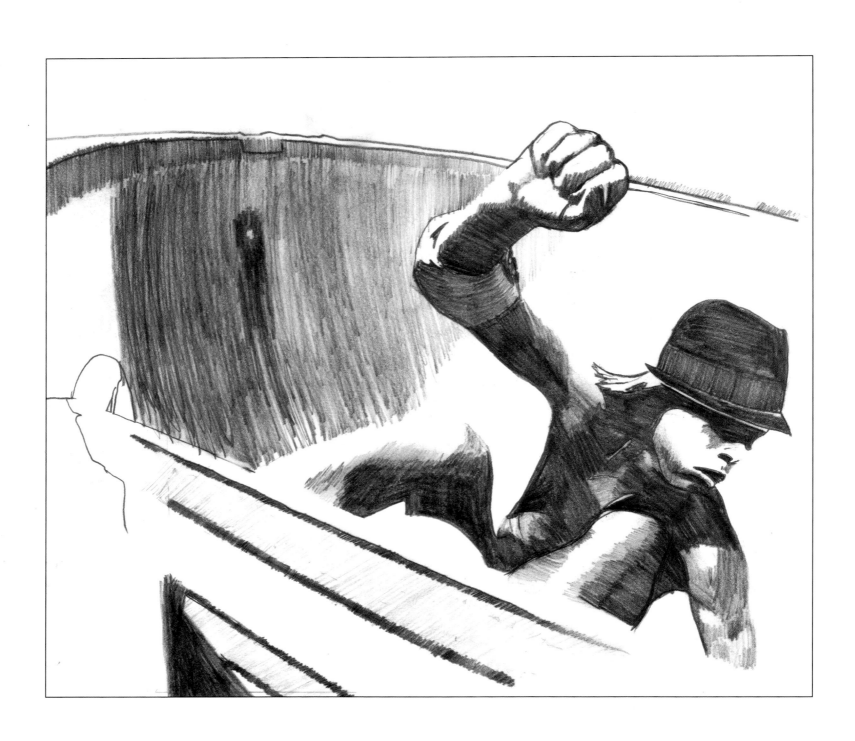

FOREWORD
BY JEFF AMENT

After long practices with all the bands I've been in with Stone Gossard—over twenty-six-plus years!—we would often have delirious conversations about the gamut of things pertaining to us. At times we'd get frustrated with some aspect of our organization/family, and initially, I think I said seriously, "We need to find somebody young and hungry to do the job, somebody like us." We have referred to that comment with much humor over the years, because it seems harder and harder to find someone young *and* hungry.

Almost eleven years ago, we found that someone in Brad Klausen. He would take the smallest morsel of something that one of us left around the area and would create an intricate web, a mountain of creative depth in the form of a beautiful piece of art that the band could use as a poster. We've been the benefactors of some of Brad's lifework, stuff from his soul, straight to his pen. Lucky us.

Brad is a smart, passionate, stubborn motherfucker who creates right to the edge and sometimes beyond—that's what I love about him the most.

DON'T STOP...
-EVER.

Jeff Ament

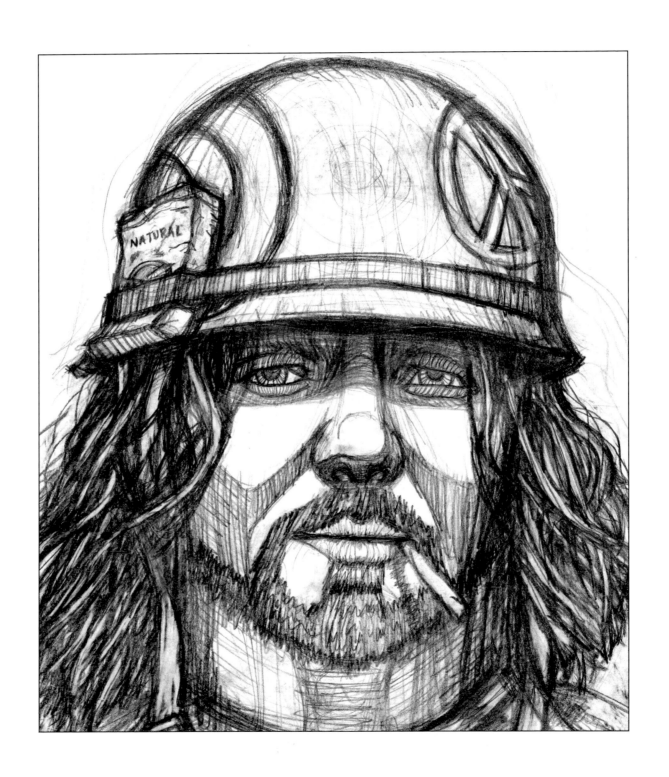

Brad Klausen is not insane...

INTRODUCTION
BY EDDIE VEDDER

Rather, a sane man in a world gone mad. His sensitivity to our planet and the corrupt ways in which it has been desecrated by those who have accepted greed into their hearts is a driving force behind his art and way of thinking. It informs his work, which in turn informs those who come in contact with it. The majority of his output are prime examples of art as activism.

That being said, if the planet were somehow to become pure and perfect, I am damned sure that Mr. Klausen would still create. His creativity is a part of him, as critical to his being as a heart or lung. Art as a vital organ.

Pearl Jam took advantage of his vitality, and from late 1999 (the week of the WTO protests in Seattle) till mid-2008, Brad was the artist-in-residence at our band's headquarters. For nearly ten years, most every piece of art connected to our group had his stamp on it.

It was during these years of creating and laying out the visuals for PJ records and *Into the Wild* that Brad and I developed a close relationship and a brotherly understanding of each other. Our workdays would begin at a normal time in a bustling office. Quickly this would forward to us being the only ones working in an empty building into hours that some folks deem as ungodly.

In our deadline-fueled delirium we would frequently offshoot into orbits of thought regarding diplomacy (or lack thereof), corporatism, and conspiracies so poorly disguised that we had to question their conspiratorial nature. These diversions may have lengthened the process of completing our artistic responsibilities, but always made the experience more fulfilling.

To realize that he created most of the pieces displayed in this mighty book while keeping up with the constant requests for band-related items speaks volumes to his output and harnessed focus during this time.

Now that he is on his own and proudly independent, I have to say that I miss the long nights of grinding out the work and together solving the world's problems all at the same time. Not to mention the intensity of the laughter not normally associated with dissecting global issues.

In parting, allow me to reiterate . . . Brad Klausen is not insane. Then again, some of my favorite artists are or have been.

And he certainly is one of my favorite artists.

E. Vedder
Seattle 2010

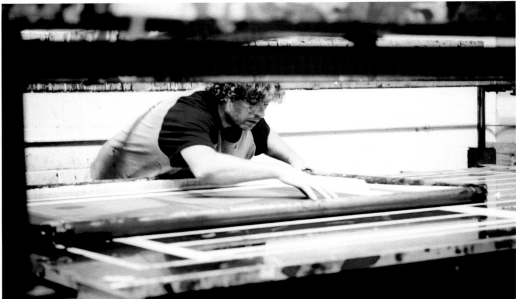
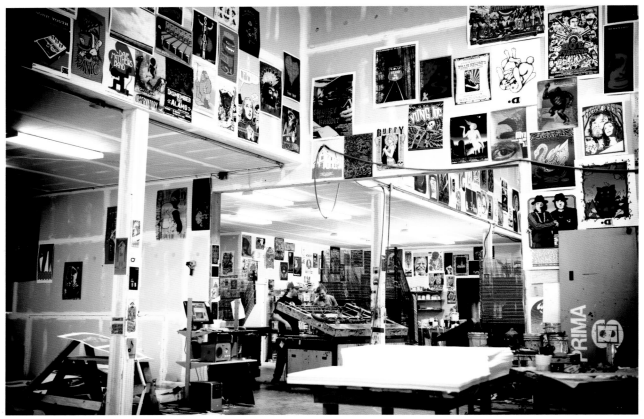

PHOTOS BY ANNA KNOWLDEN

D&L SCREENPRINTING

In the screenprinting world, there are two types of artists: those who print their own posters, and those who hire a printer. Printing one's own posters requires a number of complex elements: multiple large screens, emulsion, exposure unit, washout booth, pressure washer, vacuum table, drying racks, large-format printer for film, stacks of large sheets of paper, homemade or automated press, squeegees, paper guillotine, a rainbow of different buckets of ink, ample space for storage, printing, and drying, a tremendous amount of diligence, and—most important of all—time.

I've always been envious of the artists who print their own work. They can experiment on the fly with colors and overprinting, changing things up as they go. All things which they can then factor into how they are going to design future posters. At the same time I am envious of them for that, I don't understand at all how they have the time to not only work on the designs, but to then go through the many steps of the printing process.

Luckily for me, one of the best screenprinters in the country happens to be located in my neighborhood. Justin Hampton turned me on to D&L back in 2005, and with the exception of about five posters, they've printed all the images in this book. They are integral to the look and feel of my work. The guys at D&L never cease to amaze me in their ability to not only crank out high-quality posters, but to then deal with the various quirks and peculiarities of the array of artists who they print for. This roster of artists includes some of the biggest names in the rock poster world: Emek, Jermaine Rogers, Justin Hampton, Rob Jones, Todd Slater, Daniel Danger, and Tyler Stout, to name just a few. Over the years that I've been working with D&L, it seems like the majority of poster artists out here have had their work pulled through D&L's screens. They are a major hub of the screenprinting world, and their handiwork is rightly hanging on walls all across the globe.

I am beyond grateful for all the hard work that D&L has put into printing my posters over the past six years, and I can't thank them enough for always putting up with me.

D&L Screenprinting is: Steve Horvath, Cary Holt, Jason Hunt, Pete Jay, Josh Dieters, Jon Smith, and Odulia Horvath.

Brad Klausen
Seattle, Washington
September 2010

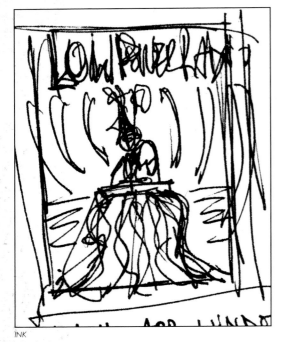

INK

PENCIL AND INK

PENCIL

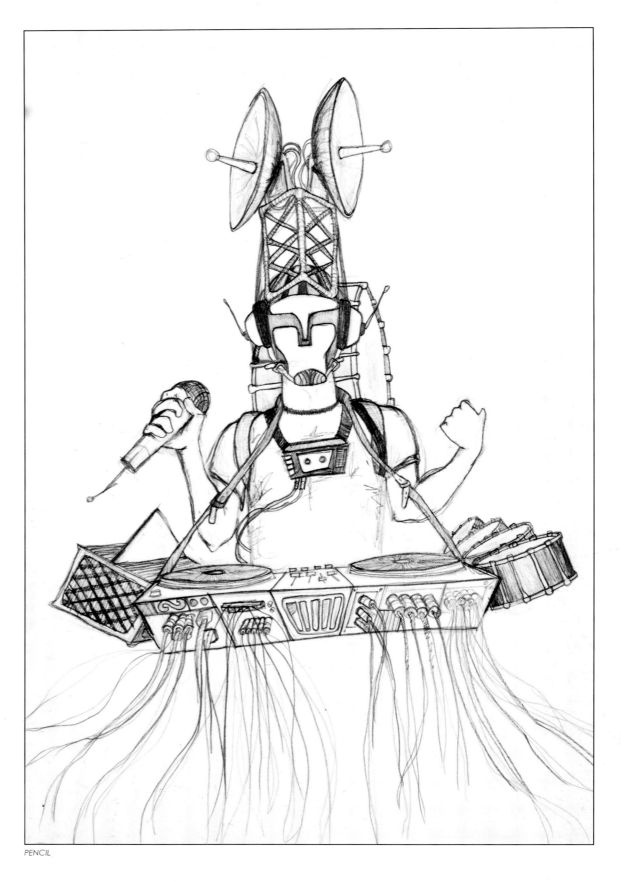

PENCIL

This was my very first poster, and was an offset print rather than a screenprint. Jeff Ament told me one day about a design concept he had for the Joint Artists and Music Promotions Political Action Committee's (JAMPAC) push to make low-power radio legal and thus allow for more voices to be heard on the airwaves.

Jeff described his concept and asked if I would bring it to life. Originally, he imagined a big boot of the FCC hanging over a one-man band.

I adapted the head image I had previously used for some of Pearl Jam's merchandise from the *Binaural* tour, and stuck it on the body of our one-man band/radio station. The pencil drawing was then run through the Photoshop "cutout" filter to create the effect of the final image. My friend Blake had just turned me on to this effect, and I was using it on everything. At this early stage, I was mostly focused on using the computer to design, and wasn't really drawing very much by hand.

LOWPOWERRADIO

WASHINGTON APPLICATION WINDOW

JUNE 11TH -15TH, 2001

FOR MORE INFORMATION & APPLICATIONS GO TO JAMPAC.COM

PENCIL AND MARKER

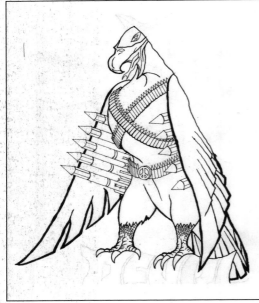

INK

INK

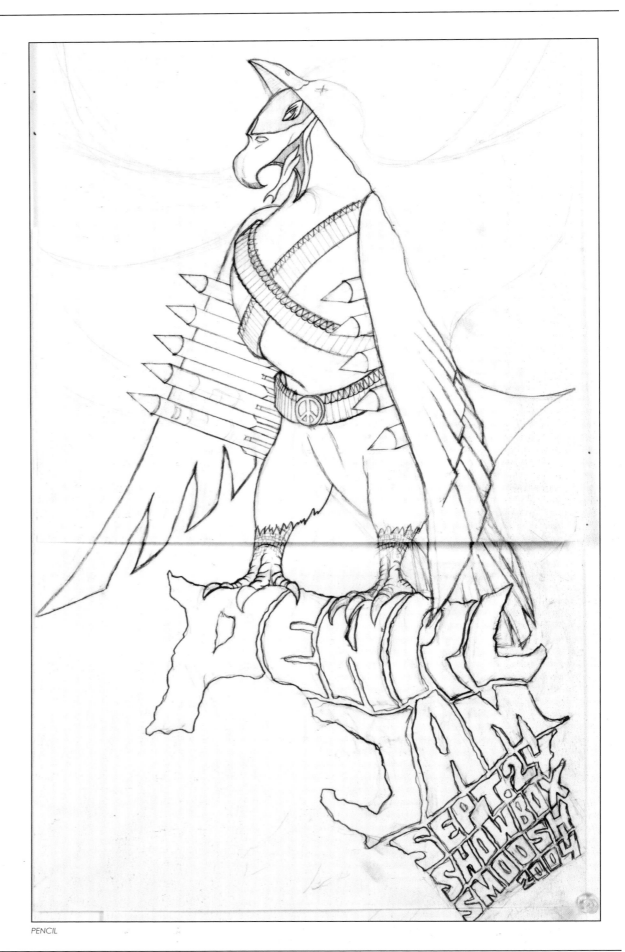

PENCIL

During a period of my life where I would say I was stuck in quite a rut, wallowing in depression, my sister threw out the suggestion that I should take a class. Do something other than just sit around being unhappy. This sounded like a good idea. So after I hung up the phone with Lauren, I went online and looked up what classes the Seattle School of Visual Concepts had to offer. Much to my surprise, there was a poster design class being taught by Jeff Kleinsmith. I couldn't believe it. Jeff is one of my favorite artists and has been a huge influence on my desire to make posters. I had been wanting to get into designing screenprints for years, and now one of the godfathers of the genre happened to be teaching a class in my town. This is the poster I designed for that class. Little did I know then the impact the class would have on my life. I am forever in debt to Jeff and to my sister for changing the direction of my life.

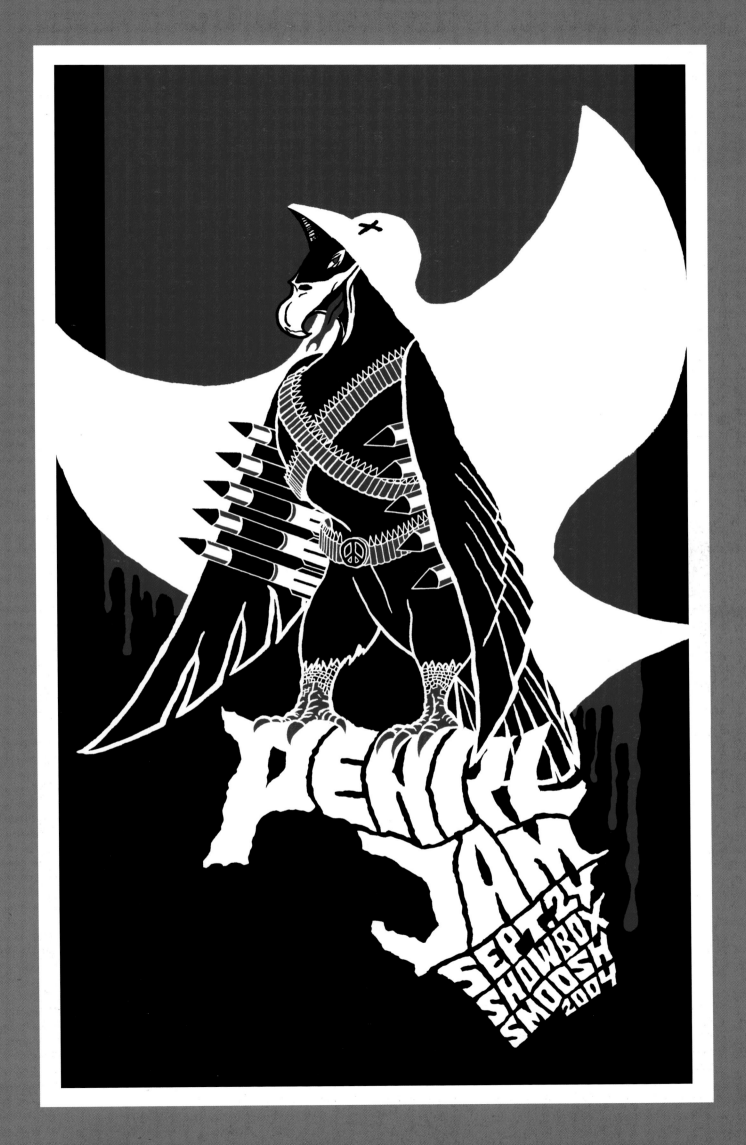

PEARL JAM
SEPT. 24 SHOWBOX SMOOSH 2004

PENCIL

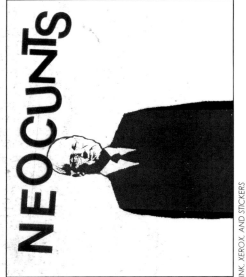

INK, XEROX, AND STICKERS

INK

PENCIL

This series was produced for six shows of Pearl Jam's Vote for Change tour in 2004. I find it somewhat amusing that Dick Cheney and Co. are referred to as "neocons," when the prefix *neo* means fresh, new, or recent. If you watch Adam Curtis's brilliant BBC documentary *The Power of Nightmares*, you realize that the con Cheney, Rumsfeld, and Wolfowitz were pulling was not at all new. They pulled the same con in the mid-1970s while working within the Ford administration. Instead of employing terrorists as the evil bogeymen who hate us, they used the Soviets. The con was exactly the same as it is today: convince the public that there's an elusive enemy stockpiling nuclear arms that it plans to use to attack and conquer America. Action must be taken to stop them or we will all be destroyed. If the intelligence community comes back and says they can't find any supporting evidence, then just create new intelligence to come up with something that does fit the narrative, even if it is complete fiction.

They did, however, fine tune the con by removing the bogeyman's association to a particular nation. That way you can play bogeyman whack-a-mole for eternity. Or as Dick said: "A war that won't end in our lifetime."

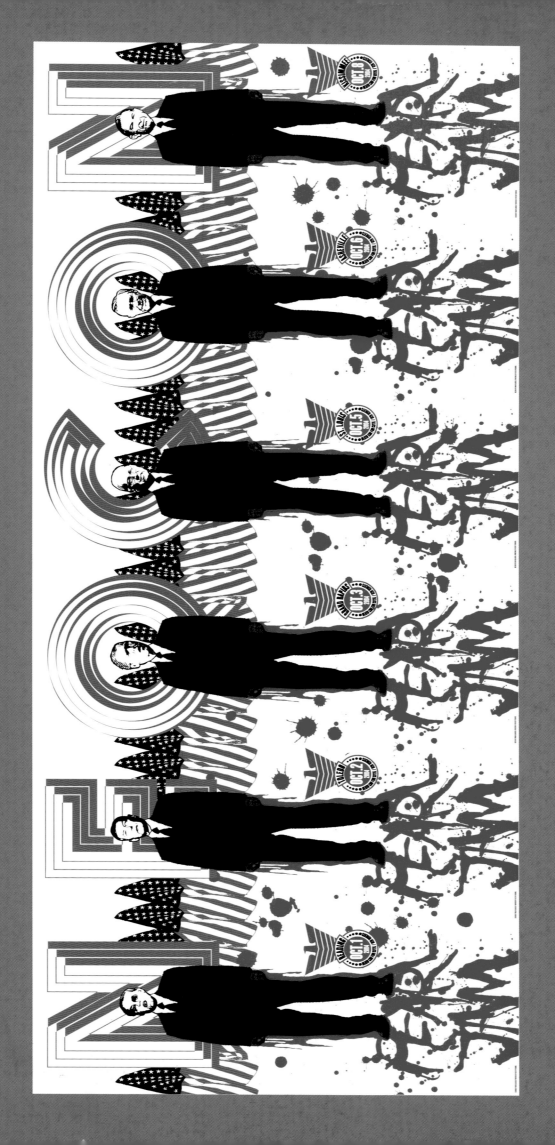

17

OCTOBER 2004: PEARL JAM / DEATH CAB FOR CUTIE / GOB ROBERTS

READING, PA / TOLEDO, OH / GRAND RAPIDS, MI / ST. LOUIS, MO / ASHEVILLE, NC / KISSIMMEE, FL; 17 1/2" X 21 1/2"; 2 COLORS

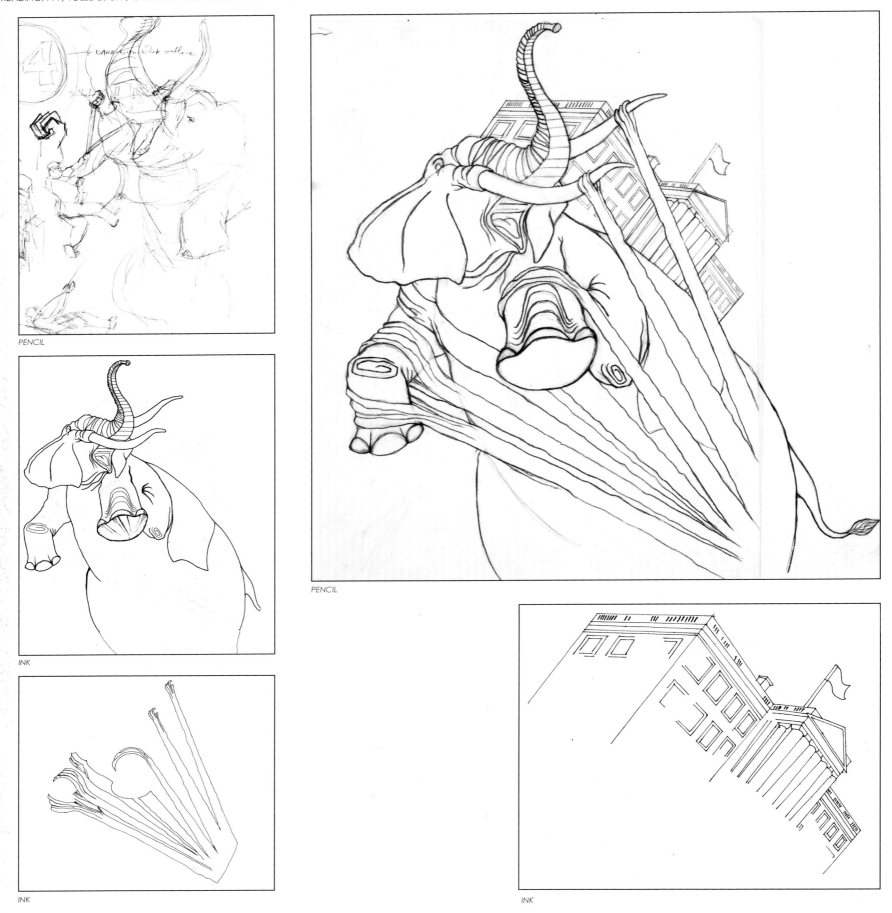

PENCIL

INK

PENCIL

INK

INK

Before I had come up with the neocon series for each individual show of the Vote for Change tour, I was originally asked to do just a single tour poster for all the dates. On this tour, Pearl Jam, along with Bruce Springsteen, the Dixie Chicks, R.E.M., Ben Harper, Dave Matthews, and many other bands, played shows throughout the swing states to rally folks to vote in hopes of seeing the Republican elephant toppled and dethroned from the White House.

Unfortunately, it didn't turn out that way.

While I enjoyed drawing this one, and relished the prospect of never having to see Dubya butcher simple sentences on TV again or invade any more innocent countries, I've always been a political atheist. My perspective on the charade of democracy can be found on pages 92–93.

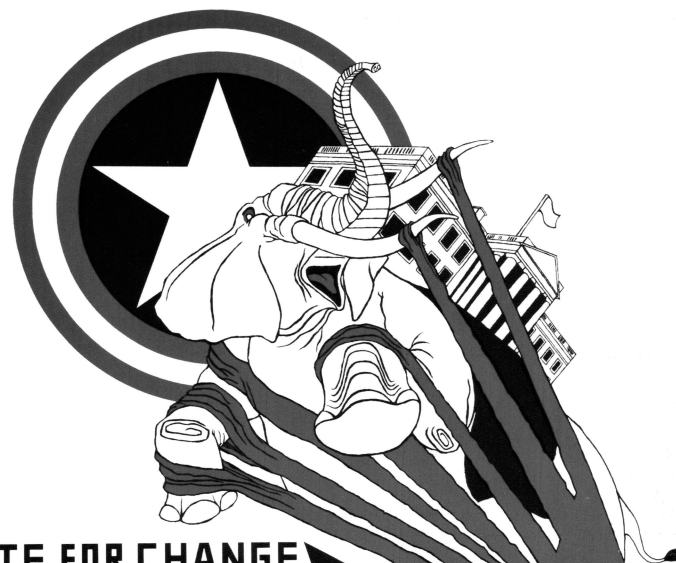

VOTE FOR CHANGE
PEARL JAM

GOB ROBERTS
DEATH CAB FOR CUTIE

★ OCTOBER 2004 ★ READING ★ TOLEDO ★ GRAND RAPIDS ★ ST.LOUIS ★ ASHEVILLE ★ KISSIMMEE ★

SEATTLE, WA; 17" X 25"; 4 COLORS

PENCIL

PENCIL

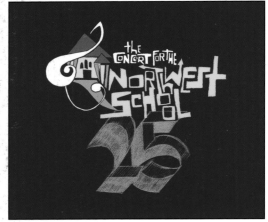

T-SHIRT DESIGN

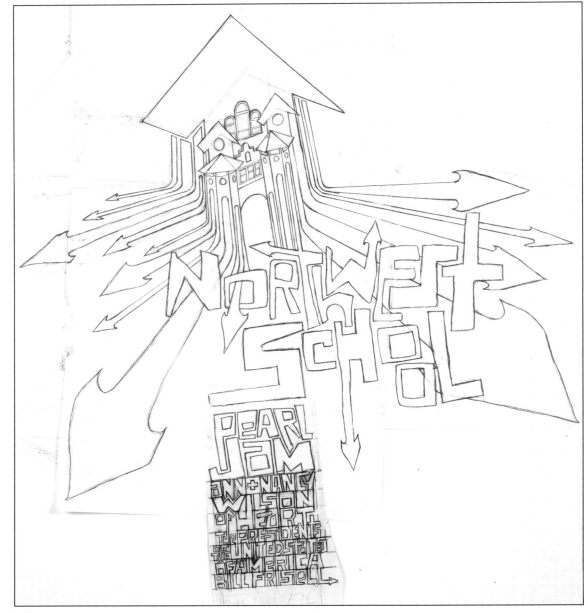

PENCIL

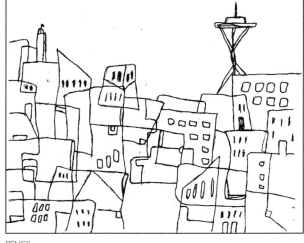

PENCIL

I came into work one day and was told I'd been volunteered to collaborate with some kids from the Northwest School on creating art for a concert to benefit the school. There was a contest in the art class to come up with the best design—the winner would then work with me to turn it into a poster for the show.

They chose two winners, Beth Corry and Matthew Noren. I had assumed once I sat down with the kids that we'd brainstorm ideas for the poster. First thing I asked them was to work up some concepts, and they both looked at me a bit funny and said that they already did that . . . for class. That's how they were chosen as the winners . . . dummy. Given that they had already done their brainstorming, I now had to do mine. So I decided to take parts of their respective designs and incorporate them into what you see here: I used Beth's city as the backdrop for the poster, and Matthew's rendition of the school, musical clef, and number 25 for the T-shirt.

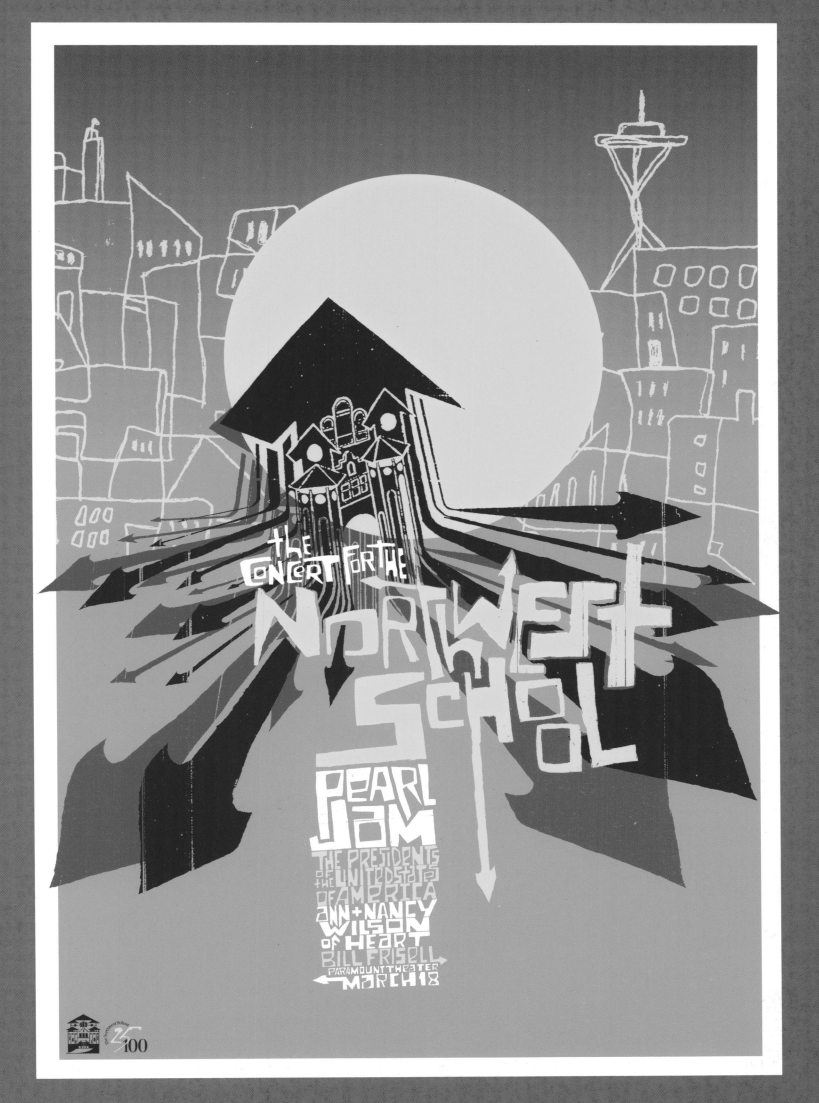

21

PENCIL

PENCIL

PENCIL

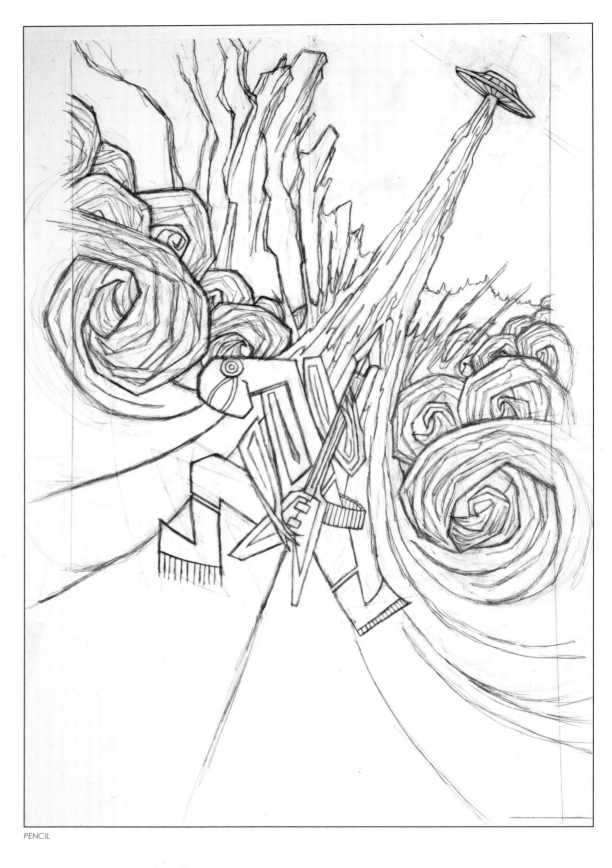

PENCIL

I was unaware of the band UFO and the musician Michael Schenker until I was asked to do this poster for Mike McCready's UFO tribute band, Flight to Mars. Using gaffer tape, Mike had made one of his Flying V's resemble Schenker's black-and-white Flying V. I wanted to incorporate that element somehow, and was trying to think about what kind of space creature would play a Flying V. The humanoid robot Gort from *The Day the Earth Stood Still* seemed like an obvious choice. I en-visioned him losing all his statuelike rigidity once he picked up a guitar and started shredding. Music loosens everyone up, even Gort.

During this period, I wasn't doing a lot of inking, rather just using the rough pencil lines for the final image. I like the effect it had on this one, a bit messier in the rocks and clouds.

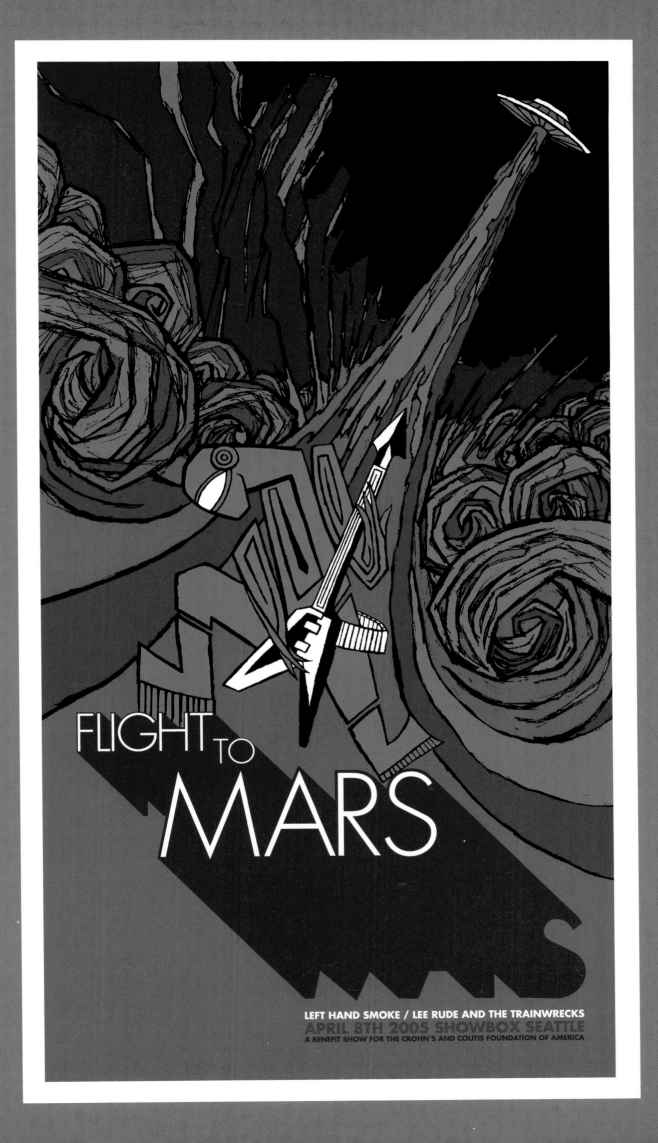

FLIGHT TO MARS

LEFT HAND SMOKE / LEE RUDE AND THE TRAINWRECKS
APRIL 8TH 2005 SHOWBOX SEATTLE
A BENEFIT SHOW FOR THE CROHN'S AND COLITIS FOUNDATION OF AMERICA

EDMONTON, AB; 18" X 24"; 3 COLORS

PENCIL

I made this poster at the height of my obsession with Queens of the Stone Age. I still love them, but when I was working on this poster, I listened to them ad nauseam. Their first album forever altered my musical tastes and has been playing in heavy rotation ever since I first heard it. This poster was for the *Lullabies to Paralyze* tour, and there's a song off that album called "Someone's in the Wolf." They always make me think of Grimm's fairy tales, stories of dark and twisted lessons you learn the hard way. The concept for this one originally depicted a sad child who had been swallowed whole inside the belly of the wolf, but I started liking the shapes I had for the bust of the wolf instead . . . plus I don't think I had enough time to make the drawing so elaborate, and the original idea was perhaps too literal. It's one of the fun aspects of the process, you never know how the drawing will evolve from concept to paper. It's always changing and growing as you go.

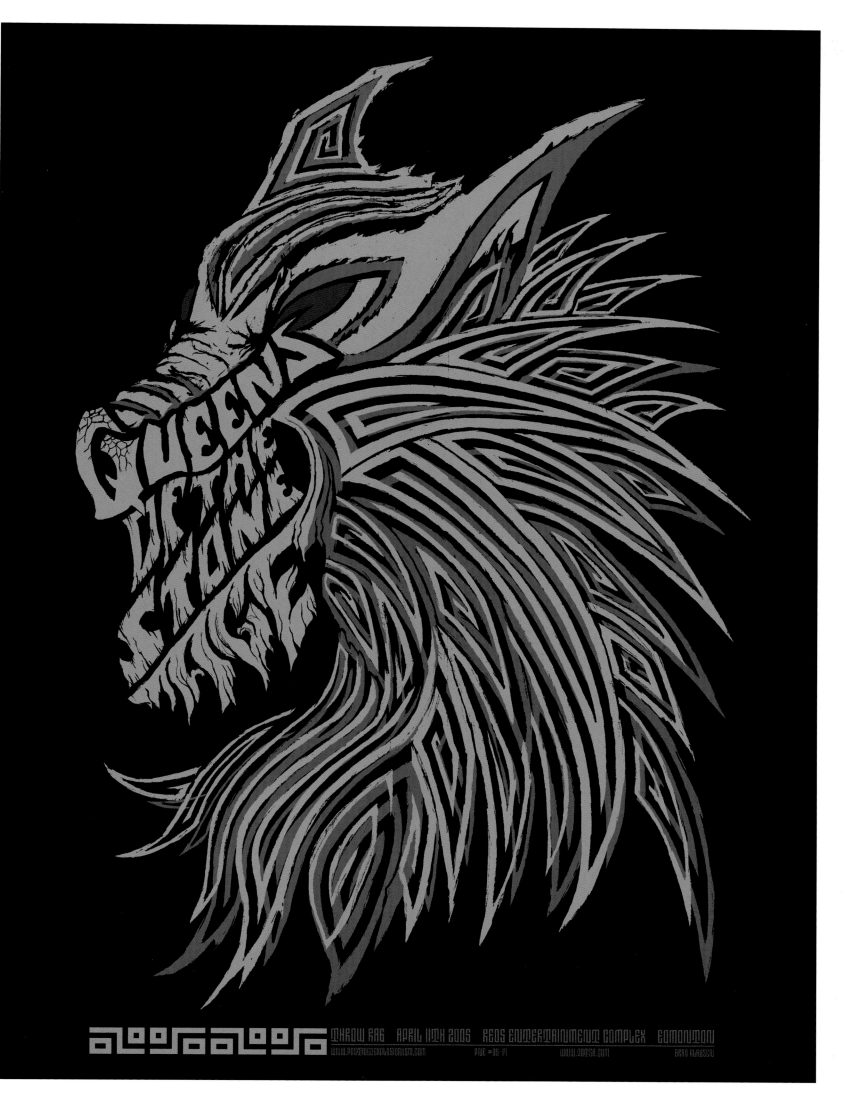

PENCIL

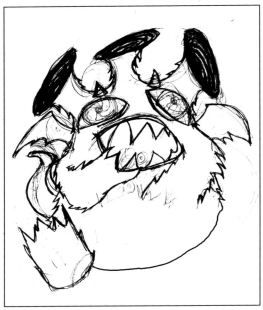

PENCIL

PENCIL

PENCIL

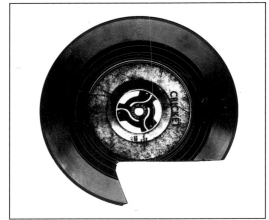

SCAN

SCAN / PHOTOSHOP

This one was for a show for the Coalition of Independent Music Stores (CIMS). A bunch of indie music store owners were in town for the weekend for a series of events, including a secret Pearl Jam show inside Easy Street Records in West Seattle.

I was talking with my friend and coworker at the time, Rob, about what I should do for this show. While I don't recall everything about the conversation, I'm pretty sure he threw out the idea of a record-devouring monster. I liked that concept. Rob gets the credit for this one. There was a stack of random old 7" records in my office, and I cut them up to make the individual letter shapes. I tried drawing the façade of Easy Street as best I could, only to realize afterward that by focusing on getting all the molding right, I had drawn it a bit too skinny and tall. So it got reproportioned in Photoshop to make it closer to reality.

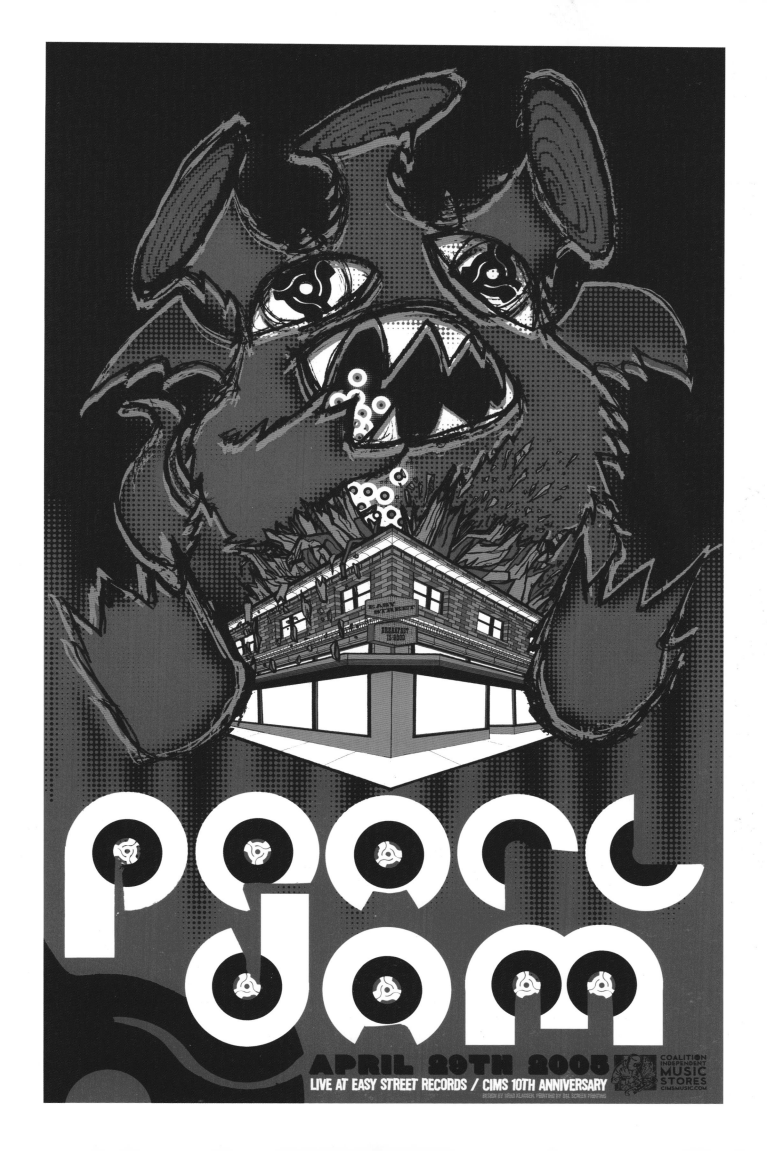

INK

PENCIL

PENCIL

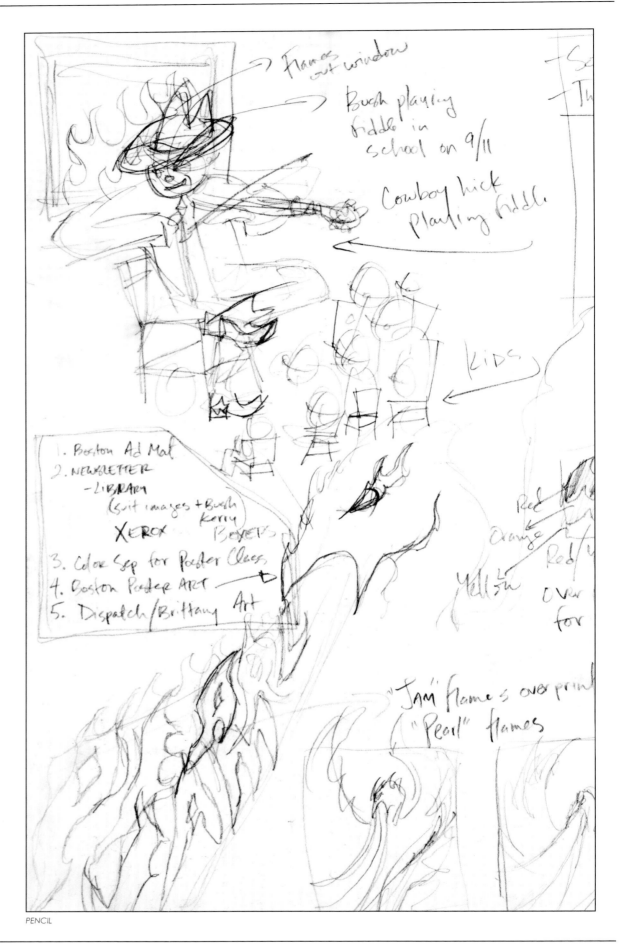

PENCIL

My friend Jason often mentions that he very much enjoys this poster, and that I shouldn't tell him the inspiration behind it, since he's given it his own meaning (even though he already knew what the inspiration was just by looking at it and knowing me). So, Jason, if you're reading this, don't look at the sketch above.

I am a messy sketcher. When I have an idea for something, I scribble it down using the most basic shapes just to make sure I don't forget it. Oftentimes, the scribbles only make sense to me. I liked the feel of this one and thought it worked well on its own. It reminded me vaguely of Ed Fotheringham. So I left it as it is.

The other images here are sketches that I decided not to use for the *Gorge* box set album art. (There were three shows in that release, and I had drawn out these sketches in a similar style for the packaging.) I really liked all the parts and how everything fit together, but it felt overly political. It wasn't a good fit for the live CDs.

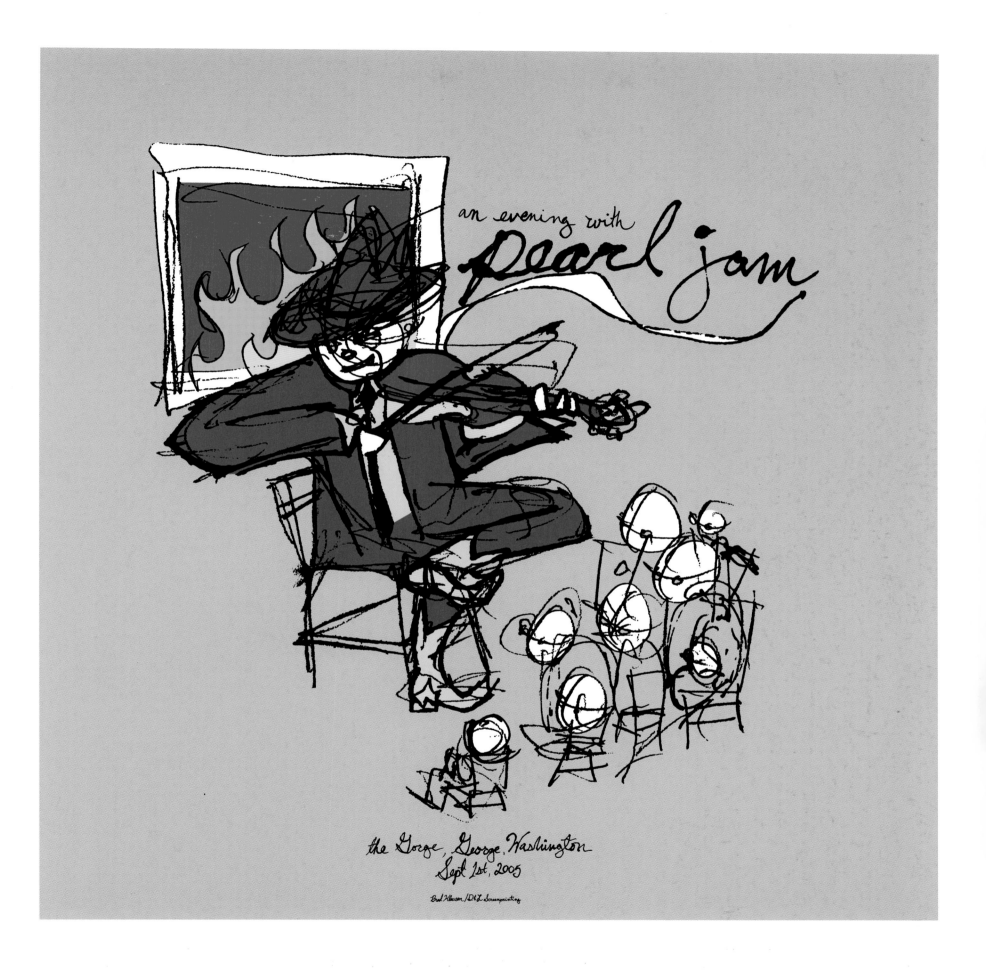

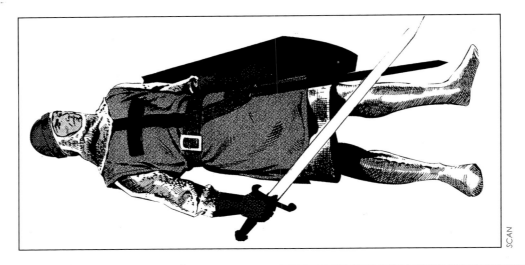

SCAN

Scientific Apparatus 107

SCAN

108 Scientific Supplies

SCAN

106 Scientific Apparatus

SCAN

Scientific Supplies 109

SCAN

This poster came out of my love for image catalog books. These pages are directly out of the first volume of the aptly titled *Scan This Book*. I had long desired an excuse to steal the layout of all the wonderfully strange beakers and instruments. It wasn't until I started drawing more frequently that I stopped wanting to use found images. Early on as a graphic designer, using found imagery and fonts was how I made everything. Nowadays, it's much more fun to try and draw everything.

By throwing the crusader knight into the lettering, the concept of the laboratory experimentation of science vs. the strong-arm sword-wielding of the religious crusades started to take shape. I liked that juxtapostion a lot.

However, in looking back on this poster now, it makes a much different impression on me. I instead see the modern instruments of the laboratory alchemist used for creating tinctures and stones. I view the knight not as a symbol of violently enforced religious ideology, but rather as one of the Knights Templar. He's not standing in the way of science or progress, he's defiantly defending the Royal Art with sword in hand.

30

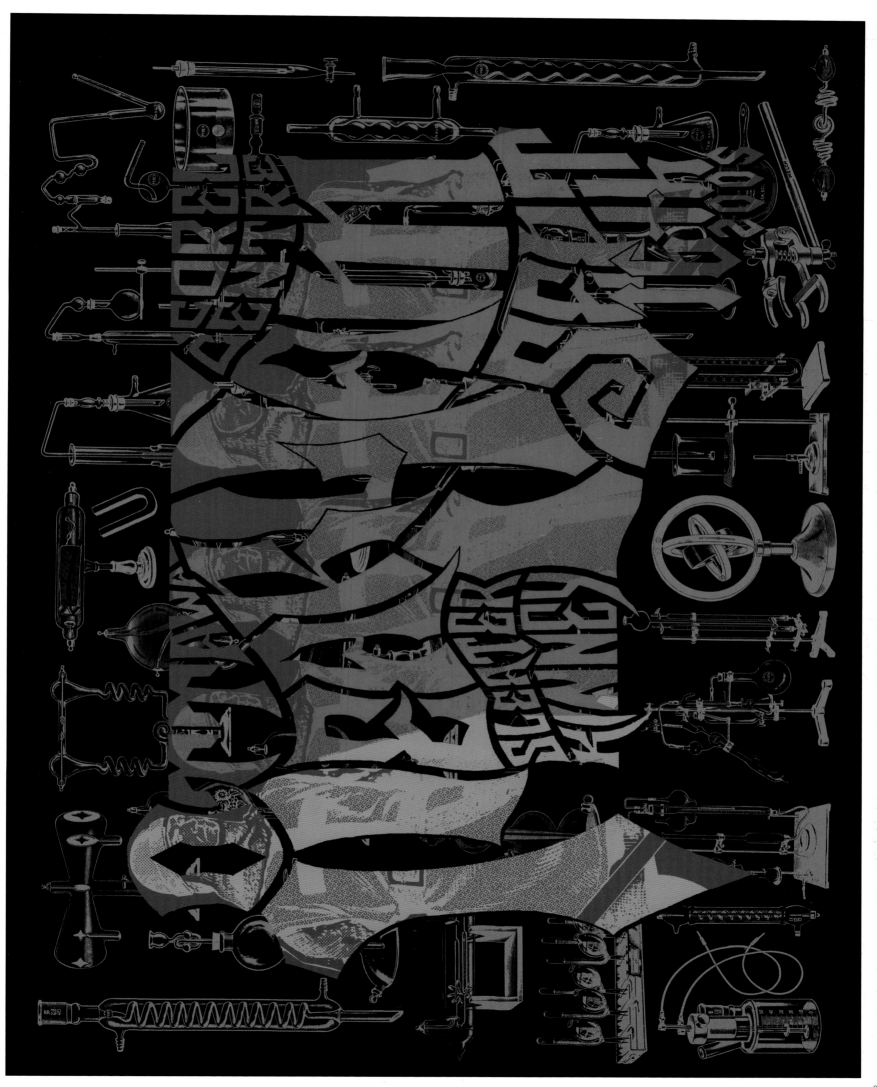

PENCIL

PENCIL

PENCIL

PENCIL

Back in high school in the early '90s, I'd often draw in the margins and back pages of my textbooks. I would fixate on sketching one particular thing over and over, until I became bored with it and moved on to the next thing. This tommy gun–toting mobster was one of those recurrent things. But once I stopped drawing this guy, he never reappeared in my mind again . . . until over a decade later when I was working on this poster for a show in Atlantic City. As I was sitting down trying to come up with a concept that fit with the city, this image just resurfaced out of the blue. I was amazed by this. I am not a very organized person, so to find out that some filing minion of my memory had safely kept this image in a drawer for over a decade, and then knew exactly where it was hidden and managed to bring it back to my attention, was almost unbelievable to me. I was certain I had killed off all those memory minions in the bars around the University of Denver.

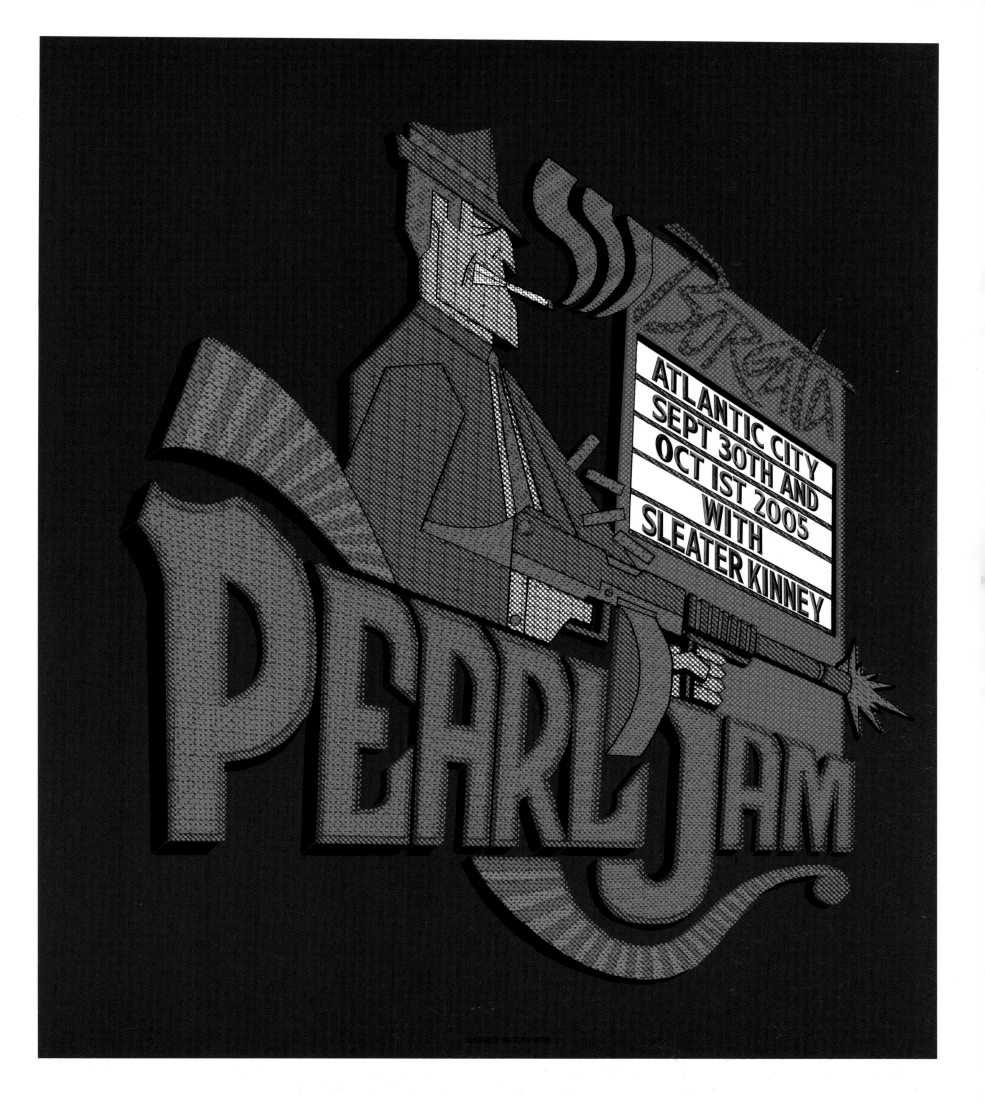

NOVEMBER & DECEMBER 2005: PEARL JAM / MUDHONEY

SANTIAGO, CHILE / BUENOS AIRES, ARGENTINA / PORTO ALEGRE, BRAZIL / CURITIBA, BRAZIL / SÃO PAULO, BRAZIL / RIO DE JANEIRO, BRAZIL; 22 5/16" X 31"; 6 COLORS

PENCIL

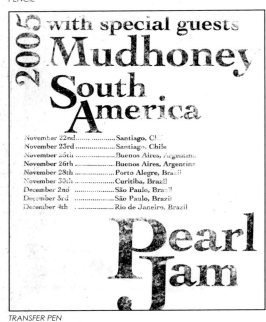

TRANSFER PEN

TRANSFER PEN

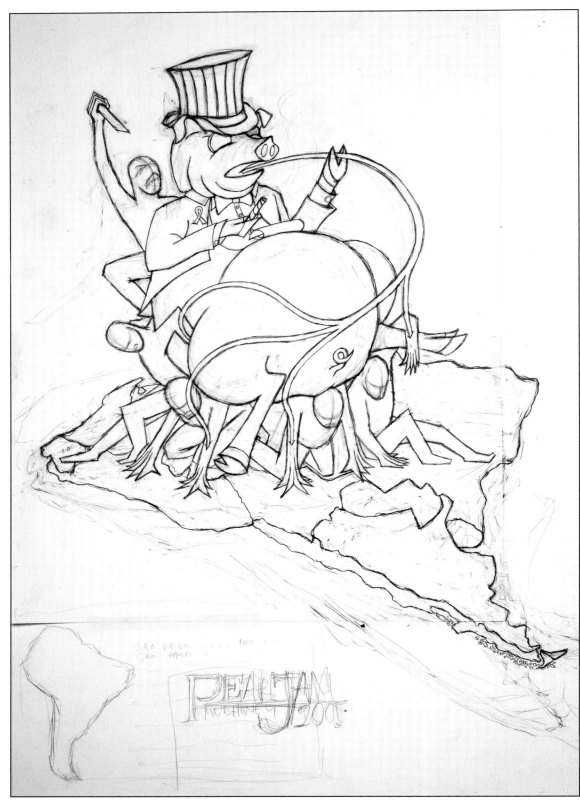

PENCIL

I was having a hard time coming up with a concept for this poster so I called my good friend Jason, who was living in Brazil at the time, and picked his brain a bit about his impressions of South America. He spoke about how there's a strong resentment toward American companies that come in and take the natural resources out from underneath the people they belong to, and then resell them back at much higher prices. He mentioned Eduardo Galeano's book *Open Veins of Latin America*, which speaks directly to this subject. The title alone gave me all the visuals I needed. The idea was to try and make it look like and old '30s economics magazine cover. At this point in time, I was quite fond of using transfer pens to create texture, and it worked out well for the vibe I was trying to create on this one.

Despite its heavy message, this one will always remind me of my friendship with Jason, which I am quite grateful for.

Pearl Jam

with special guests

Mudhoney

South America
20
05

November 22nd.....................Santiago, Chile
November 23rd.....................Santiago, Chile
November 25th.....................Buenos Aires, Argentina
November 26th.....................Buenos Aires, Argentina
November 28th.....................Porto Alegre, Brazil
November 30th.....................Curitiba, Brazil
December 2nd.....................São Paulo, Brazil
December 3rd.....................São Paulo, Brazil
December 4th.....................Rio de Janeiro, Brazil

Brad Klausen / D&L Screenprinting

PENCIL

INK

PENCIL

PENCIL

Choosing a favorite poster is tough, they're all like my children. That being said, this one has always been one of my favorites. I love the fact that it's two colors and the shapes are pretty straightforward, as well as how the outline is reversed to the paper. Whenever I see this one nowadays, it makes me think that I need to get back to doing more simple things like this, using only two colors. I also like the story being told in this poster . . . for once the bull finally gets some justice. Originally, the idea was to have the stadium full of horrified bull-fighting fans gasping at the tragic turn of events. However, after drawing two faces, I realized it would take me forever to draw enough of them to fill the space in the stands behind the ring. You can see in the thumbnail above that the stadium was initially supposed to be full of people. The two faces I did draw would later end up being used in a poster I made for the Gossip on pages 64–65.

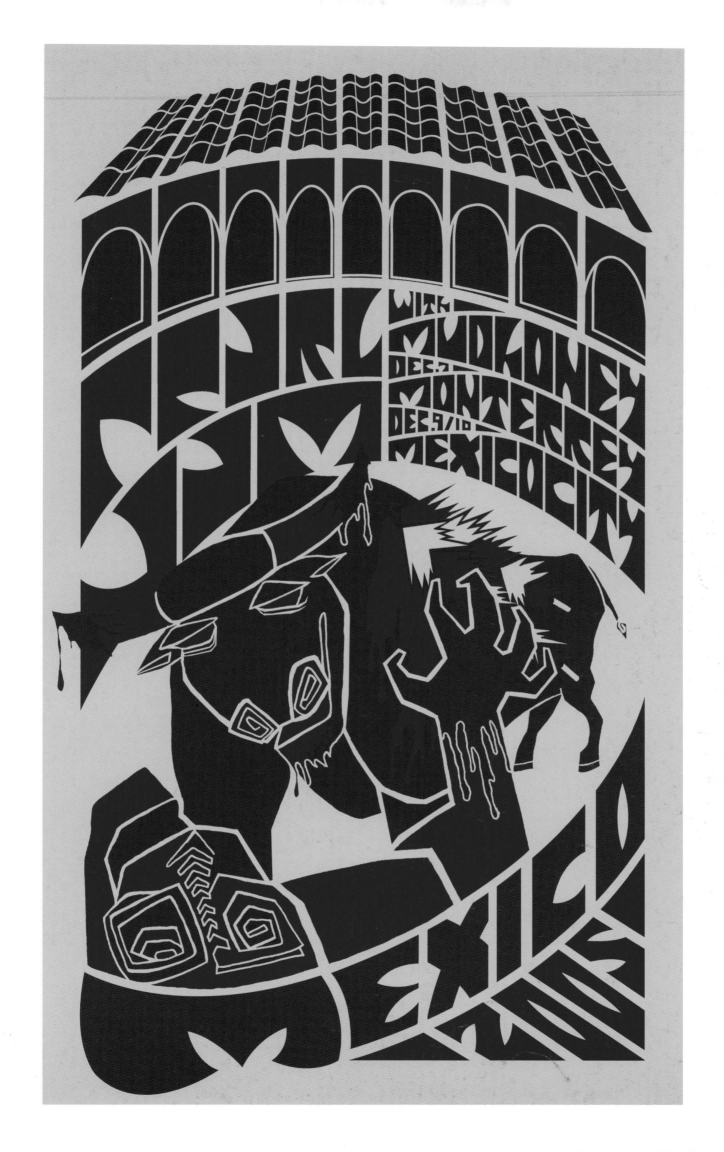

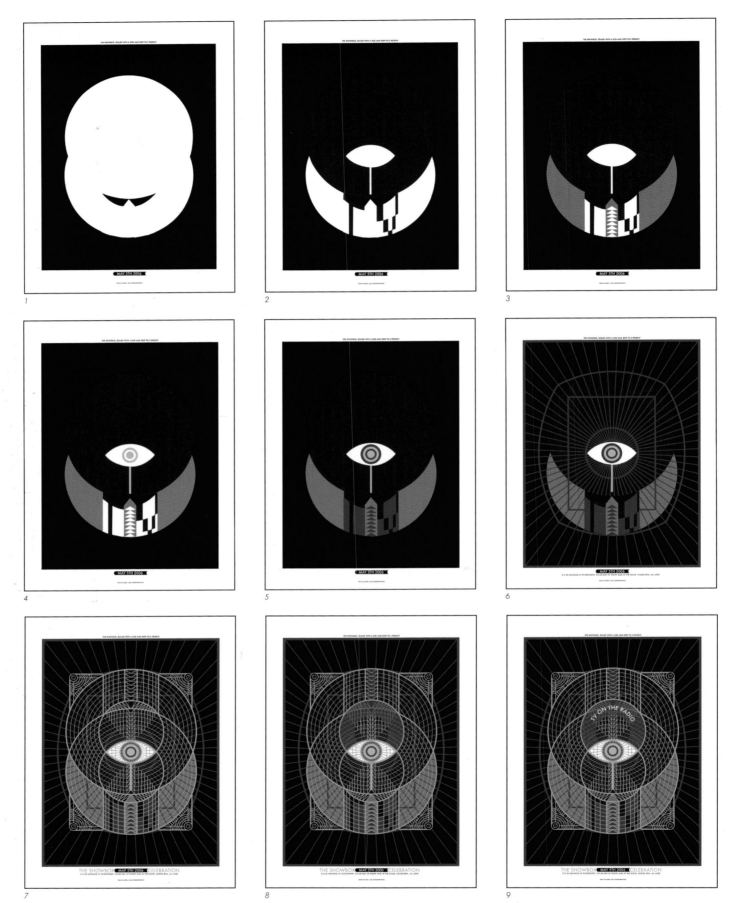

I wanted to create an image that resembled one of those old Indian head test cards they would show in the early days of TV after the station signed off. I was trying to make sort of a hypnotic test pattern. This poster is a perfect example of the wonders of found imagery. The whole design was built by layering two patterns from a Dover book called *Geometric Designs*. Then I just colored them in.

Collaging found imagery was something I used to do a lot. During the early part of my career, that's how I made everything—through reappropriating found imagery. I had no problem doing that. The rock poster world is one with a long history of using found imagery; fliers for shows are often about clever use of such images. But as time went by, I started to feel less comfortable with this method. It felt like cheating. It wasn't mine, I didn't make it. The more I became involved in the scene, the more impressed I was with artists who created every part of their design.

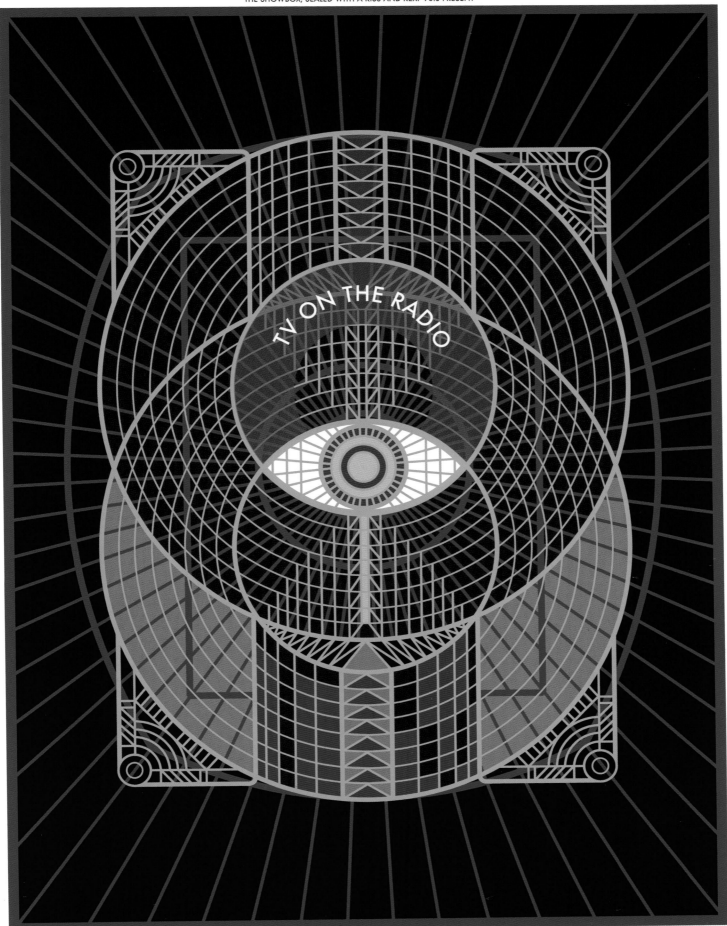

THE SHOWBOX MAY 5TH 2006 **CELEBRATION**
$13.50 ADVANCE AT TICKETSWEST. $15.00 DAY OF SHOW AND AT THE DOOR. DOORS 8PM. ALL AGES

BRAD KLAUSEN / D&L SCREEENPRINTING

TORONTO, ON; 17" X 24"; 5 COLORS

PENCIL

PENCIL

INK

PENCIL

INK

The first time I heard Pearl Jam's song "Severed Hand," I knew I had to make a poster about it. I think it's one of the more accurate accounts of what tripping is actually all about: "If I don't lose control / explore and not explode / preternatural other plane / with the power to maintain." Hallucinogens allow you to cross over into an entirely different level of existence, and navigating through that plane can be quite precarious if you aren't careful. Just as much as they allow you to grow and expand your perceptions on life and existence, if you aren't capable of dealing with what you find in that realm, you can explode and lose your shit. It's a fine line to walk. "You'll see dragons after 3 or 4." In high school I was pretty antidrug but always curious about acid. I held this naïve notion that if you took acid, you'd see dragons. Each trip I've taken, I have always quietly hoped that that would be the occasion they'd finally show up. I'm still waiting for them . . .

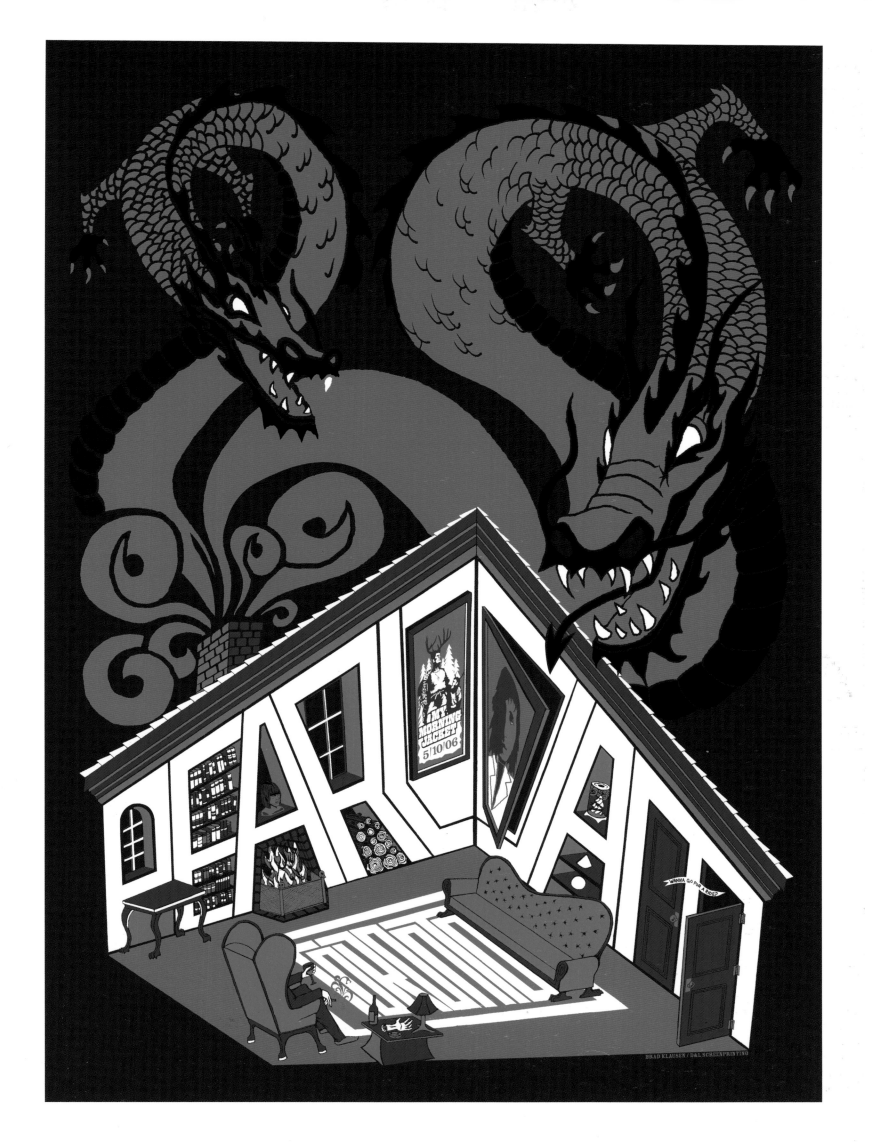

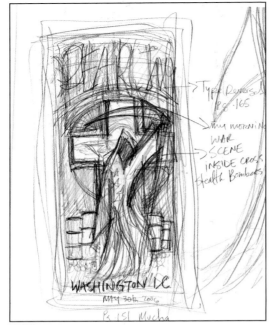

PENCIL

PENCIL

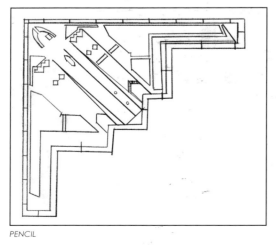

PENCIL

PENCIL

There are some pieces in this book where the meaning behind images becomes subtle or even unclear. But when it comes to politics, I tend to be pretty blunt. While divvying up the shows for this tour between the Ames Bros and myself, I specifically asked for DC. I was harboring a great deal of anger toward Dick Cheney and his brood for all their transparent lies and abhorrent crimes against humanity. And how did they get away with such atrocities? By using simple symbols to psychologically steer the population into their line of thinking. And the majority of Americans went right along with them, having no problem invading an innocent country they knew nothing about based on absurd lies. Or as Voltaire puts it: "Those who can make you believe absurdities can make you commit atrocities." We must never forget, Saddam was involved in 9/11. Well, that was a total lie, but he did have WMDs, right? Nope, another lie . . . umm, Freedom for Iraq! Third time's a charm.

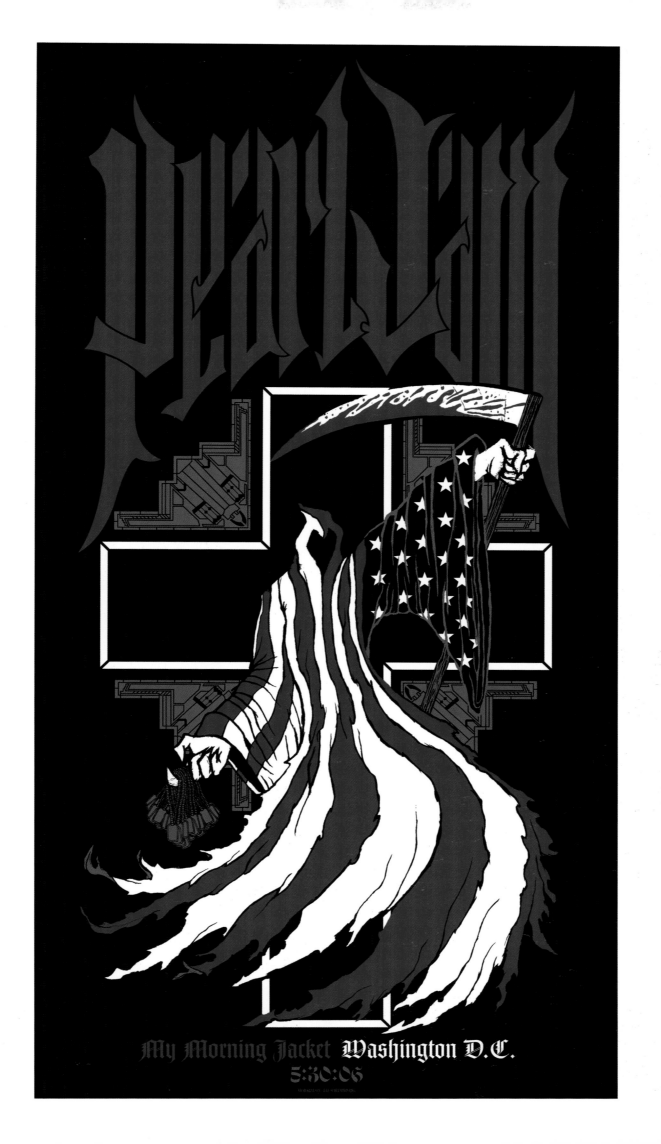

ILLUSTRATOR AND PENCIL

PENCIL

PENCIL

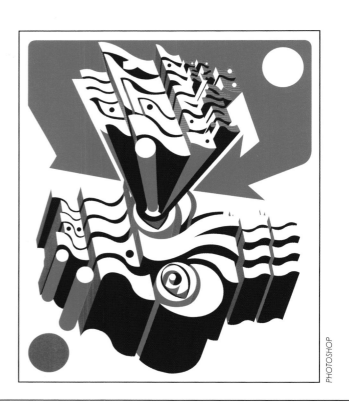

PHOTOSHOP

Ah, the Denver poster: praised by poster designers when it was released, loathed by Pearl Jam fans everywhere.

This was for a show Pearl Jam was playing with Tom Petty. When I set out to design the poster, I wanted to make sure that both bands had equal billing so that neither name was larger than the other. So I set out to sort of split the poster in two, one side for Pearl Jam, the other for Tom Petty. I was pretty pleased with my solution.

But when it came time to hand in the final image, I was told it couldn't say *Tom Petty* on it due to whatever contracts are made by merchandise people. I had no idea this was the case, as no one had passed along that important piece of info to me when I started. So with only about a day to fix it, I had to scramble. I figured I'd just have it say *Pearl Jam* twice. That way it would look like the Pearl Jam skull is either projecting the word from its eye, or perhaps since it says *Pearl Jam* on its head, it just sees everything as it sees itself.

I have no idea why I decided to change the colors from my original scheme—the purple/pink/cyan design was way better.

44

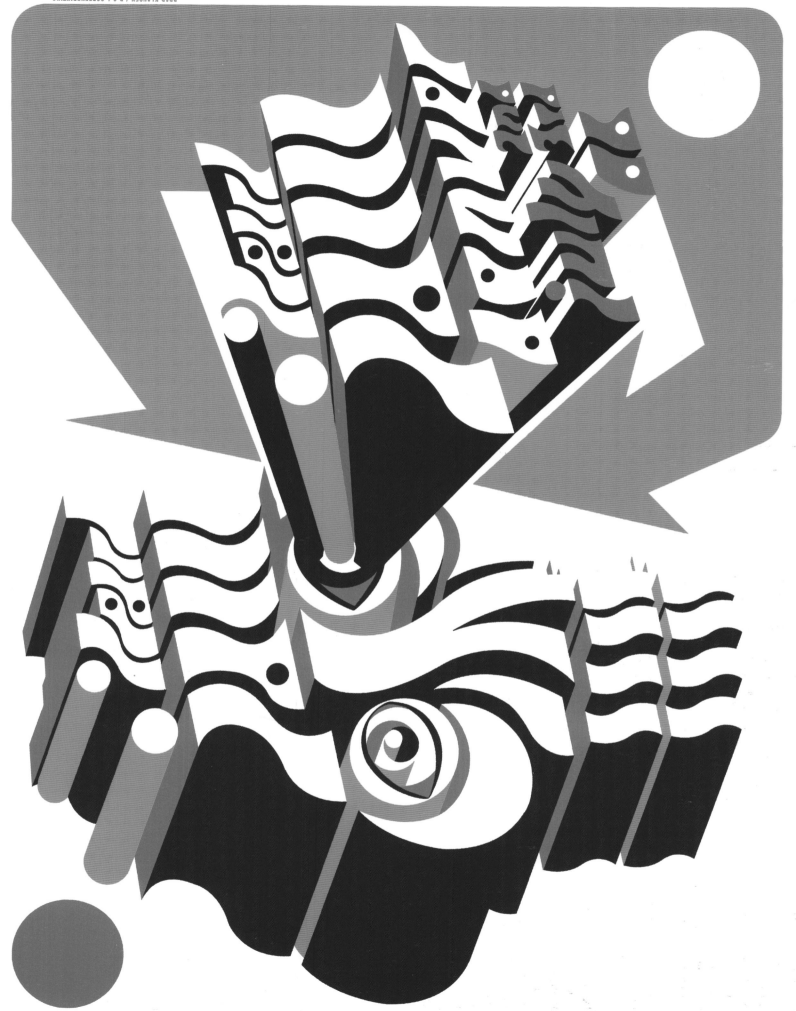

PENCIL

PENCIL

INK

ILLUSTRATOR

Sometimes a poster concept stems from a sketch where I have the image and need to figure out how the type will be incorporated. Other times I just start drawing type and try to figure out what sort of image will go with it. And sometimes the type and the image arrive at the same time. This one was based off the type. Once the type was complete, it felt like it wanted to have a circle under the *A* and the *M* of *JAM*. That turned into a sun. LA is sunny . . .

The surfer image I redrew from the cover of an old issue of *Surfer* magazine. I don't remember which issue, but it was one of the earlier ones from the '60s. I also directly lifted the wave logo from somewhere, and the palm trees are plain ol' clip art. This one's all about the type.

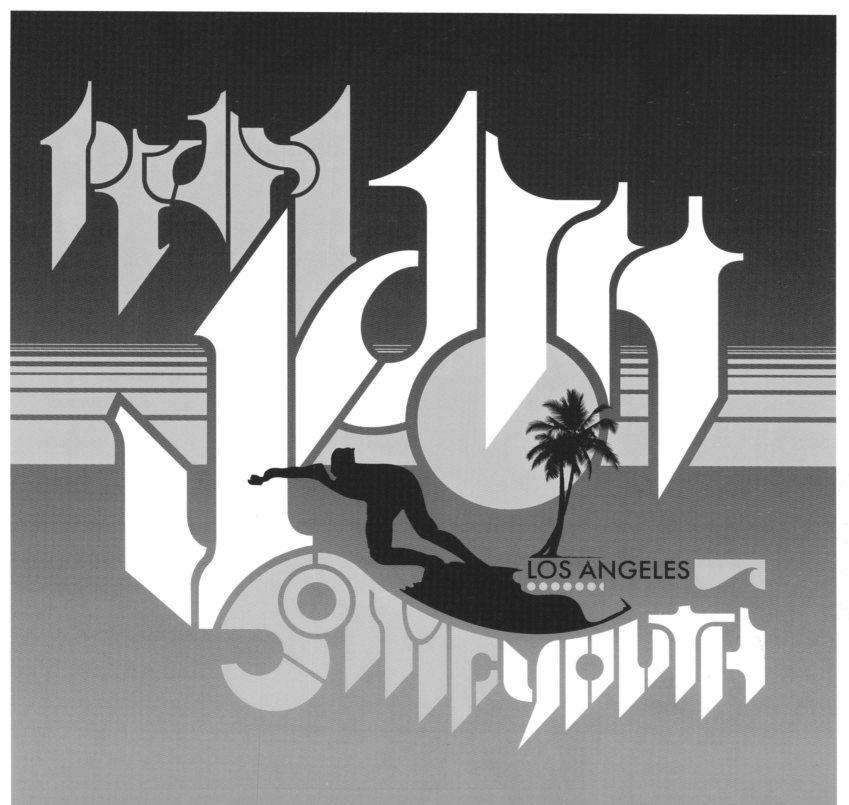

LOS ANGELES

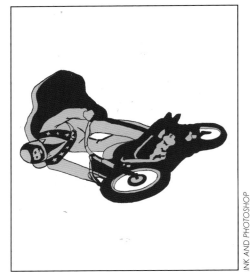

INK AND PHOTOSHOP

PENCIL

PENCIL

PENCIL

It's always fun to try and incorporate something relevant to the city of the show in the poster. It's also fun if you can do that while simultaneously incorporating things you know the bands like as well. Eddie Vedder likes Evel Knievel. The Gorge, Evel Knievel—it was a perfect match.

This is one of those cases where I was able to marry the image and the type. It's always fun to try and figure out ways that you can turn an image into typography. Being a fan of typography, my brain tends to try and turn everything it sees into a letterform.

I've also been a fan of things that aren't instantly recognizable. I like the idea that you might have to take a minute to see that there are actually letters and words in the cliff. Being that these posters were not used for promotion, I could get away with not having things be immediately legible.

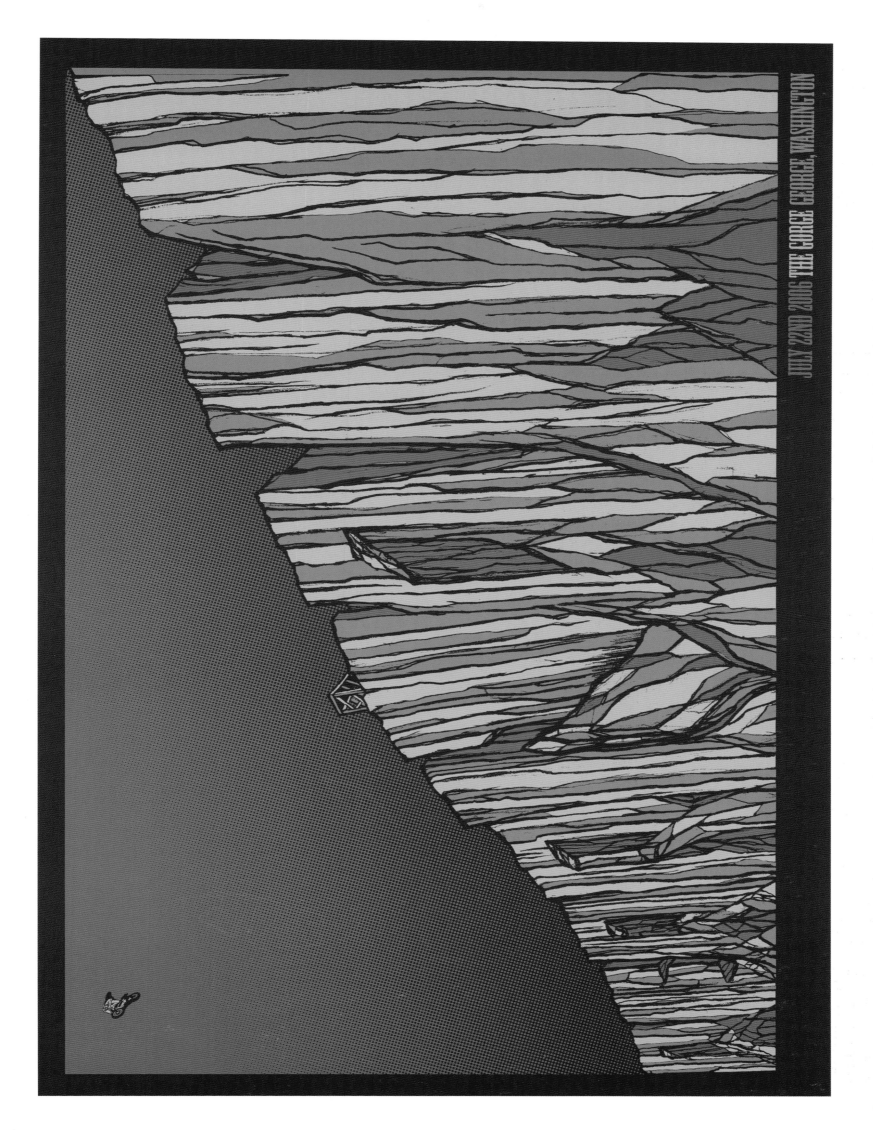

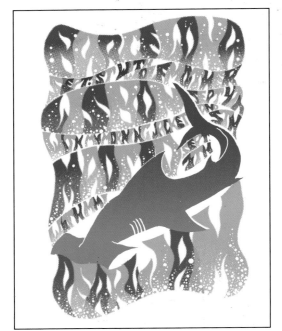

PHOTOSHOP

ILLUSTRATOR

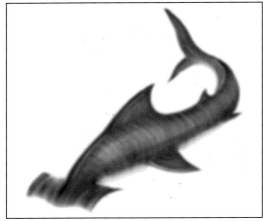

PHOTOSHOP

PENCIL

Nowadays, I try and put a lot of thought into figuring out the appropriate image for a given city; earlier on, that wasn't always the case. I would just make something that hopefully looked good. For a while I had been wanting to put a hammerhead shark on a poster, and figured that I might as well for Barcelona, Lisbon, and Madrid, since there are hammerheads all over those cities . . .

The shark was fun to create. I took the outline of the sketch and filled it in with a single gray color. Then, using the burn and dodge tools in Photoshop, I could start shaping it and giving it more dimension. I was pleasantly pleased with what happened to all that shaping once the image was converted into halftones. I've always been a fan of halftones and wanted to try to do something different with them. I would eventually use the same dodge-and-burn shaping on some sharks for the "No Fin, No Future" print on page 113.

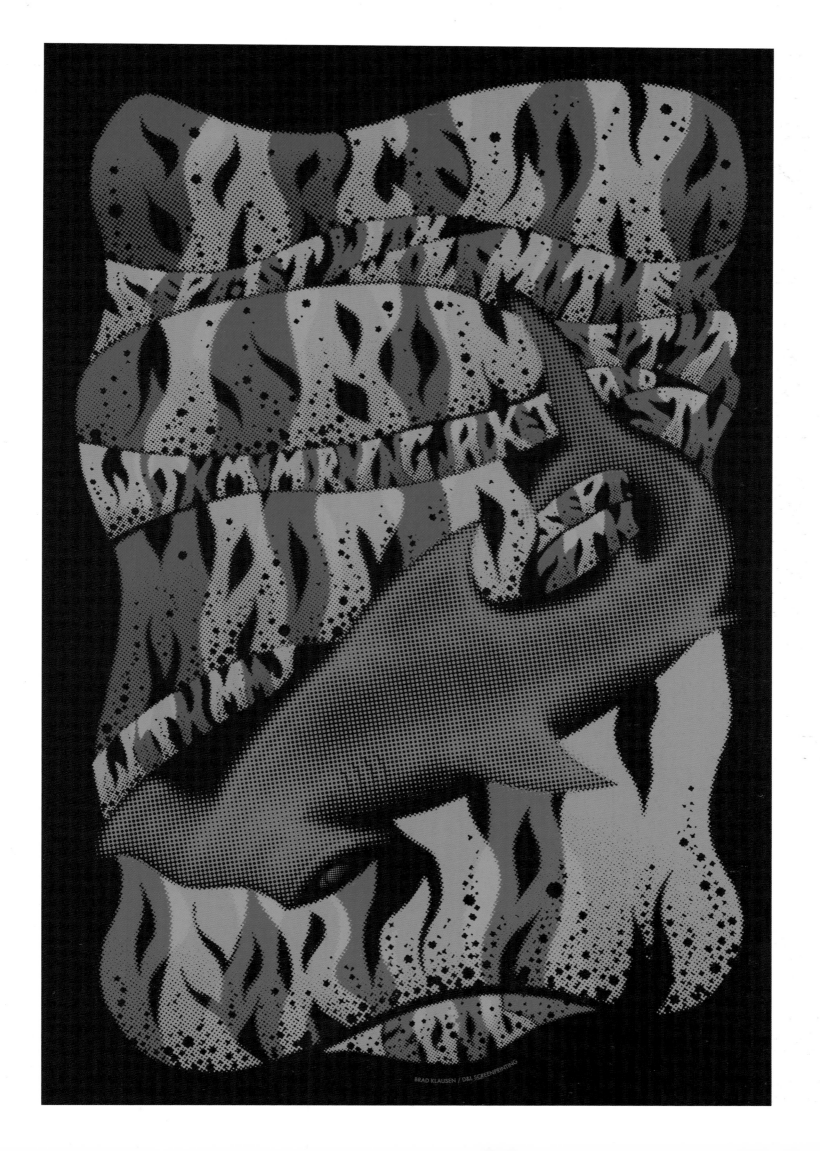

BRAD KLAUSEN / D&L SCREENPRINTING

INK

INK

PENCIL

I don't think there was supposed to be a poster for this show, but I had an idea for one and asked if I could do it. Apparently, U2 doesn't typically sell posters, so it took some discussion to convince them to let us make one. Once I got the okay to move forward, I then had to again convince the merchandise people to let me make it seven colors, since I had a strong idea and couldn't get rid of any of the colors. So this one took some talking.

Given that Eddie Vedder is friends with big-wave surfer Laird Hamilton, I figured it would be cool to find an image of Laird to draw from. The one on the top is from the famous shot of him surfing the big, mean, thick wave at Teahupo'o. Both figures riding the wave are based on Laird surfing, hence the life jacket and foot straps, but I don't recall which particular wave he's riding in the bottom half.

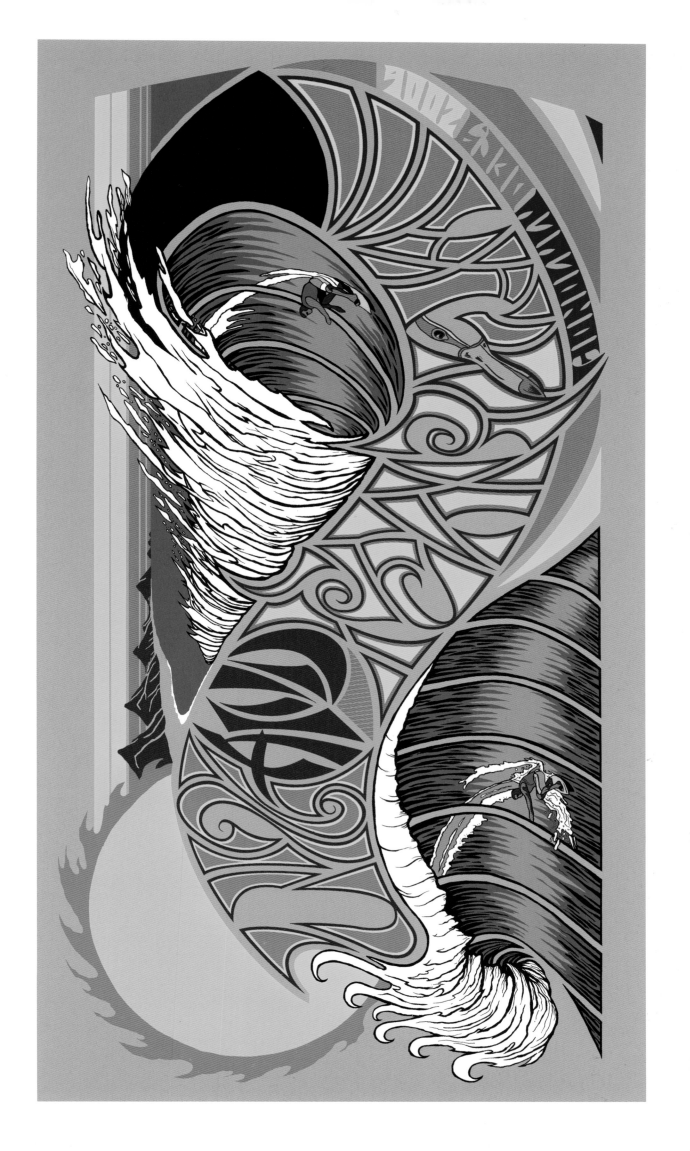

PENCIL

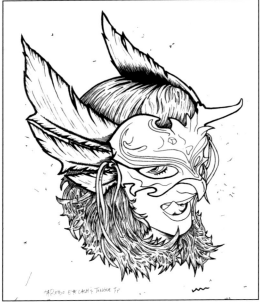

INK

PENCIL

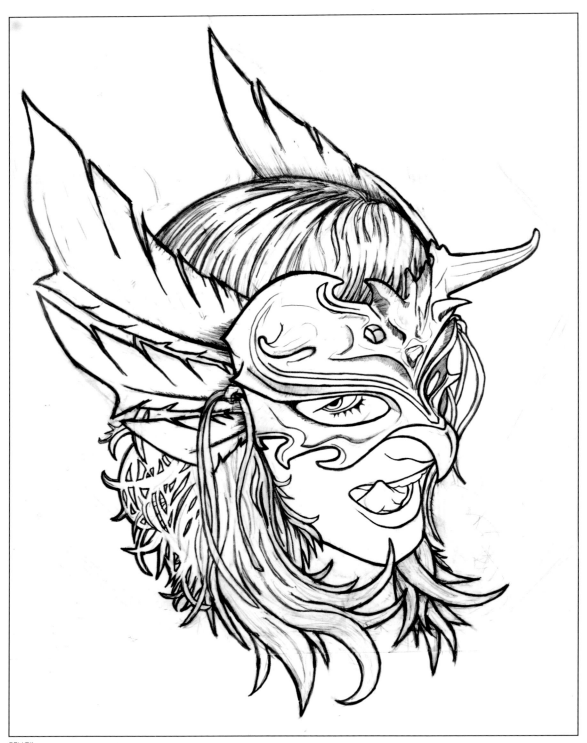

PENCIL

Eagles of Death Metal are one of the few bands out there that can break my normal head-nodding stance and compel me into full-on body movement. Punchy, catchy, hooky songs all brought to you by the mustachioed charisma of Jesse "The Devil" Hughes. Eagles shows always make me feel like I just came across a traveling "doctor" in town trying to sell me some snake oil. Only this ain't snake oil, it's the one and only Jesse "The Devil" Hughes's very own boot-scootin', electro-shootin', supersonic, sexy tonic, and he knows exactly how to sell it. So I figured I'd try and capture that idea and make an old-timey label for such a tonic. Luckily for me, the most beautiful woman in the world kindly obliged me and modeled for this one.

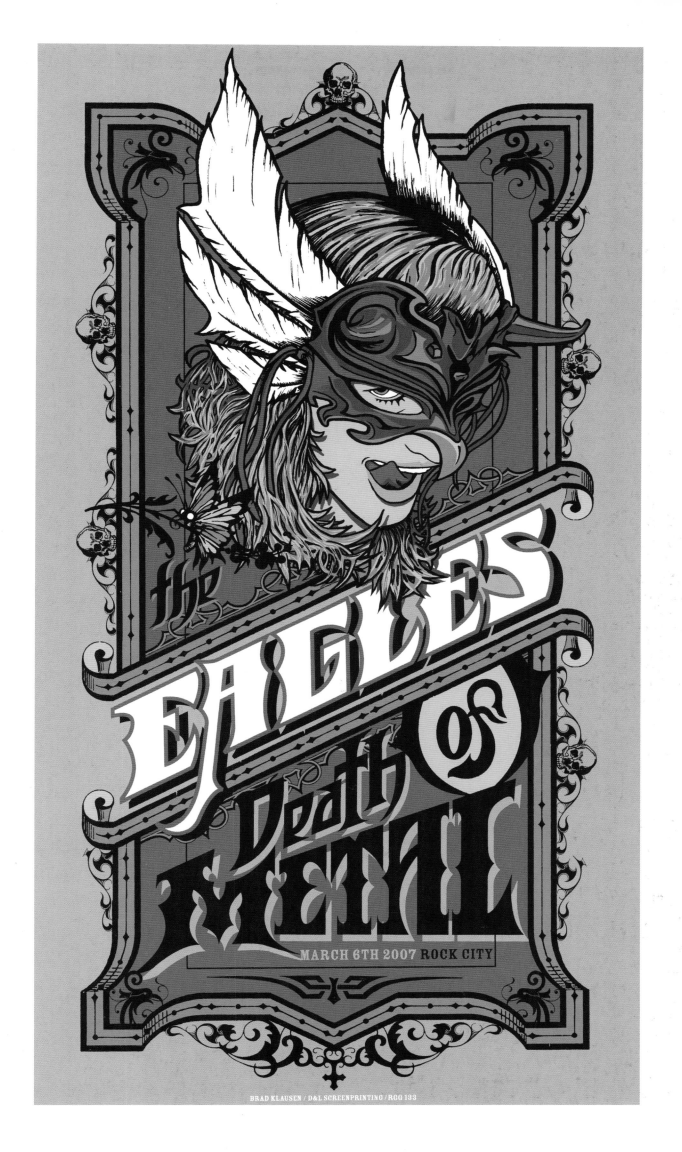

THE EAGLES OF Death Metal

MARCH 6TH 2007 ROCK CITY

PENCIL

PENCIL

PENCIL

My friend Ryan asked me to make poster for a show his band, The Young Sportsmen, was playing with Aussie band You Am I. Ryan's a big You Am I fan, so he was pretty stoked to be playing with them, and I was happy to do something for him. Apparently, You Am I got its name from an Australian airline.

In Seattle, it seems like two-thirds of the people I meet play an instrument, and usually play it well. There are some talented people writing and playing in their basements all over this place. Ryan is one of those guys who's just an unbelievably talented musician and songwriter. I've never seen someone more at home with a guitar in hand than Ryan. He's a natural. Whenever I go to one of his shows, it always makes me smile to see him doing what he was put here to do.

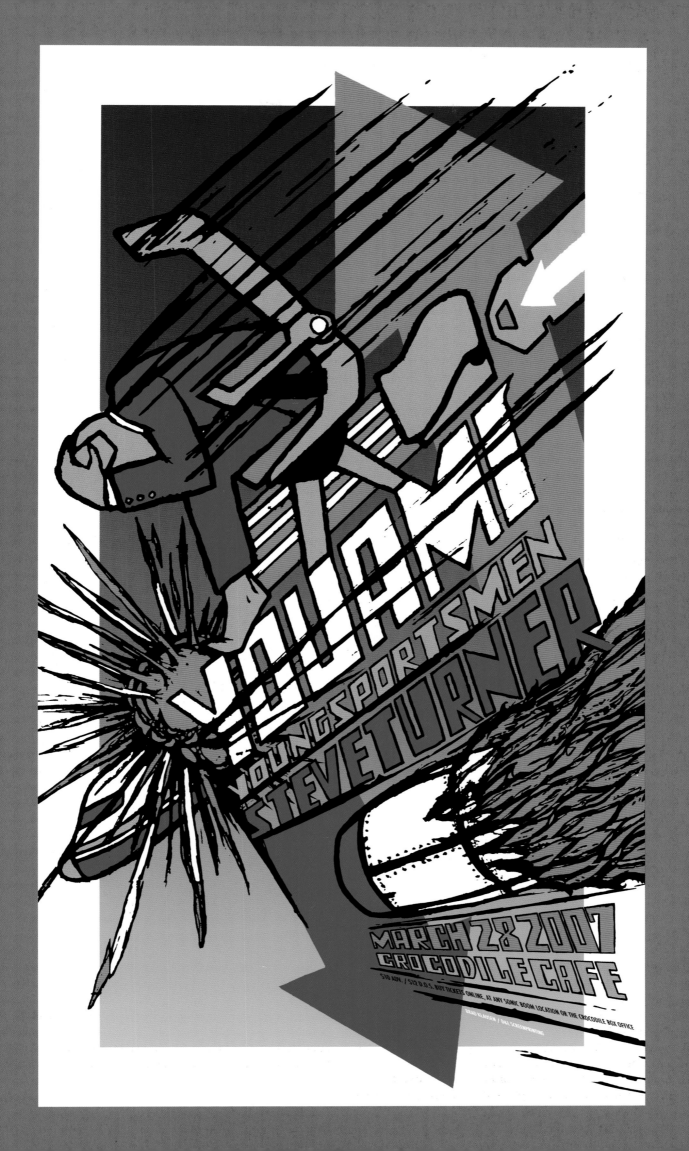

VOLCANO

VOLCANO
YOUNGSPORTSMEN
STEVETURNER

MARCH 28 2007
CROCODILE CAFE

PENCIL

PENCIL

Montauk the Monkey was part of a top secret mission to Mars to investigate the origins of human life on Earth. The main objective of the Montauk missions was to search out and retrieve the flower of life in the genetic code of man. For it was well known that the double-helix plant was cultivated on Mars. There were numerous failed Montauk Monkey missions to Mars. Some of the monkeys never made it out of the atmosphere, while others who successfully landed vanished after bizarre disturbances in their communications to Mission Control. However, Montauk #51 was able to safely maneuver through the ancient pyramidal ruins to the flower of life fields. Amidst the barren, crumbled red dirt, there was one last flower of life off in the distance, defiantly sprouting through the alien soil. Mission Control was speechless. Like he was trained to do, Montauk proceeded to carefully collect the flower and place it in a containment vessel stored on the back of his pack.

Many folks claim that the Montauk Monkey missions to Mars are no longer taking place . . . well, no longer taking place using rockets, that is. But that's N.O.Y.F.B.

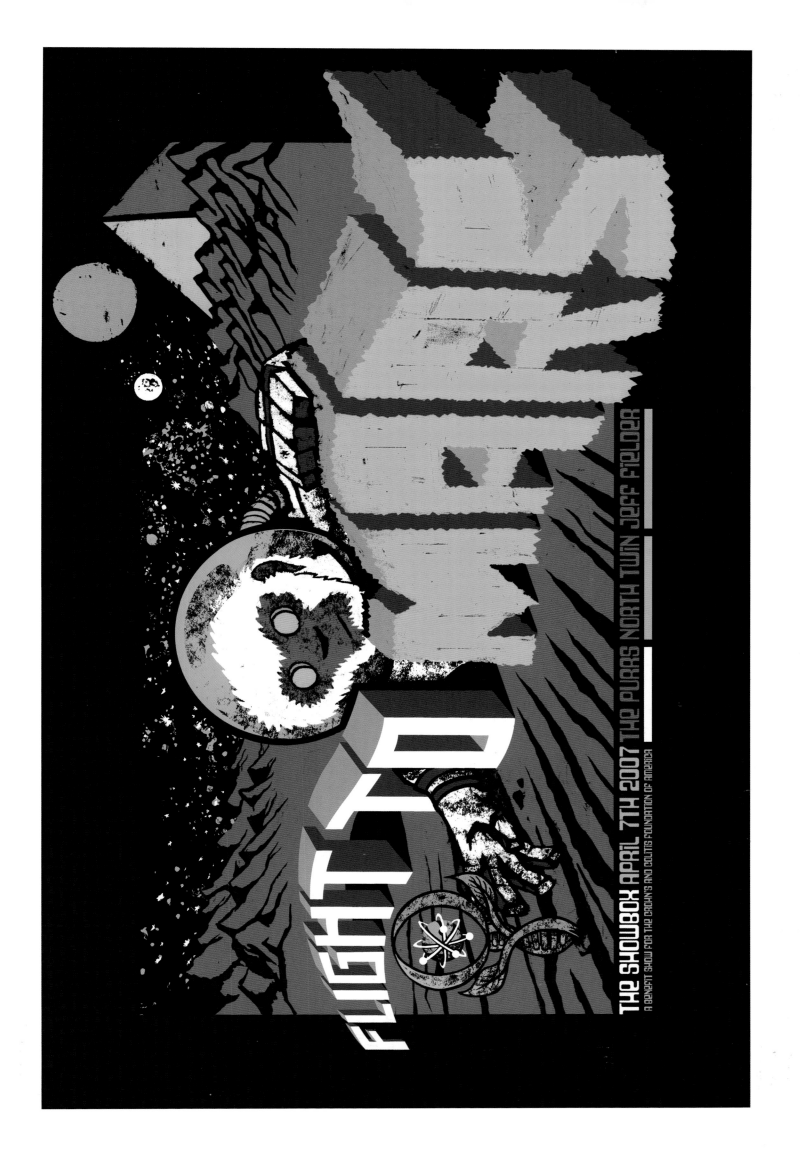

Explosions in the Sky are one of the most captivating instrumental bands out there. For more than ten years, I would take my dog Zoe to play frisbee at night at the local parks or fields. I always had a Discman or iPod with me, and EITS albums were some of the most fitting atmospheric musical backdrops for being out under the canopy of stars.

The imagery for this piece is a self-portrait. To me, it perfectly represents my many nights out with Zoe and the stars. Those walks often allowed me time to contemplate not only concepts for projects I was working on, but also to ponder some of the bigger questions about life and the universe. That's why I chose this image for the cover of the book. It tells the story of how so much of what's in here and in my life came to be. Zoe took me outside. She kept me in contact with the stars and the trees. If you listen, they have much to say . . .

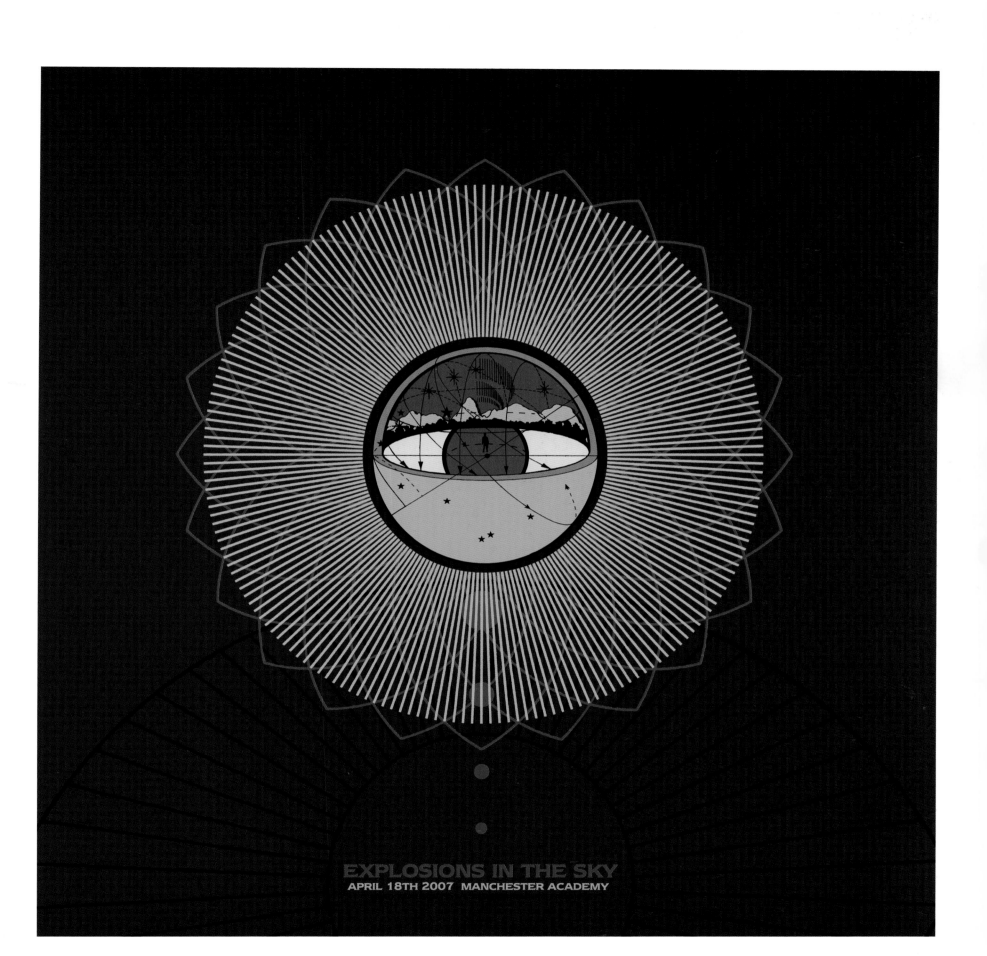

JUNE 21, 2007: PEARL JAM

DÜSSELDORF, GERMANY; 13 5/8" X 24 1/8"; 6 COLORS

PENCIL

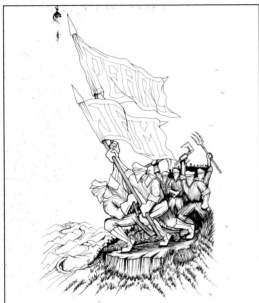

INK

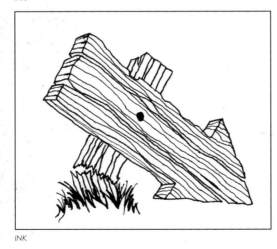

INK

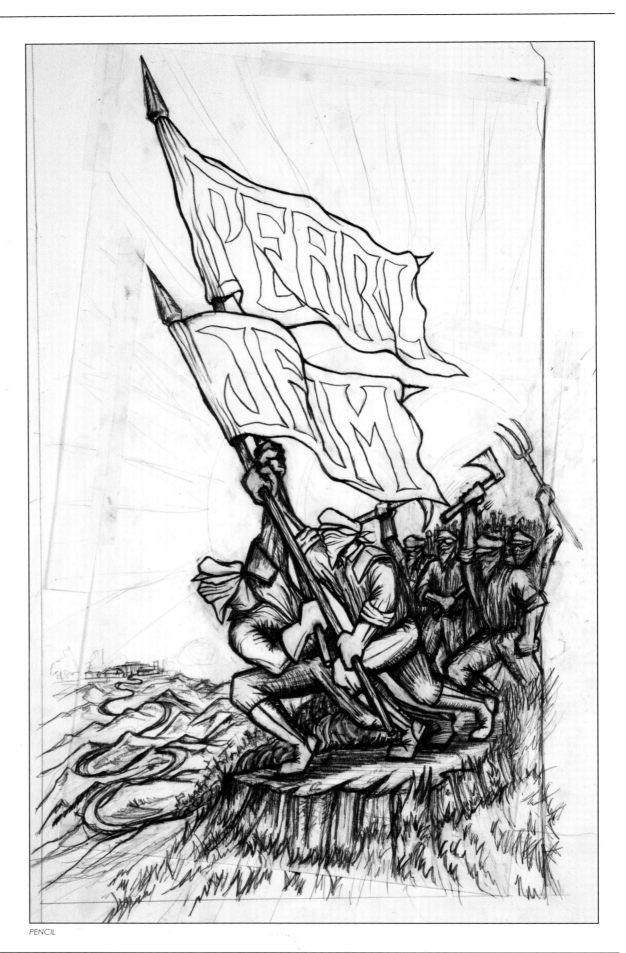

PENCIL

The flags started this one. I had drawn the type and flags by themselves to be used as admats. (Admats are the ads you see in the paper announcing dates and times of ticket sales.) It was just the flags and a burst behind them, and that was it. It wasn't until a month or so later that I sat down and started to put the flags into the hands of the revolutionary mob.

As you can see from the sketch above, I had originally intended for the mob to head down the mountain to storm the gates of the king's palace and bring him their list of grievances via axe and pitchfork. The composition wasn't working for me and the mountain road part was edited out. No need to know where the mob is heading, you just need to know that they are coming . . .

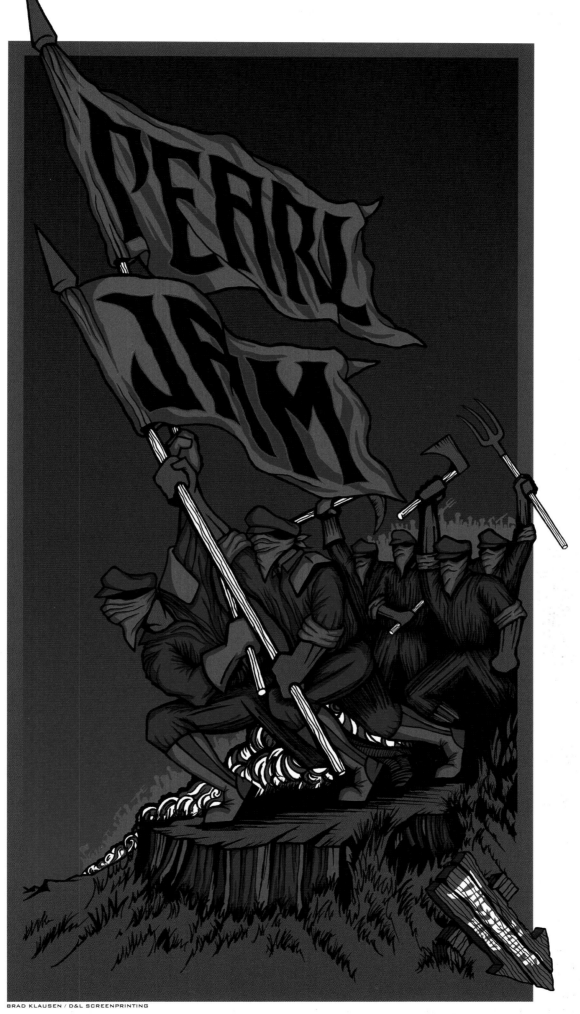

BRAD KLAUSEN / D&L SCREENPRINTING

SCAN

PENCIL ON PRINTOUT

PENCIL

PENCIL

MEXICO CITY 10/12
MONTERREY 7

As I mentioned earlier, these two heads were originally supposed to be part of the audience in the bullfighting ring of the 2005 Pearl Jam poster for Mexico.

This is one of those instances where I saw something I hadn't previously noticed in an old sketch. When I came across these two again, I realized the shape of the mouth of the first guy made a *G.* Reviewing the other one, I could see an *S, I,* and *P.* Not to mention they were drawn just far enough apart from one another to fit in the missing *O* and *S.* And their facial expressions were perfect—the one on the left looked surprised or shocked. The one on the right looked like he was saying something. It was almost as if it was intended from the outset to be designed for this poster and not Mexico.

I added the pattern in the landscape to represent the ugly background noise that is gossip. It just makes the air dirty. The solid blue lines under the head on the right represent the telling of the gossip, while those on the left show someone whose mind is being blown by the gossip he's hearing.

I also like the idea of the head's mouth on the right looking like an *S*—as the information leaves his lips, it changes shape. Just like with all gossip, the story gets more and more warped as each person tells it.

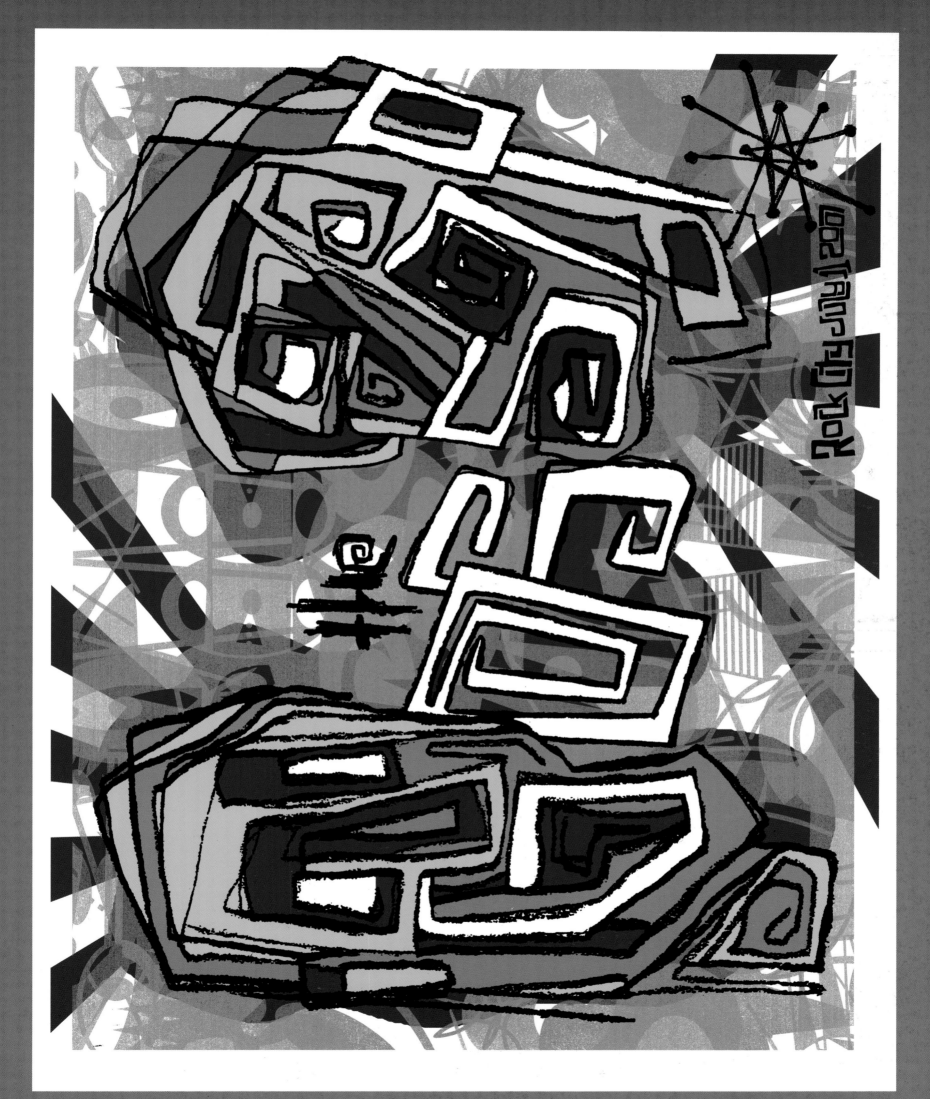

65

INK

PENCIL

PENCIL

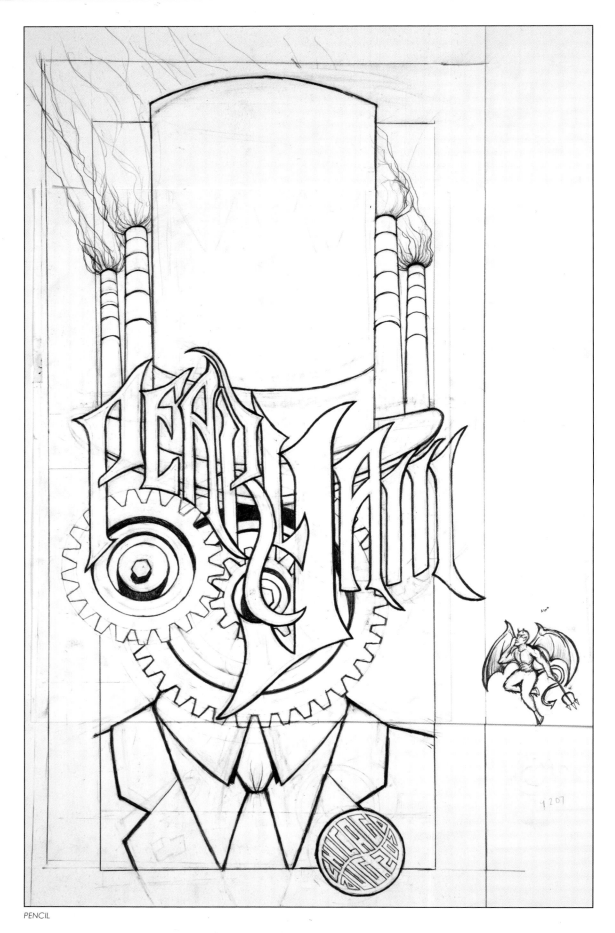

PENCIL

Inspired by a lyric from the Pearl Jam song "World Wide Suicide": "Tell you to pray, while the devil's on their shoulder." I interpreted this in the context of not just praying, but also when those who tell you to practice good are themselves champions of destruction and greed. The devil, stroking the man's ego by whispering of financial bounty and the accompanying societal perks, is able to persuade the cogs of industry to begin spinning and start devouring the land. The man, whether he's a corporate CEO or politician, likes what he's hearing. The spinning machinery of his mind pulls a large grin across his face. He selfishly sees only the immediate benefit to himself and his family, as he's cleverly deceived to make billions of dollars at the expense of the environment he and his family must exist within. And by doing so, inevitably destroying not only his own environment and existence, but the world's. Committing worldwide suicide.

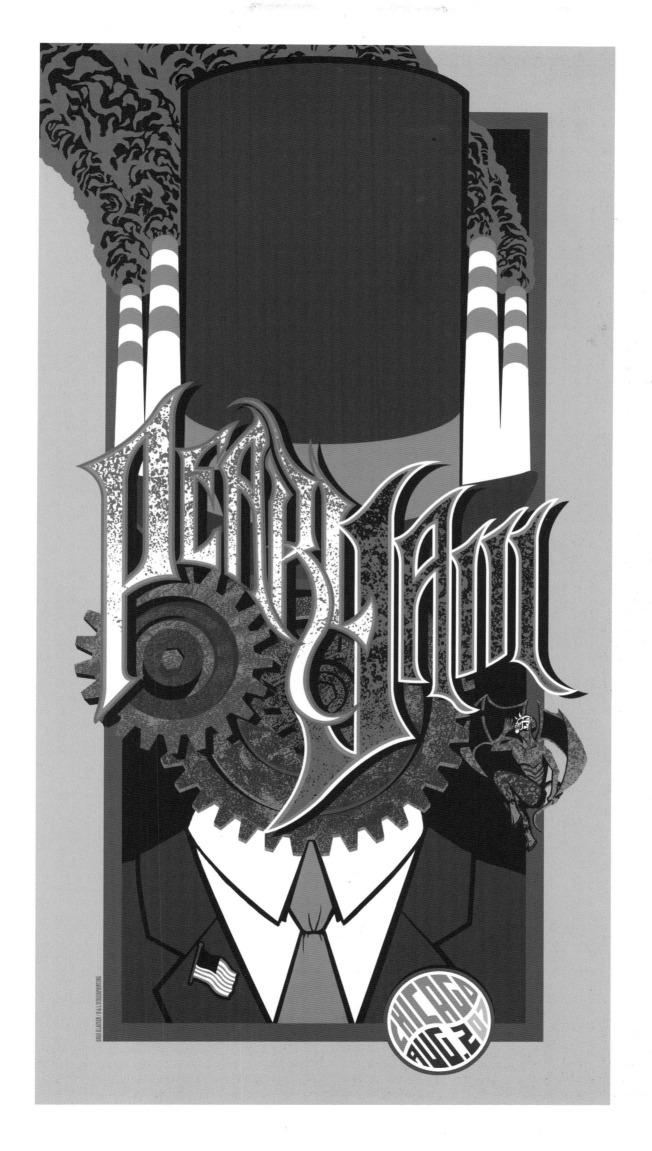

14 3/4" X 24 1/4"; 3 COLORS

INK

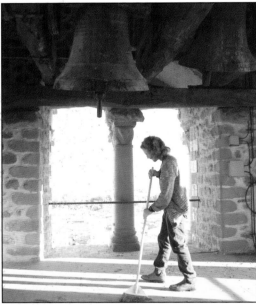

SCREEN GRAB

PHOTOSHOP

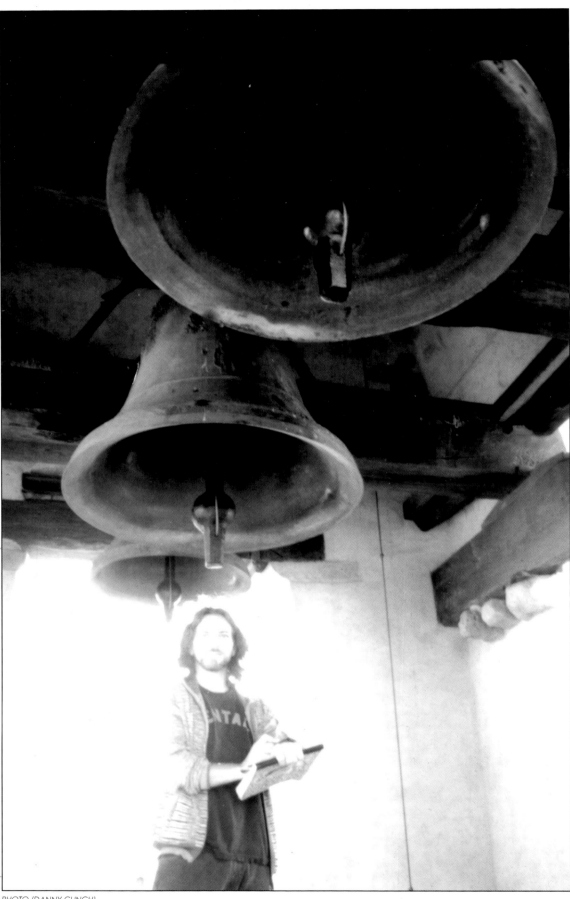

PHOTO (DANNY CLINCH)

Ed has an oversized Italian movie poster for *Diabolik* that I've always liked. So when it came time to do a poster for a film about five shows the band played in Italy, I used parts of that poster for inspiration. Particularly the very bottom with the logos and type. In general, I wanted to try to make a classic movie poster.

I had watched the movie but was still stuck for what to do imagewise. Tim Bierman, who works with Pearl Jam, came into my office and suggested that I should do something with the scene at the end of Ed sweeping in the bell tower. That scene proved to be the perfect idea!

Luckily, Danny Clinch, who shot and directed the film, had some images of Ed in the bell tower. So I took the bells from one of Danny's photos and the shot of Ed from a screen grab and combined the two.

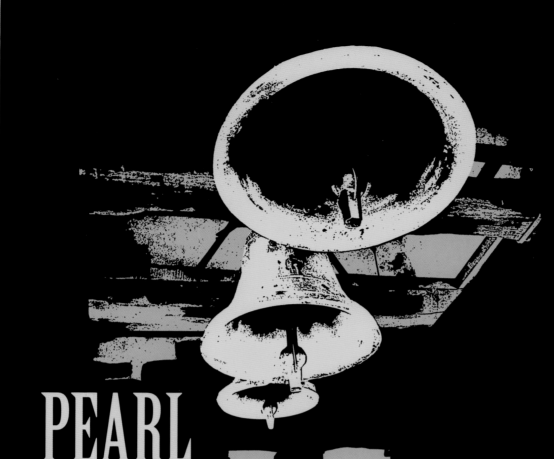

PEARL JAM

A FILM BY DANNY CLINCH

IMMAGINE IN CORNICE

BASS JEFF AMENT
DRUMS MATT CAMERON
ORGAN BOOM GASPAR
GUITAR STONE GOSSARD
GUITAR MIKE MCCREADY
VOCALS / GUITAR EDDIE VEDDER

 THREE ON THE TREE PRODUCTIONS

DIRECTED BY **DANNY CLINCH** | *ITALIA 2006*
Bologna, Verona, Milan, Torino, Pistoia | **TECHNICOLOR**

 From Super 8 to High Def

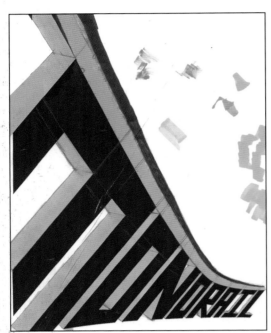

PENCIL AND MARKER

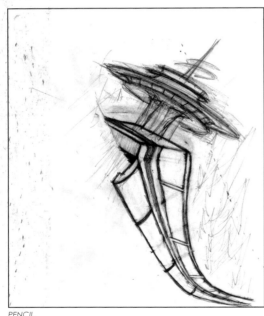

PENCIL

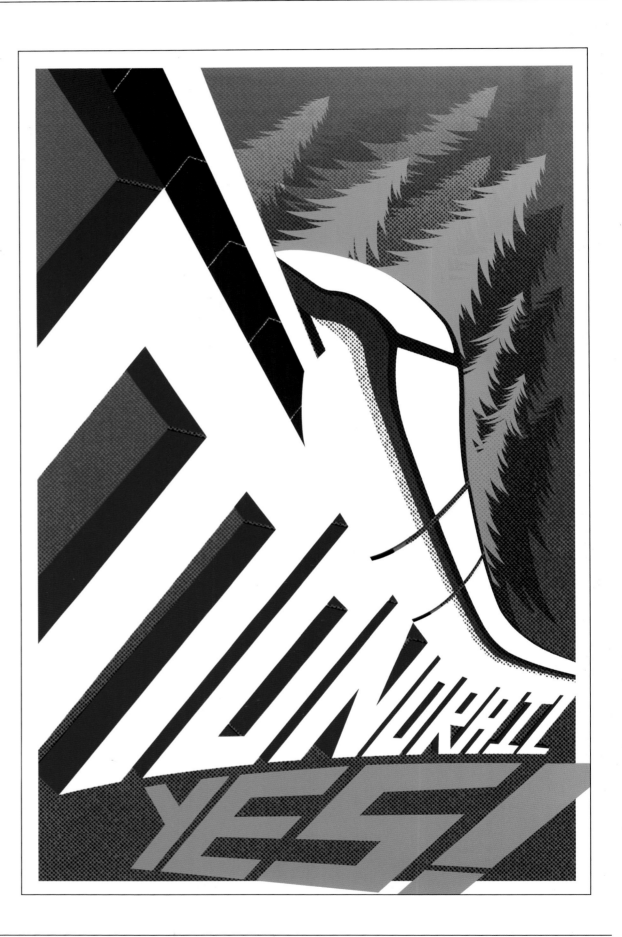

There was a contest to come up with a poster to help promote the idea of bringing a commuter monorail to Seattle; not to be confused with the Seattle Center monorail, which was just a World's Fair gimmick, but one that covered some distance and went fast. This contest happened within the first year or two of me moving to Seattle, and I was still chomping at the bit to do design work for as much stuff as I could around town.

My submission to the contest is pictured above. I didn't win. But I always liked the design, so I retooled it for Flatstock, which takes place at the Seattle Center. The thing I love about the Seattle Center is that back when it was designed for the World's Fair in '62, it was considered to be a futuristic twenty-first-century design. Now you go there and it very much looks like something from the past. The future-past.

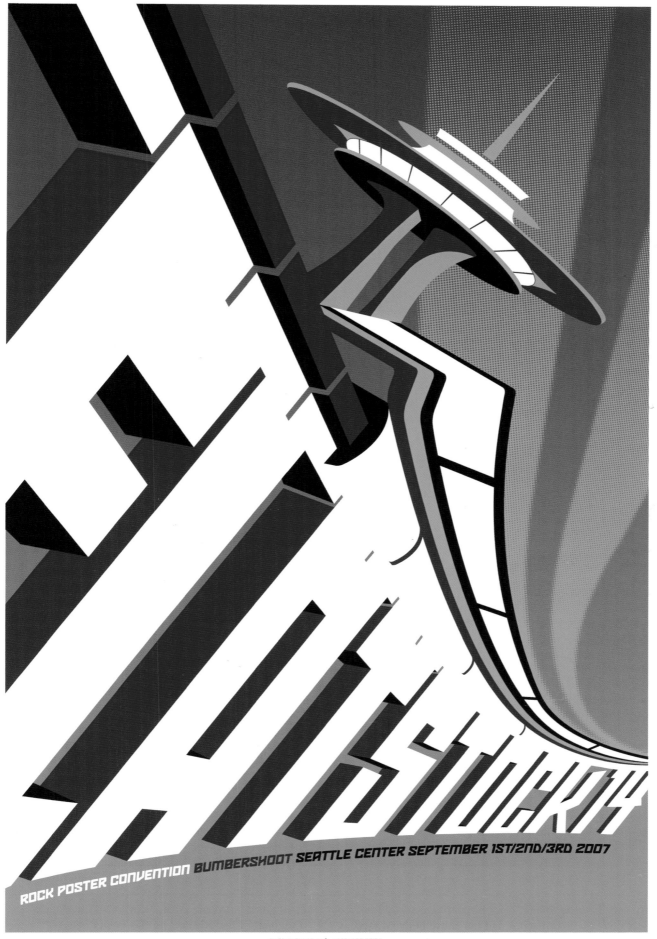

FLATSTOCK4

ROCK POSTER CONVENTION BUMBERSHOOT SEATTLE CENTER SEPTEMBER 1ST/2ND/3RD 2007

BRAD KLAUSEN / DEL SCREENPRINTING

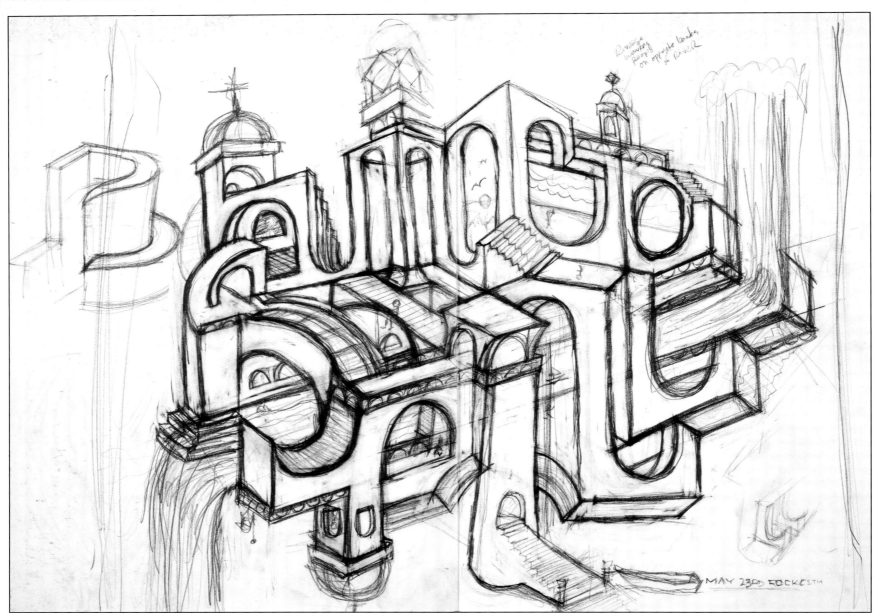

PENCIL

PENCIL

ILLUSTRATOR

M.C. Escher is one of my very favorite artists. A lot of people are only familiar with his most famous pieces, which are amazing, but his entire body of work is truly incredible. His series of Italian landscapes are some of my favorite pieces of his. It never ceases to amaze me what he can do with just black and white. Escher is one of those rare artists who fills me with tremendous inspiration and a powerful drive to be better, while also making me want to just give up entirely. That's true of all my favorite artists—they're all wonderfully and painfully inspiring.

Originally I had planned on this poster being far more detailed. I had hoped to give the city walls more texture, depth, and shadow. The main concept also included a boat being tied up to a post near the stairs in the *I* of *SPILL*. On top of the *I* would be a man pouring water from the boat out of a bucket into the pool of water above. Unfortunately, I ran out of time.

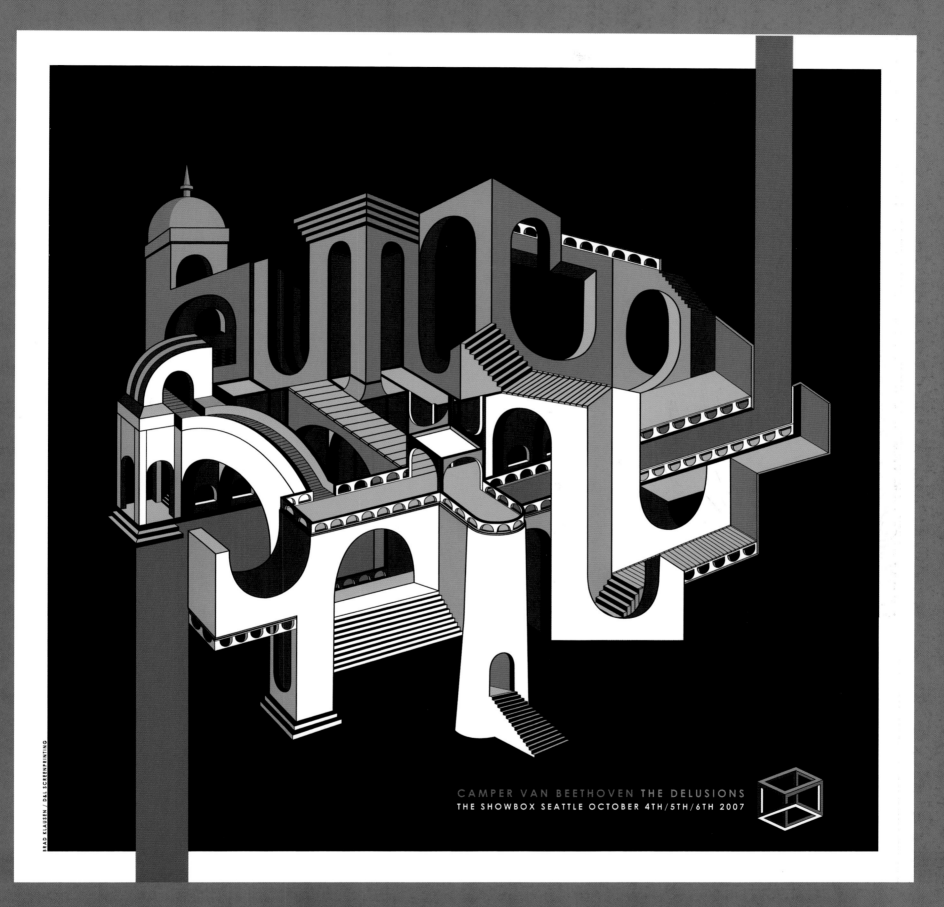

CAMPER VAN BEETHOVEN THE DELUSIONS
THE SHOWBOX SEATTLE OCTOBER 4TH/5TH/6TH 2007

BRAD KLAUSEN / DELL SCREENPRINTING

SEATTLE, WA; 14" X 26"; 5 COLORS

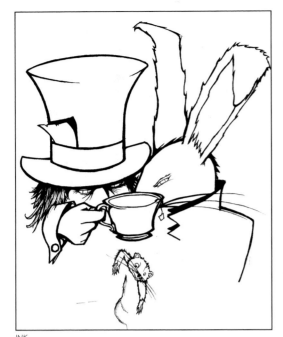

INK

INK

PENCIL

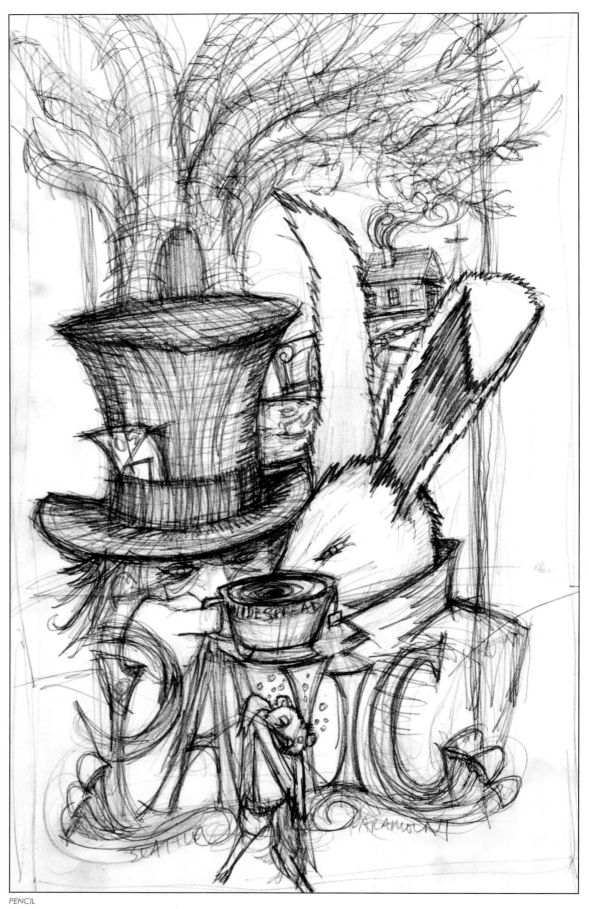

PENCIL

When I was in college, we had an assignment to come up with a fictitious brand for either a coffee or tea company. I thought I'd invent a tea company with flavors like "Creativi-tea" and "Insani-tea." I remember at the time thinking this was terribly clever. For the "Insani-tea" label and design, I figured the best combination ever of insanity and tea was the Mad Hatter tea party. So I drew this crazy-eyed Mad Hatter peering over the edge of a giant tea cup. I drew it so that if you turned the

drawing upside down, the tea cup became a mushroom cap, and the Mad Hatter's hat became the stem of the mushroom. Because I'm pretty sure that's the kind of tea that they were drinking in Mr. Carroll's story.

That image was revisited for this poster, but without the giant tea cup reverse image. I wish I had figured out a way to keep the field mouse in the letter *N*, as I was quite fond of how I originally sketched him in there.

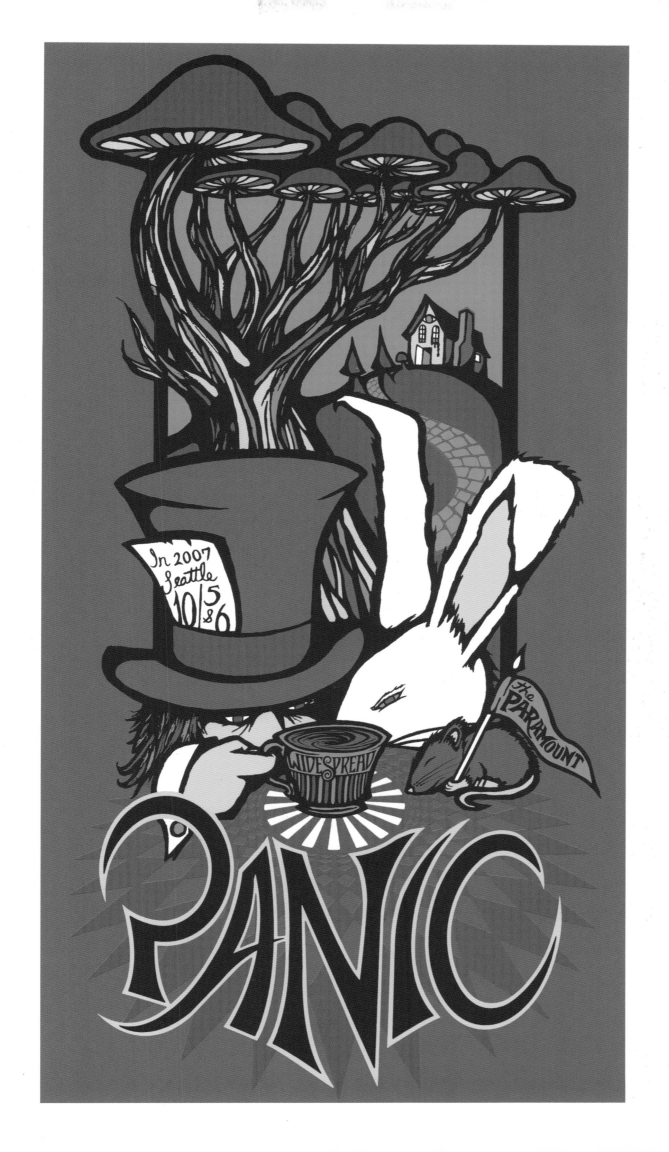

INK

PENCIL

BLUE AND PURPLE PENCIL

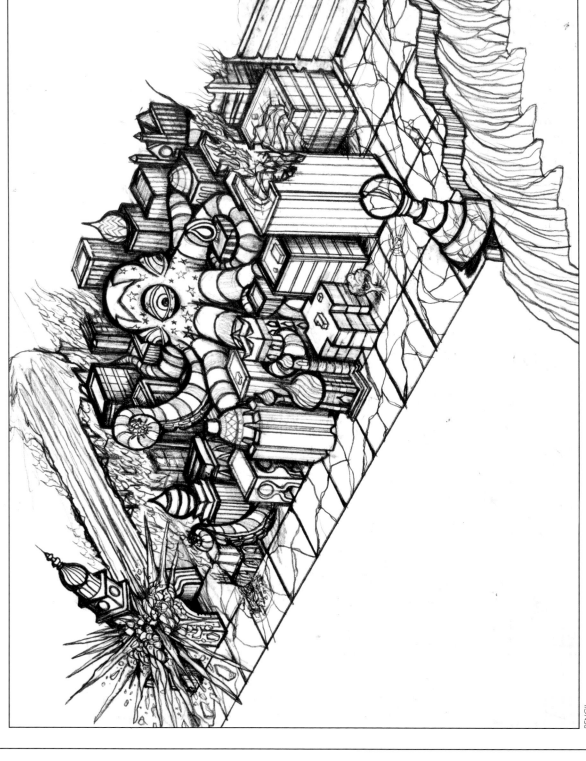

PENCIL

I was talking on the phone with artist Jermaine Rogers about vinyl toys: I mentioned to him this character I created who was a suit-wearing eagle-conquistador with a tank for legs, a mini-gun for one arm, and a hammer for the other. Jermaine said I should make the hammer a gav-el and develop a series called "Judge, Jury, and Executioner." I thought that was brilliant.

The drawing for this one took a long time, and the whole project from concept to final printing took even lon-ger. I debated back and forth about whether it should be a screenprint or a giclée. There were so many colors that I figured maybe a giclée would make more sense, plus I wouldn't have to separate or trap any of it. In the end I'm glad I went with screenprint-ing. Steve at D&L did an amazing job printing all sixteen colors.

The series of three prints were going to be the beginning of many politically themed post-ers I had planned that would all fall under a larger series entitled "Black Rope Hell." I had at least fifteen con-cepts for prints and vinyl toy characters. "Cloak and Veil" and "Hegelian Dialectic" were also part of the Black Rope Hell series.

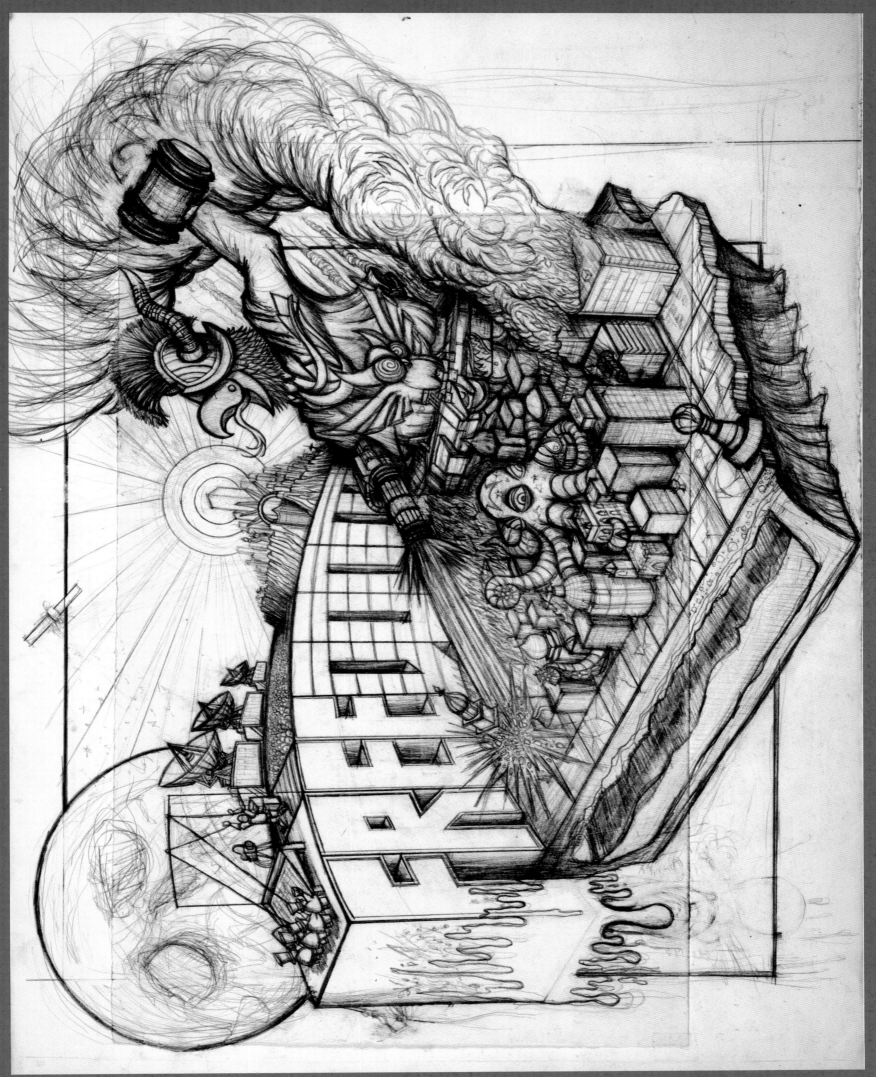

INK

INK

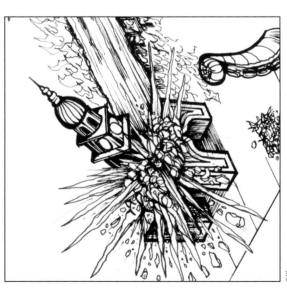

INK

INK

At some point, I realized that focusing all my energy on political prints was not healthy for me. It was taking all this anger and negativity I felt toward atrocities I saw being committed by those in power, and just amplifying more anger and negativity in my own life. By focusing my creative energy on these things, I was giving them more power, and allowing them to have control over me and my well being.

So around January of 2009, I decided to scrap all the Black Rope Hell ideas—which was really difficult to do, because I was proud of the cohesive story line and characters I had created. And I was excited about the sketches I had in the works and couldn't wait to see them printed. I could picture them all in my head, and I envisioned them on the walls of a gallery for my first art print show. Knowing that I'd never get to finish the pieces already in progress or the ones I could see in my head was tough to come to grips with.

But it was the right thing to do. Once I stopped focusing my anger and negativity on these things, a large weight was lifted off my chest and I found myself on an entirely brighter, more enlightening, and rewarding path.

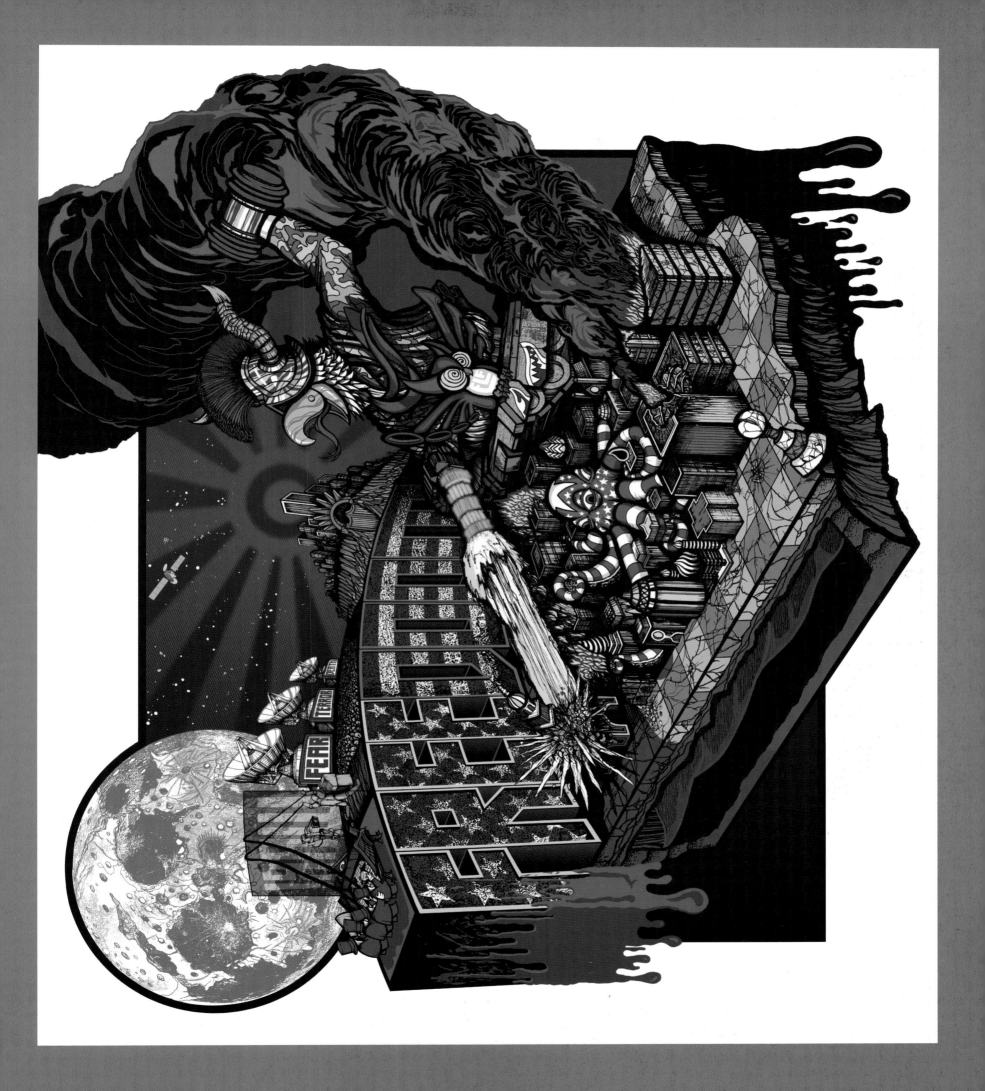

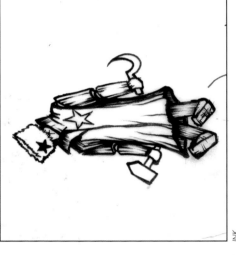

INK

PENCIL AND ACRYLIC

INK

INK

PENCIL

Here we have the unfinished "Jury" print. I was really looking forward to completing this one. There's still a lot left to do, and unfortunately it will most likely never get finished. I figured I would include it anyway.

Missing from the sketch are the brains that were going to be running in front of the loudspeaker desks of the news puppets—they were being frightened into scurrying into the chicken coop that the fox built, which was just a disguise for the incinerator. Two of the four faceless top hat–wearing string pullers are missing as well. You can kind of see where they were supposed to be. The overall proportions were also a bit off. I was expecting to do some Photoshop surgery to fit the image into a shape the same size as the "Judge" print. As it is now, it's a bit too square, and the jury box needs to be moved back to create more space between the jurors and the pawn-king. There's also five jurors missing.

The message here is all about psychology, hence the Greek letter *psi* in the background. It's about the psychological power of the tell-a-vision to implant the ideas of the few into the minds and beliefs of the many.

"But to succeed, deception needs a receptive audience. It needs the incurious, the unquestioning, the toadying."
—Pierre Tristam

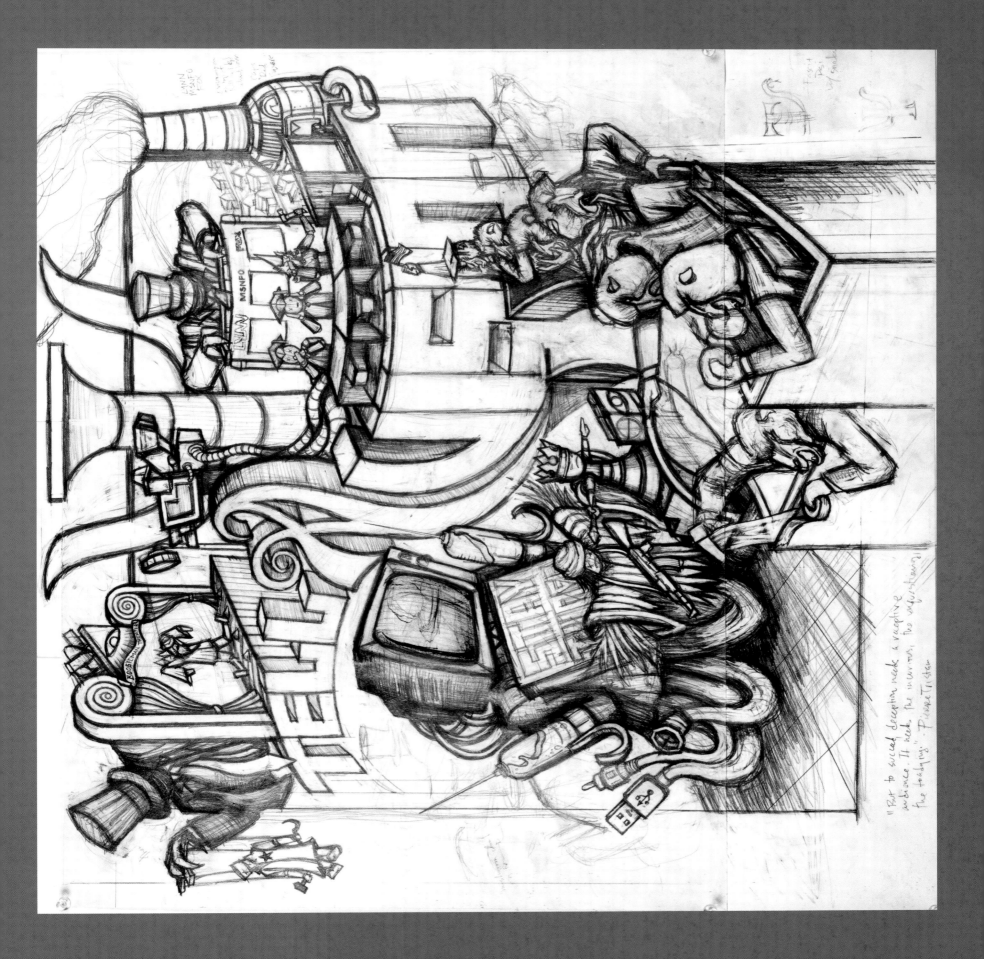

VIRGINIA BEACH, VA; 18" X 23"; 6 COLORS

PENCIL

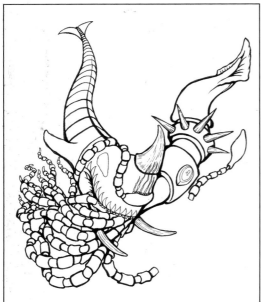

INK

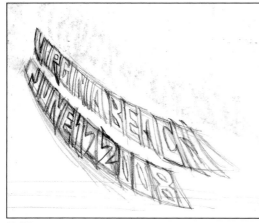

PENCIL

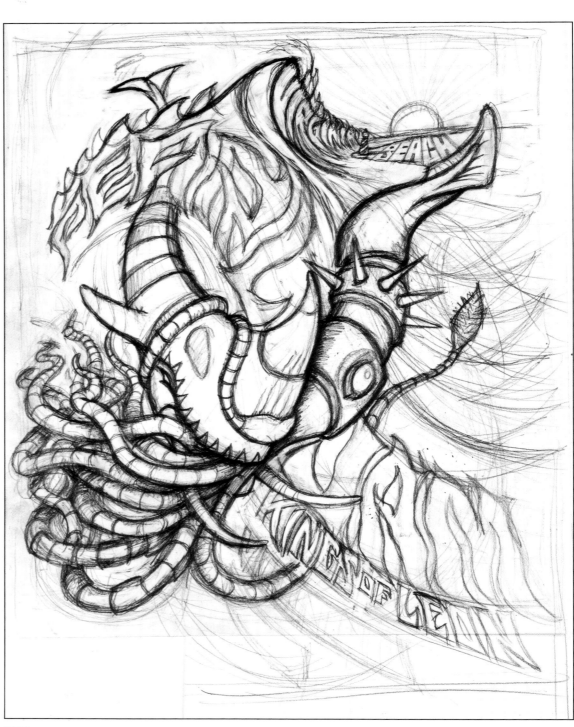

PENCIL

I had been wanting to make a squid vs. whale drawing for a long time. Giant squids are never really giant when you see them on TV, so they don't quite live up to the idea of what giant squids *should* look like. They should be GIANT! Twenty-thousand-leagues-under-the-sea, attack-your-submarine giant. Something more than just long tentacles.

While taking a painting class, I made a tusked whale that I thought would work well for a poster. Since the whale had some Dr. Moreau modifications in the painting, the squid needed some spikes to compete. This made it more fun to draw than just a standard whale-against-squid battle. They needed armament.

I was initially planning to make the Virginia Beach typeface out of a tidal wave caused by the motion of the battle, but that idea didn't pan out. Cary at D&L did a pretty amazing job keeping all the bubbles in registration.

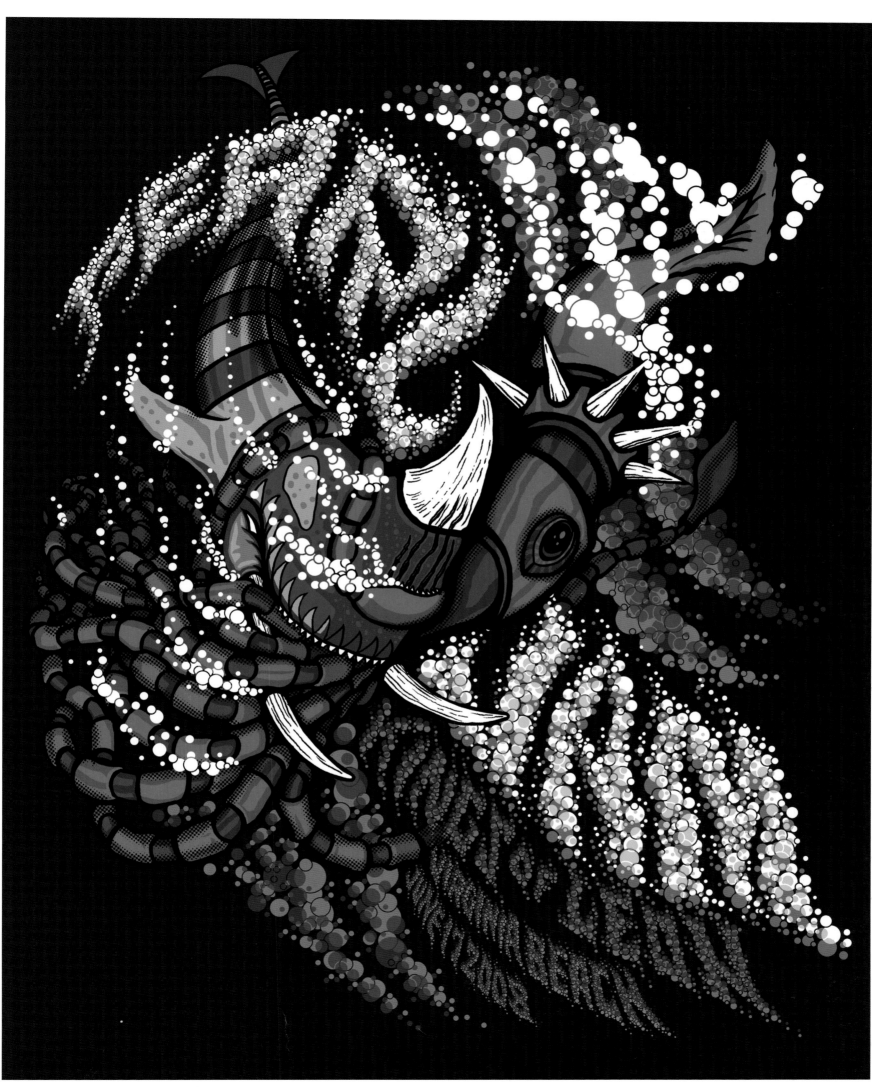

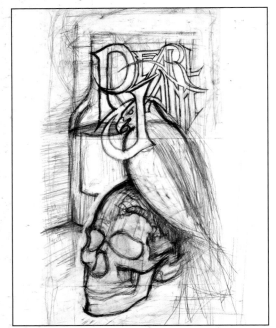

PENCIL

PENCIL

INK AND MARKER

INK

Here's another example where the type came first and directed the rest of the drawing. The type for the city and date was originally going to be incorporated into the label on the wine bottle, but the bottle wasn't working for me. At first it was just a still life scene to draw, but I realized I had two of three symbols for a theme that's found throughout art history: I had life and death in the flower and skull, and was just missing time.

The bird was not a symbol for anything in the beginning. I just wanted to draw a bird. But as the three other symbols came into play, the bird became an eagle, and the eagle started to represent America. The poster quickly began to take on a new meaning to me—turning into a little treatise on the path of America, hence the red and black and the time running out in the hourglass.

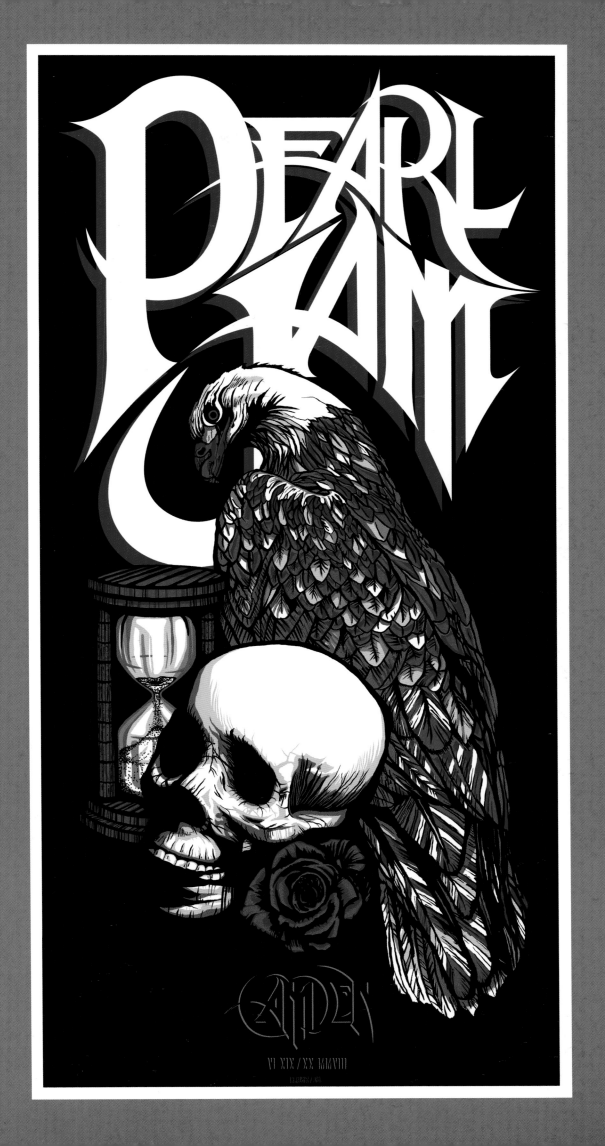

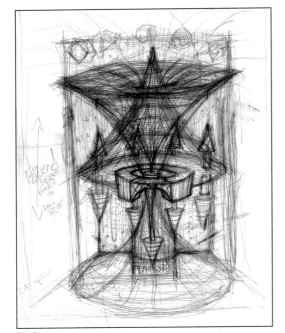

PENCIL

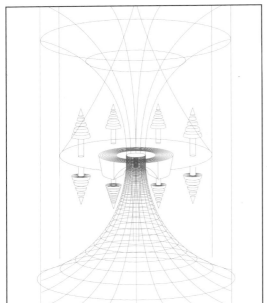

ILLUSTRATOR

ILLUSTRATOR

ILLUSTRATOR

This is a continuation or sequel to the earlier Explosions in the Sky poster—another self-portrait. The surges of ideas I had when playing frisbee under the stars with Zoe almost made me feel like I had a funnel on my head, and that the stars were just dumping information through it. If I was ever stuck trying to find a solution for a project, I'd go out with Zoe and come back full of ideas. Images and concepts seemed to be almost downloaded to me.

Along with the concept of information being funneled into the mind, the original idea also dealt with how information is funneled through the eyes, through rods and cones. I had wanted to have some cone- and rod-shaped trees to depict this stage of information input, with the park extrapolated into a downloading deck. The center platform and swirling white stars were also designed to allude to the singular eye of the universe, or the all-seeing eye of the collective consciousness.

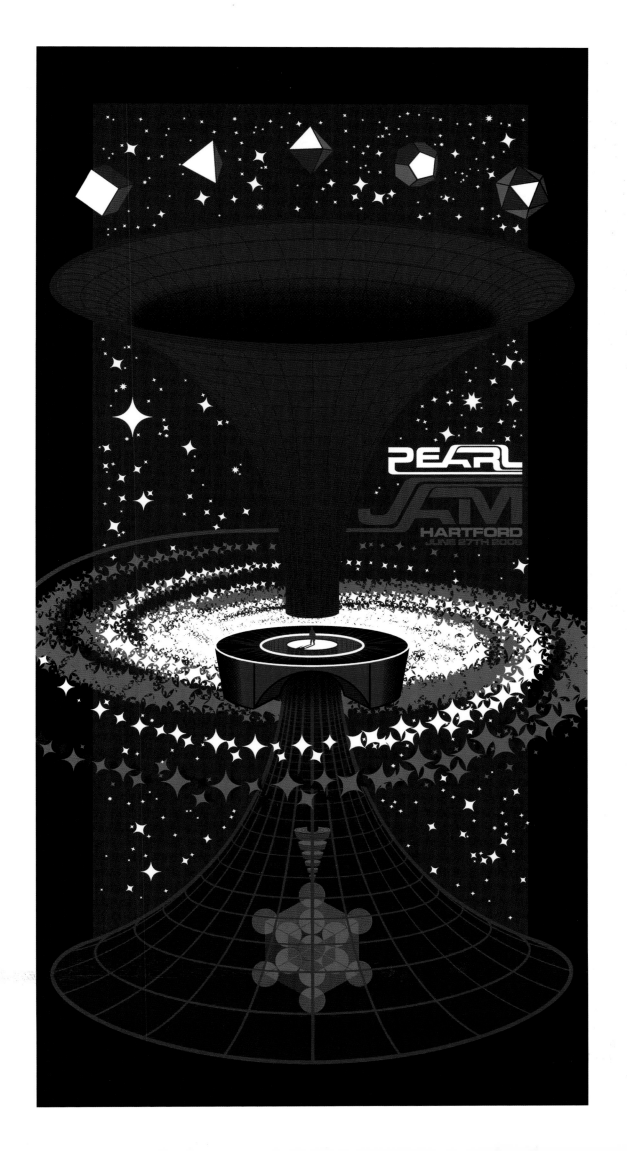

AUGUST 2008: EDDIE VEDDER / LIAM FINN

BOSTON, MA / NEW YORK, NY / NEWARK, NJ / MONTREAL, QC / TORONTO, ON / WASHINGTON, DC / MILWAUKEE, WI / CHICAGO, IL; 18" X 24"; 5 COLORS

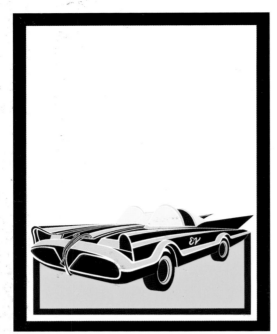

ILLUSTRATOR

PENCIL

ILLUSTRATOR

ILLUSTRATOR

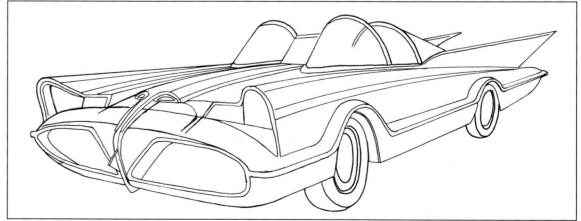

INK

If I can, I like to be able to incorporate ideas or themes that the band members themselves are fans of. There's the obvious stuff that can be picked out of lyrics and album artwork, but then there are also the other things that are learned over time, which don't necessarily pertain to the music. I can sometimes utilize imagery that is near and dear to the heart of the band or musician to make it a little more interesting for them personally.

In Ed's case, he is a fan of the original *Batman* TV show. He has some memorabilia around his place and I kept responding to some cool images he had of the old Batmobile. Ed really dug the *Into the Wild* logo, and the Batman theme allowed a convenient way incorporate that as the spotlight.

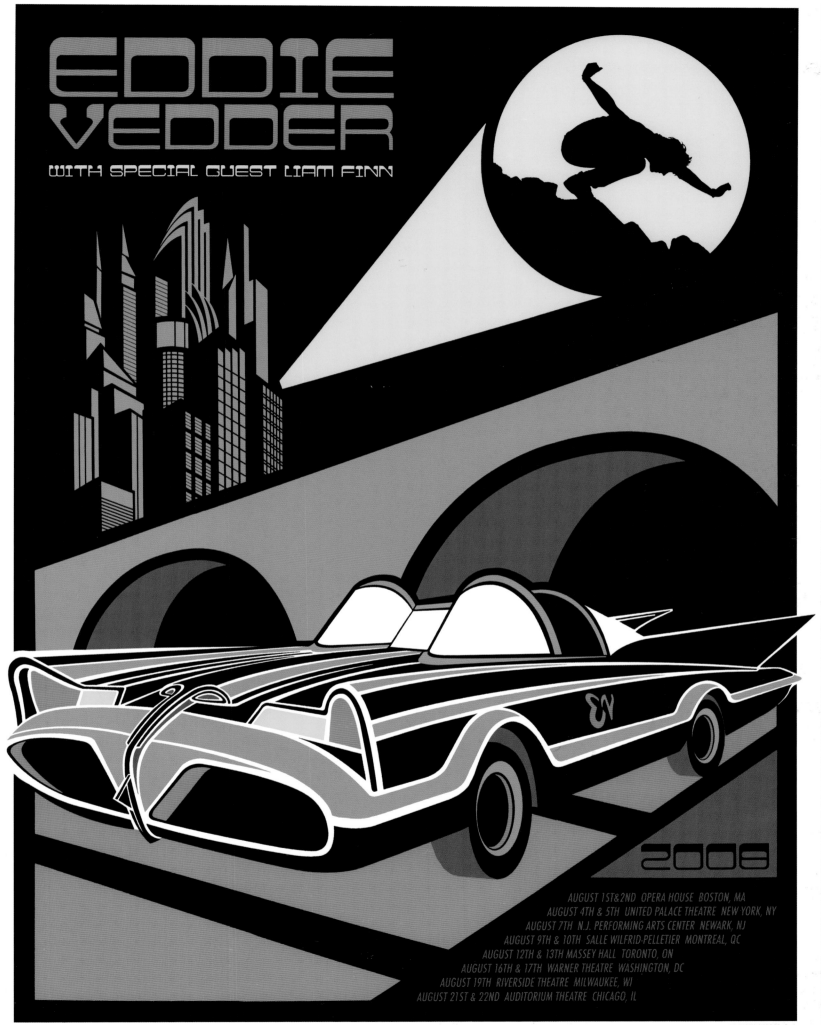

EDDIE VEDDER
WITH SPECIAL GUEST LIAM FINN

2008

AUGUST 1ST&2ND OPERA HOUSE BOSTON, MA
AUGUST 4TH & 5TH UNITED PALACE THEATRE NEW YORK, NY
AUGUST 7TH N.J. PERFORMING ARTS CENTER NEWARK, NJ
AUGUST 9TH & 10TH SALLE WILFRID-PELLETIER MONTREAL, QC
AUGUST 12TH & 13TH MASSEY HALL TORONTO, ON
AUGUST 16TH & 17TH WARNER THEATRE WASHINGTON, DC
AUGUST 19TH RIVERSIDE THEATRE MILWAUKEE, WI
AUGUST 21ST & 22ND AUDITORIUM THEATRE CHICAGO, IL

KLAUSEN. VEDDER. D&L.

PENCIL

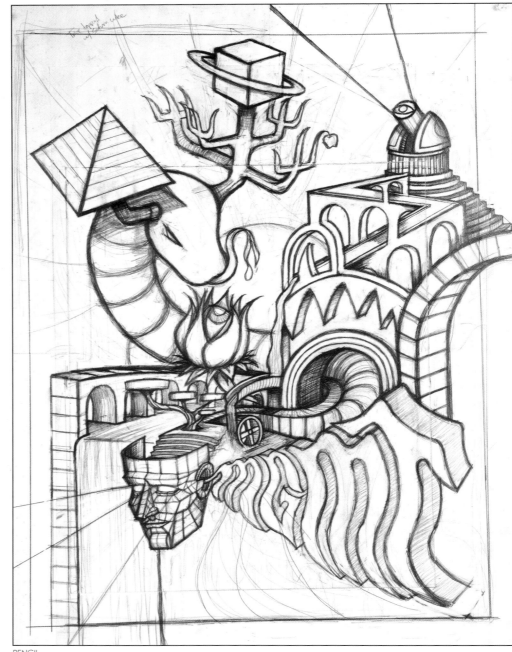

PENCIL

INK

PENCIL ON PRINTOUT

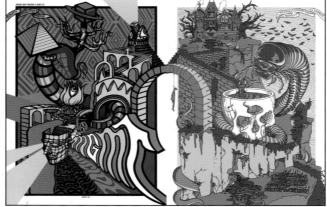

POSTER ON RIGHT BY BURLESQUE OF NORTH AMERICA

INK

I haven't really given myself enough space to go into detail about the symbols in this one. The show took place on October 30, or Devil's Night. The entire piece deals with esoteric symbols for the devil, or rather Lucifer, also referred to as the "Light Bearer." There are those who speculate that Lucifer, "the light fallen from heaven," is a metaphor for a lightning strike. Lightning strikes are symbols for inspiration. So this one is all about the power of divine inspiration from the light of the stars, the light falling from the heavens into the observatory of the mind. Myth, metaphor, alien, or fallen angel, who's to say . . . ?

My friend Brian, who was tour managing MGMT during this tour, asked if myself and Wes Winship and Mike Davis from Burlesque of North America would figure out some sort of collaboration for a poster or two. I handled the first night and they did the following poster for the Halloween show.

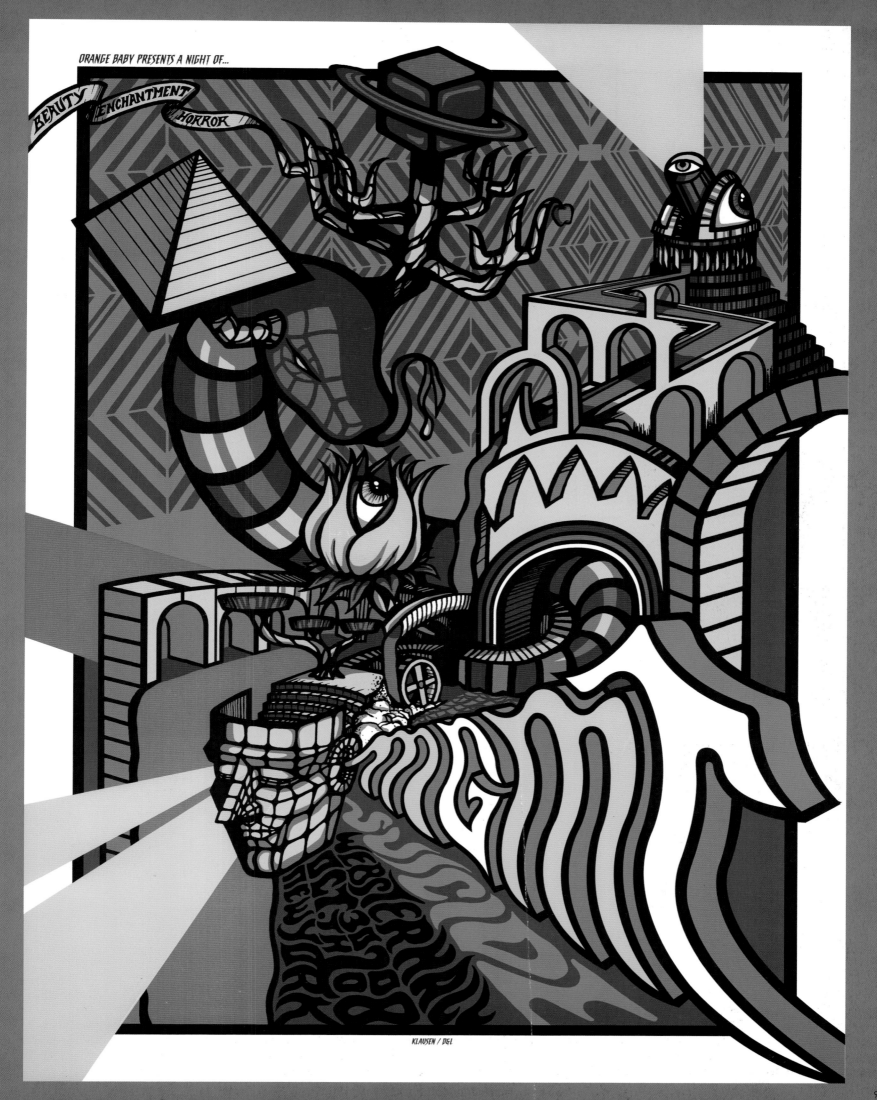

15" X 24"; 7 COLORS

PENCIL

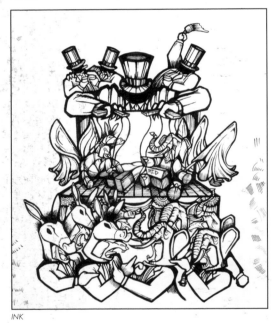

INK

PENCIL

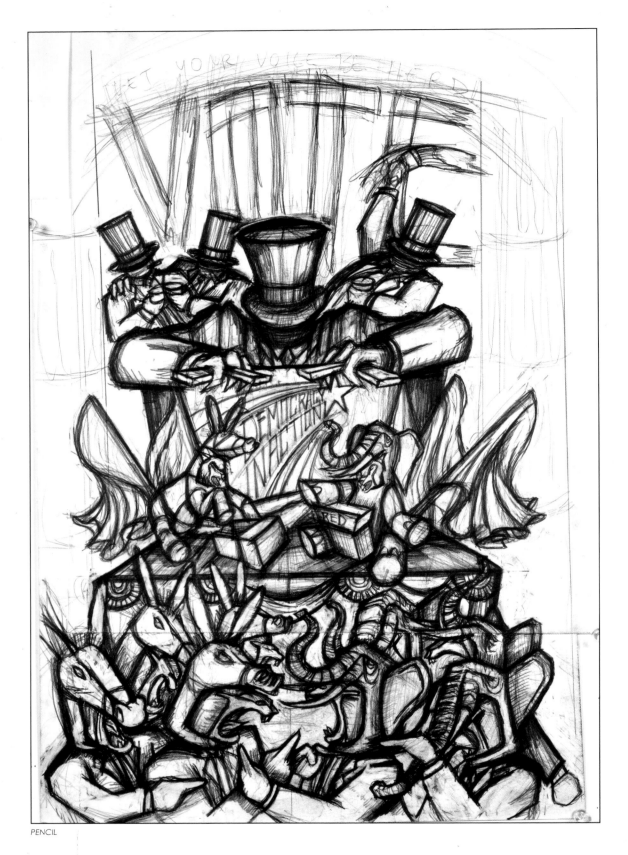

PENCIL

The Hegelian Dialectic basically (and roughly) asserts that whoever controls both the hot and cold taps of the faucet determines the temperature of the political water we all must bathe in. If you can control the temperature of the bath, you can direct the behavior and attitudes of those in the water to your desired outcome. If you can psychologically convince those in the water that they as a group are in charge of what they want the temperature to be, and that your hands are merely an extension of the group's demands, you can remain forever unchallenged in the seat of control over the group without any disturbance. In order to do this, every four years you allow the group to vote on whose hands they want on the taps. You just don't tell them that the two choices they are given are controlled by the same pair of hands that built the bathtub. If only the group would stop arguing about the water temperature and just step out of the bath . . .

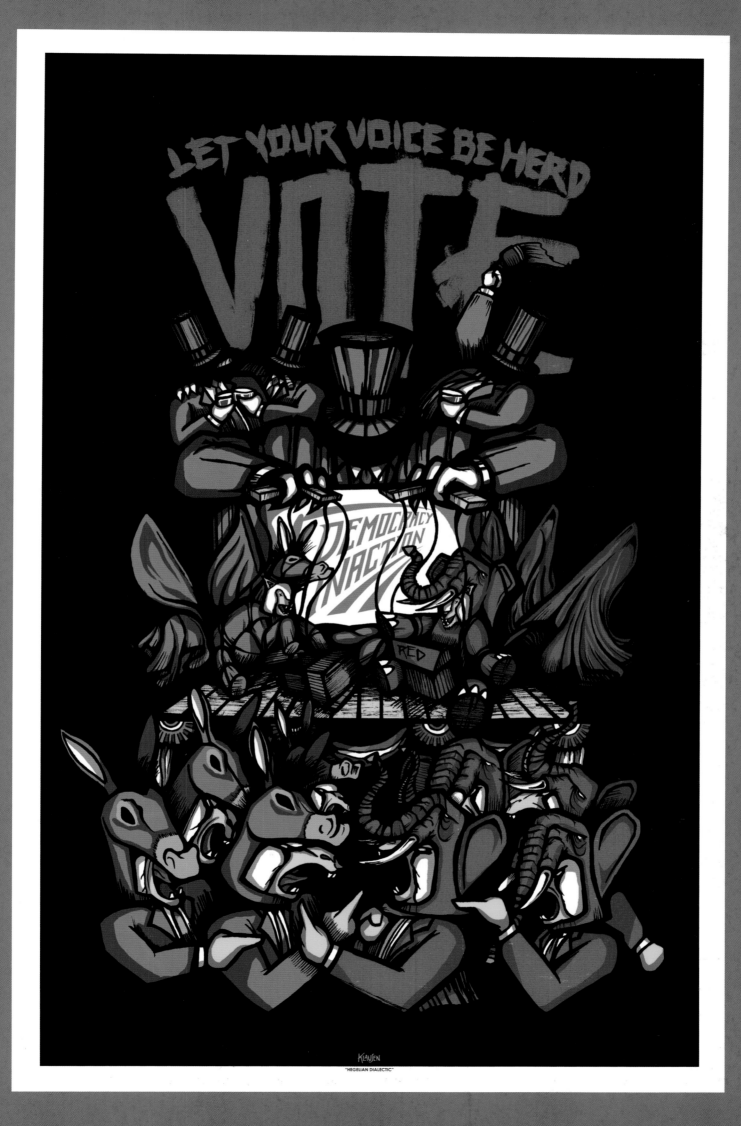

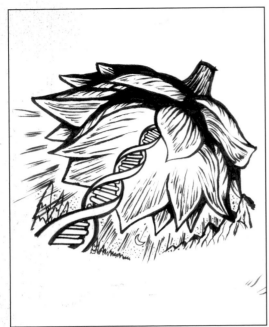

INK

INK

ILLUSTRATOR

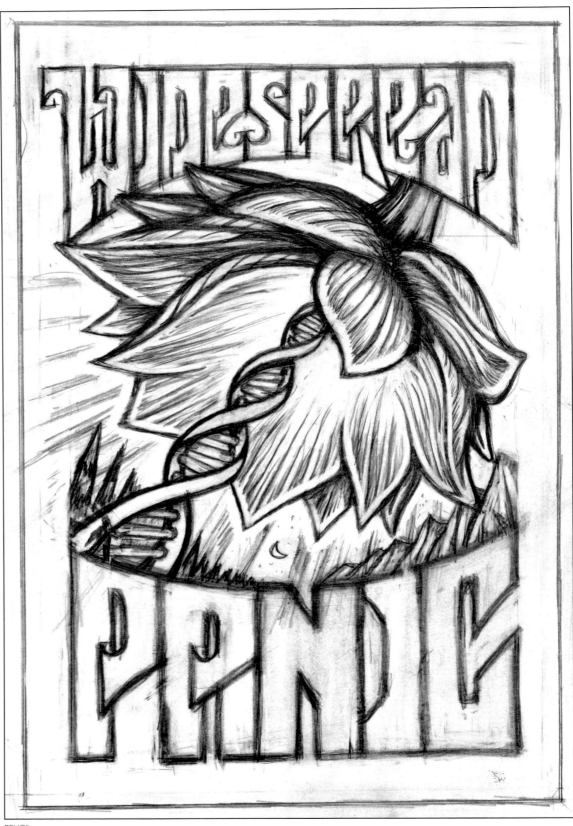

PENCIL

This one's all about the power of light. The concept stems from the idea that encoded within our own DNA are all the secrets and knowledge of the universe. We are hardwired with all the wisdom we could ever possibly need. Unfortunately, this wisdom sits dormant within us until we find the key to unlock it. Once unlocked and turned on, light illuminates the darkness, just as God's sun saves man each day when it is resurrected in the east and defeats the Prince of Darkness. The dawn of man: when man is able to step into the warmth of the light and experience the spark of dormant aspects of human DNA firing up and turning on. The opening of the lotus flower of the light of the stars, the flowering of man's development and evolution. The ascent, or flight, of man from thinking being to light being. Light which can travel to every corner of the universe in the blink of an eye. Or as the song goes: "Travelin' light . . . is the only way to fly . . ."

94

NEW YEAR'S EVE 2008
WIDESPREAD
PANIC
YONDER MOUNTAIN STRING BAND
DENVER • PEPSI CENTER • DECEMBER 30TH AND 31ST

KLAUSEN • BURLESQUE

16" X 20"; 9 COLORS

PENCIL

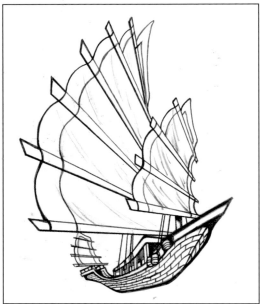

PENCIL

PENCIL

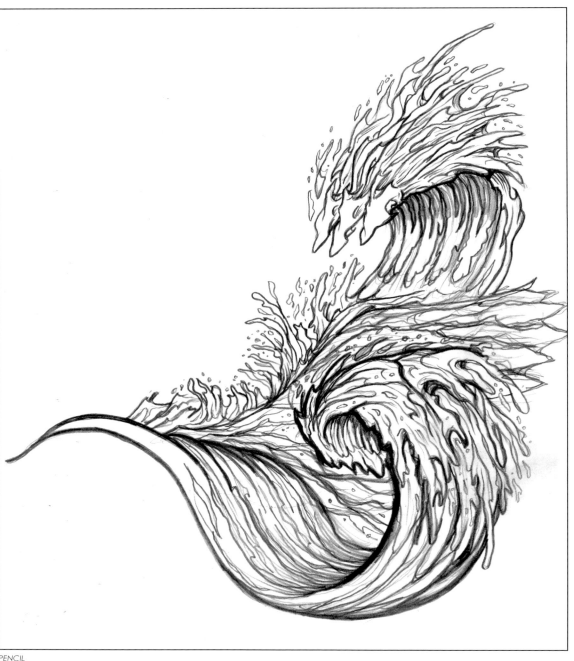

PENCIL

This piece represents a transitional moment in my life. It was created during the first month of 2009, which was the start of my first year as a self-employed artist, working for the first time on my own with no safety net. During that month, after an existential crisis, I had an epiphany. My beliefs started to change, as did my outlook and approach toward life. I realized that the foundations and traditions of the modern world are absolutely absurd. I could see the pillars of society buckling and crumbling underneath its colossal weight, which would eventually come crashing down on top of itself. Time to start building a lifeboat before the ship sinks. The elephin is a symbol representing the guide of intuition, and having faith to trust where it leads you. Time to start working toward a new, positive paradigm and abandon the current failed one which is beyond repair. Ideally there will be more pieces in this series: Day 16, Day 25, Day 34, and so on . . .

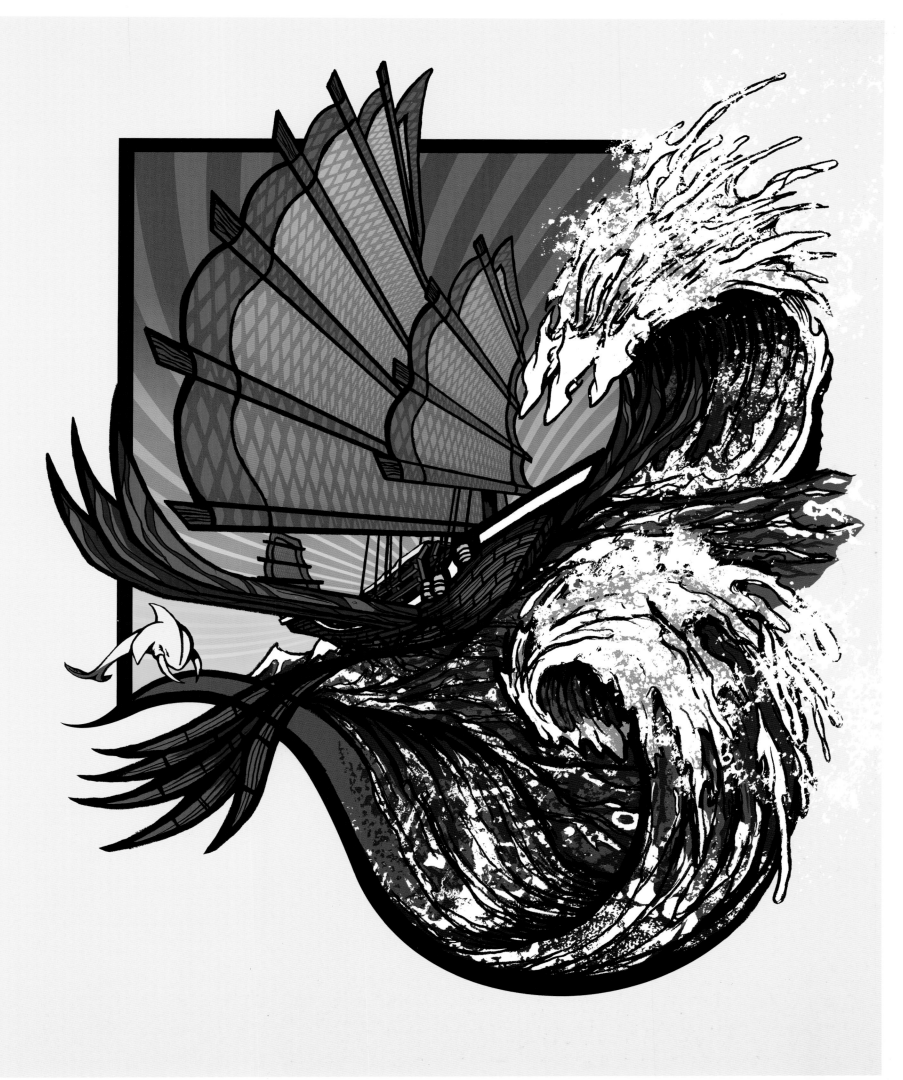

24" X 36"; 7 COLORS

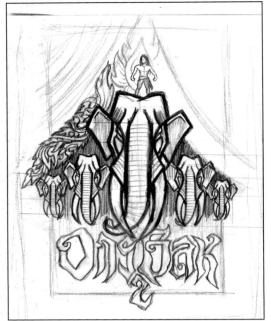

PENCIL

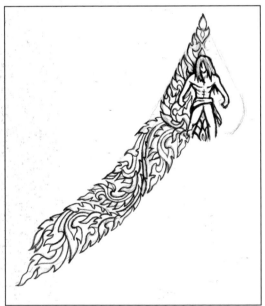

PENCIL

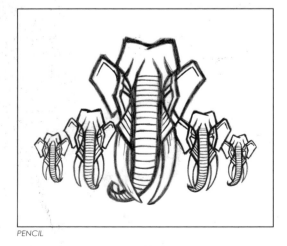

PENCIL

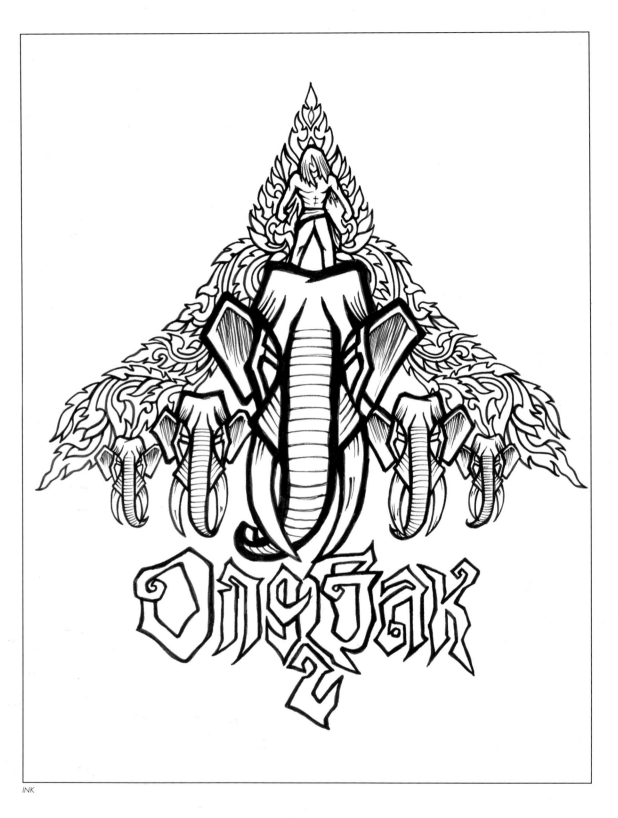

INK

I was asked to do this poster for the folks at the Alamo Drafthouse for Tony Jaa's film *Ong-Bak 2*. Only the movie hadn't been released yet, so all I could work from was the trailer. I asked if there was any way to get an advance copy, but the studio wasn't having it. I really wasn't comfortable creating art for something that I had only seen in the form of edited promotional footage. It just didn't sit well with me not knowing what other scenes or plot lines or characters I might be missing out on, even if this was a martial arts movie. It felt like I wouldn't be doing the film justice not having seen it in its entirety—like making a poster for a band after only hearing twenty seconds of one song. But I forged ahead and created this poster.

INK

INK

PENCIL

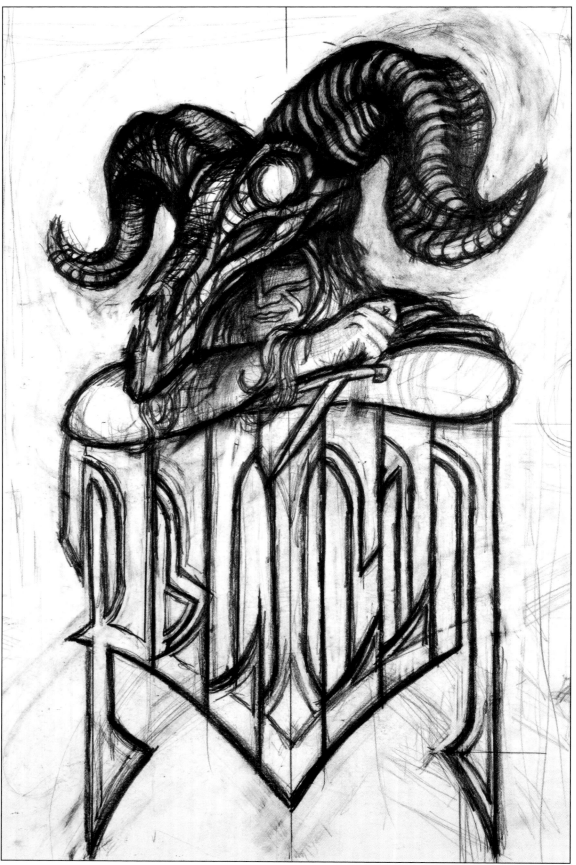

PENCIL

I had been bouncing around the idea of a drawing a woman with a horned skull for quite some time. For whatever reason, I have a whole tribe of animal skull–wearing female medicine shamans in my head, one of whom was put to paper in the Alice in Chains poster in 2010 (see page 137). When the opportunity came to make a poster for Pelican, I figured this was finally a chance to fully formulate this skull woman.

Like many poster artists, I am a huge Alphonse Mucha fan. I find myself turning to my Mucha books almost more than any other books I have for inspiration. His use of composition, typography, ornamentation, detail, and unbelievable technique is just unparalleled. Mucha is one of the masters, and it's fair to say I was trying to channel him a little bit here.

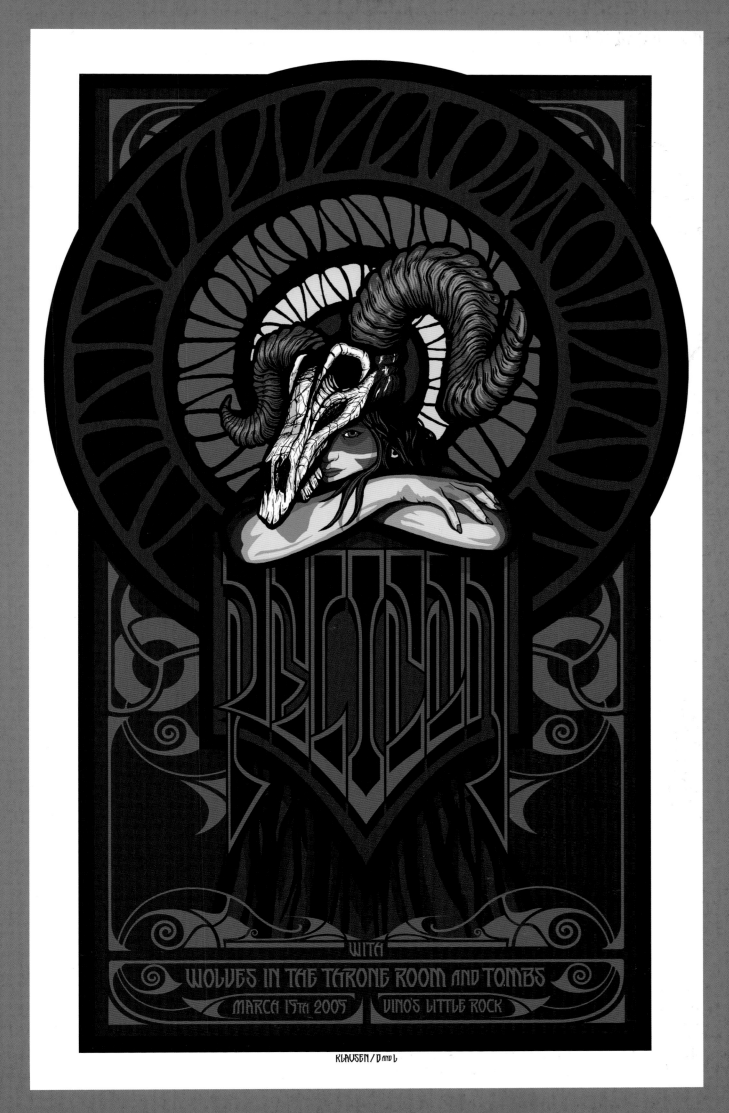

PENCIL

INK

PENCIL

PENCIL

Usually while I am working on a poster, once I have my concept figured out, I'll start listening to the music of the band for the next poster I have to do: letting the music marinate in my mind and hopefully generating some ideas. Sometimes that works, and all of a sudden an image will just appear. That's what happened with this design.

I was packing up a large order of posters and had Mogwai music continuously playing in the background for days. At some point I started getting images of this very serene and bizarre deep-water jellyfish creature, elegantly spiraling through the sea. The more ambient, pretty, quiet Mogwai songs generated this image in my mind. It seemed like a fitting soundtrack to the wonders and mystery of the alien life in the darkest depths of the water that no one ever gets to see.

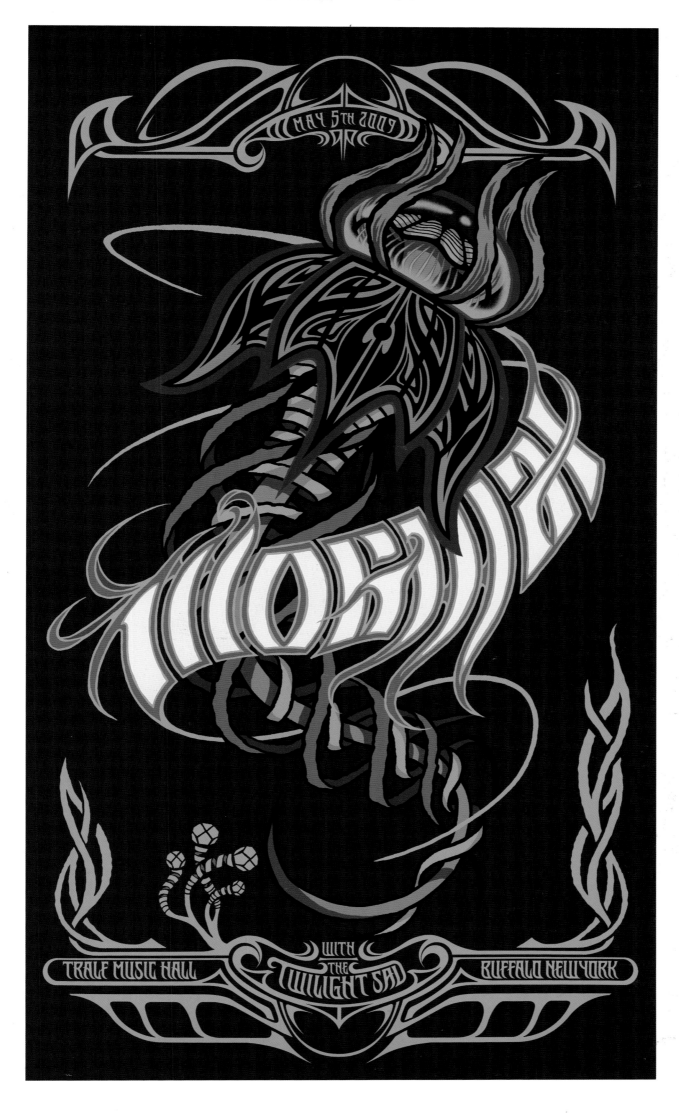

PENCIL

CHARCOAL PENCIL

PENCIL

PENCIL

My original concept for this poster was to do a portrait of the Hiphopapotamus and the Rhymenocerous. Since I was assigned two consecutive nights, I figured I could make one portrait for each, and group them as a set. I liked this idea but I kept thinking it was too obvious, that there had to be someone out there who had already depicted the Hiphopapotamus and Rhymenocerous in a Conchords poster. A quick check of gigposters.com proved this to be true—the very first poster I came across was exactly that. To avoid repetition, I opted to just draw the guys as they are . . . Ironically, in my attempt to do something different, I instead created an image that almost everyone uses for Conchords posters: a drawing of the two guys. I still kick myself for not sticking with my original concept.

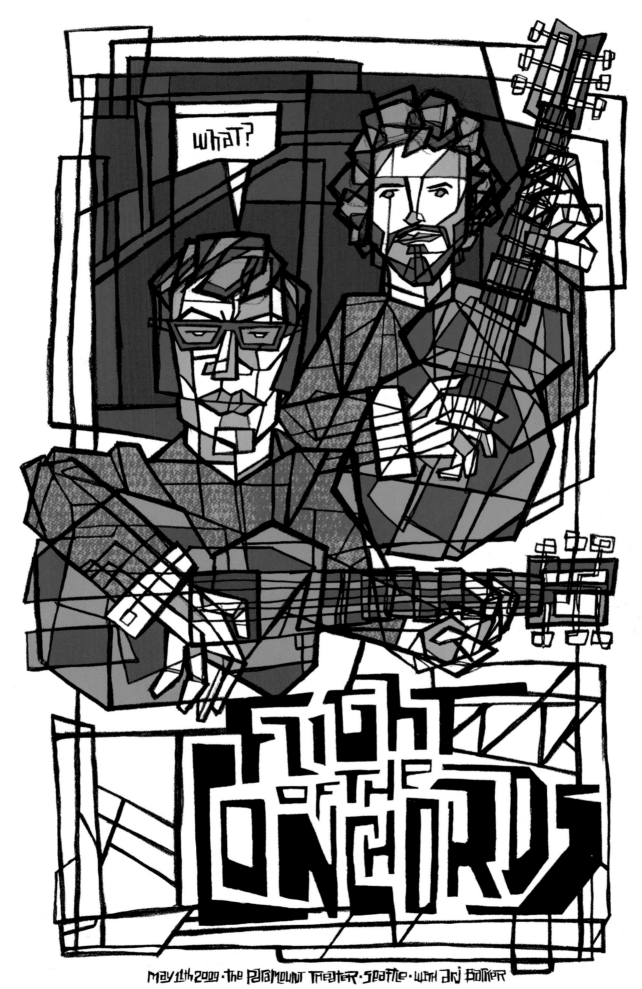

PENCIL

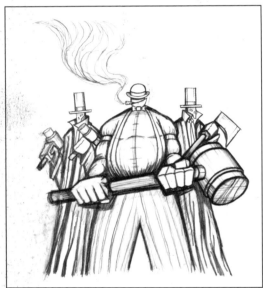

PENCIL

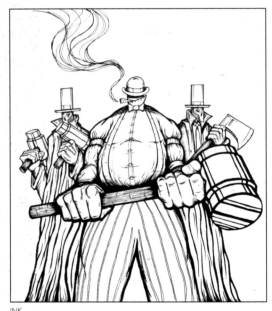

PENCIL

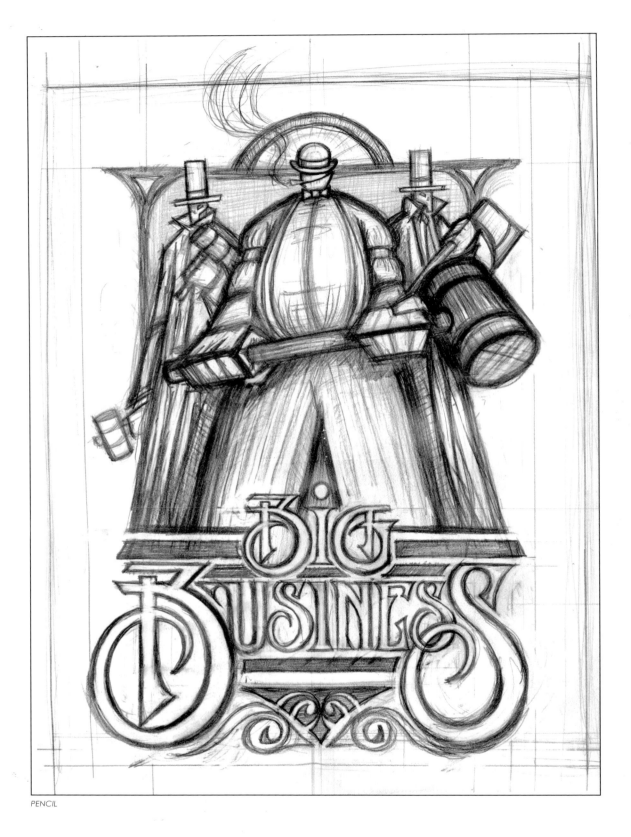

PENCIL

INK

Big Business is one of my favorite bands to come along in quite a while, especially since it seems that so few interesting heavy bands have emerged in recent years. Not just heavy, but melodic and catchy. There've been countless heavy bands to emerge that are loud and heavy, but most seem to have no grasp whatsoever on melody or hooks. Black Sabbath is heavy, and chalk full of melody and hooks. Big Business gets it.

Since they're now a three-piece, I wanted to illustrate the various elements of the band: There's our man with the giant sledgehammer, the bass. The guy with the axe is obviously the guitar. The man with the mallets is one of the best drummers you'll ever see . . .

Along with illustrating the elements of the band, it was also fun to play off the band's name and show the mob mentality of big business.

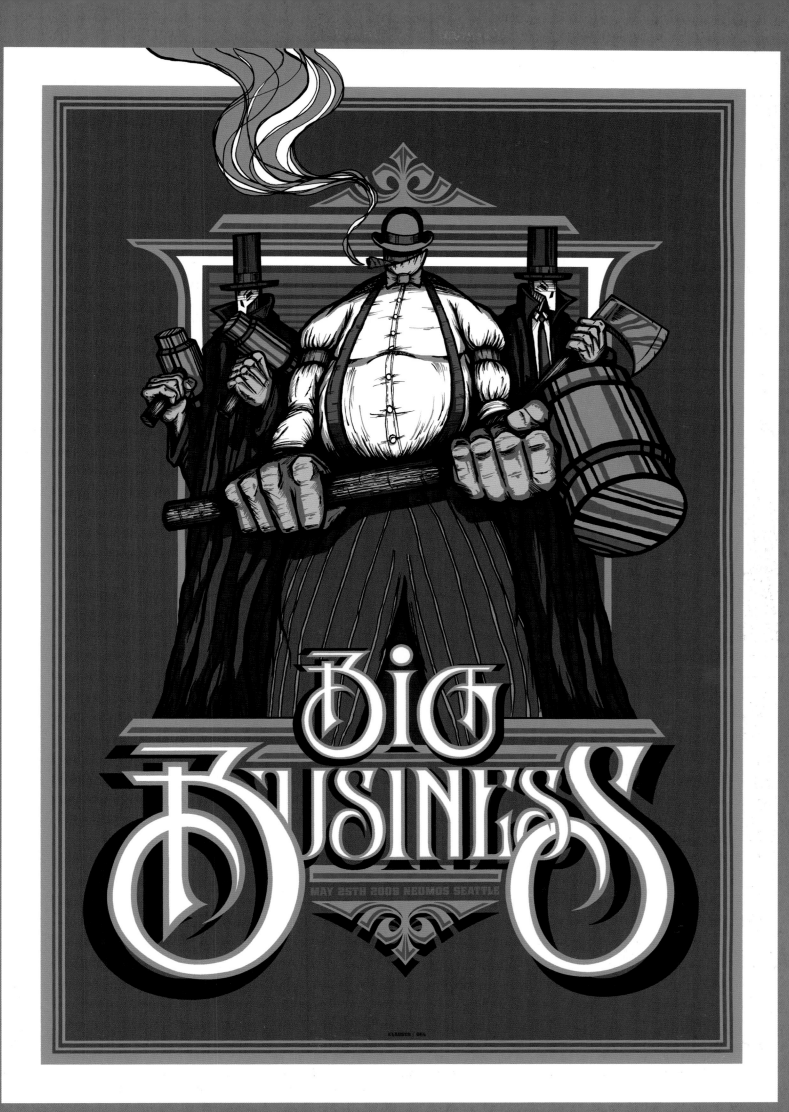

BIG BUSINESS

MAY 25TH 2009 NEUMOS SEATTLE

JUNE & JULY 2008: EDDIE VEDDER / LIAM FINN

ALBANY, NY / PHILADELPHIA, PA / BALTIMORE, MD / NASHVILLE, TN / MEMPHIS, TN / ATLANTA, GA / MAUI, HI / HONOLULU, HI; 18" X 24"; 4 COLORS

PENCIL

1

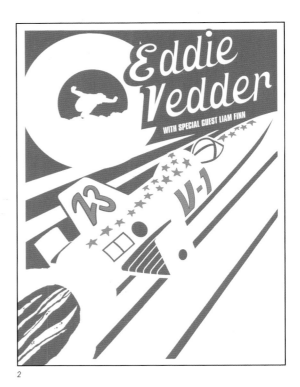

2

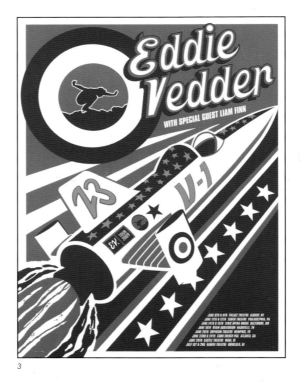

3

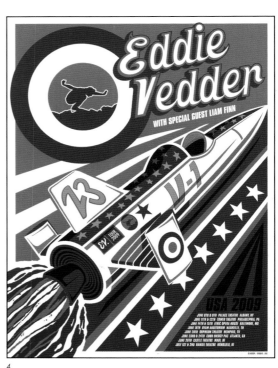

4

As mentioned earlier, Ed's an Evel Knievel fan. I wanted to try to make another poster to go along with the Batmobile one. Something to fit in stylistically with that other poster, as well as with the concept of images of things Ed digs.

I never really know what Ed is going to respond to visually. I tend to think I've got him figured out, but then he always surprises me. He keeps you on your toes. Sometimes I think he's going to hate something, and he loves it. And vice versa.

This was one of those times I thought he was not going to be into this at all. So I e-mailed him a rough mock-up, just to get his initial response, and to my surprise he dug it.

EDDIE VEDDER

WITH SPECIAL GUEST LIAM FINN

23 V-1 O

EV. TOUR 2009

USA 2009

JUNE 8TH & 9TH PALACE THEATRE ALBANY, NY
JUNE 11TH & 12TH TOWER THEATRE PHILADELPHIA, PA
JUNE 14TH & 15TH LYRIC OPERA HOUSE BALTIMORE, MD
JUNE 18TH RYAM AUDITORIUM NASHVILLE, TN
JUNE 20TH ORPHEUM THEATRE MEMPHIS, TN
JUNE 23RD & 24TH COBB ENERGY PAC ATLANTA, GA
JUNE 29TH CASTLE THEATRE MAUI, HI
JULY 1ST & 2ND HAWAII THEATRE HONOLULU, HI

KLAUSEN / VEDDER / D&L

PENCIL

PENCIL

PENCIL

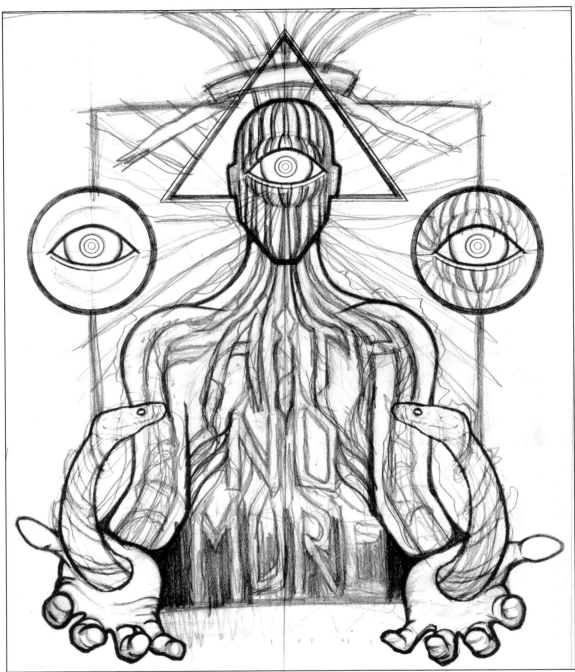

PENCIL ON PRINTOUT

INK

I am not a member of any particular faith, but the religious texts of the world are full of esoteric insight. Since the band wanted this poster to say *The 2nd Coming*, it was a good excuse to pull out some nuggets of esoteric wisdom from the Bible. The King James Bible says, "The light of the body is the eye: if therefore thine eye be single, thy whole body shall be full of light."

There are those who have suggested that this passage is all about the power of the pineal gland, or the third eye. With the raising of the two serpents of the kundalini through the seven chakras, one can ignite the pineal gland and transform consciousness. Once you've opened your third eye, or your single eye, your whole body will fill with light and you will be a light being. At that point, you will no longer need faith, you will just *know*. Faith no more . . .

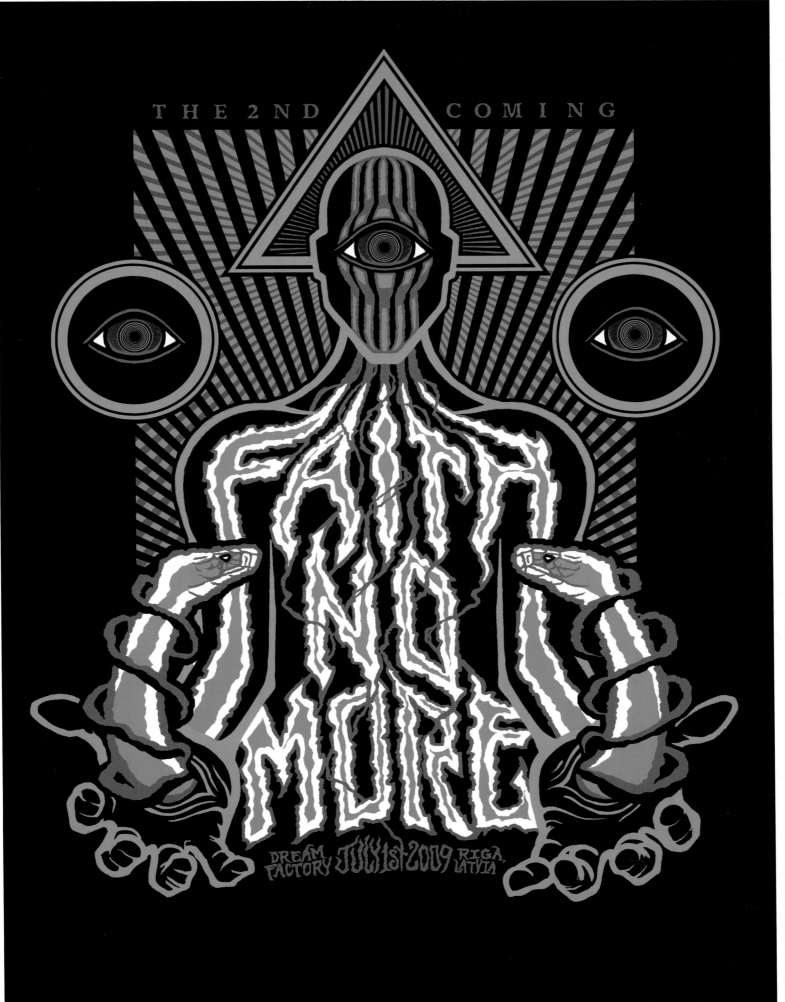

18" X 24"; 4 COLORS

PENCIL

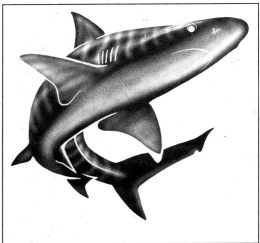

PHOTOSHOP

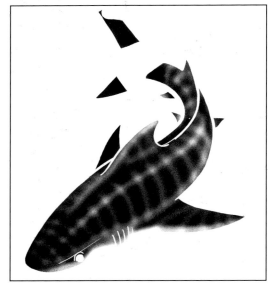

PHOTOSHOP

PENCIL

Tre Packard of PangeaSeed is a very passionate, motivated fellow, driven to build awareness to help protect the ecosystems of our ocean and planet. He asked if I would contribute a print to help raise awareness about the atrocities of shark finning. This was my piece for their "No Fin, No Future" campaign.

In this print, I wanted to convey the idea of harmony and balance. The yin and yang seemed to be the perfect symbol for this. Along with describing how seem-ingly disjointed or opposing forces (sharks and humans) are interconnected and interdependent in the natural world, the yin and yang also symbolizes a process of harmonization, ensuring a constant dynamic balance of all things.

Since shark finning is rampant in Japan, the red circle represents both the yin and yang as well as the Japanese flag. Hoping that harmony and balance could be brought to the sharks of that area.

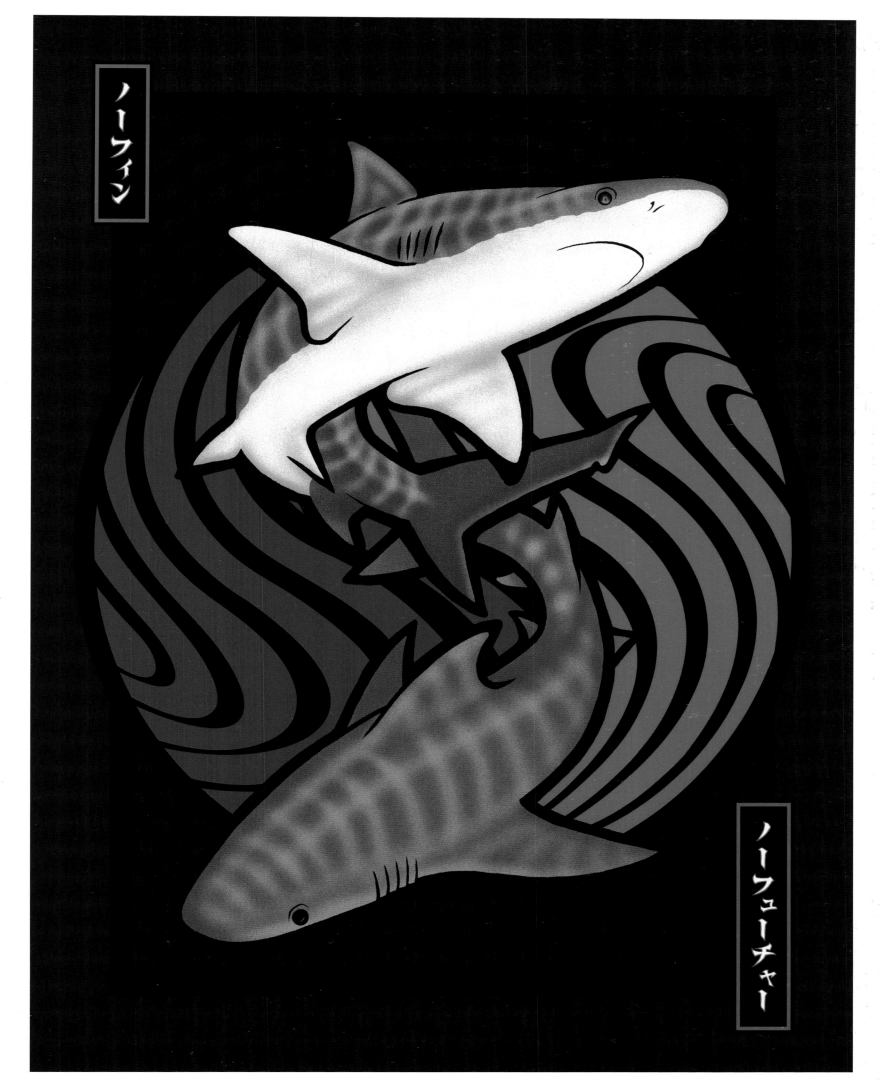

ノーフィン

ノーフューチャー

PENCIL

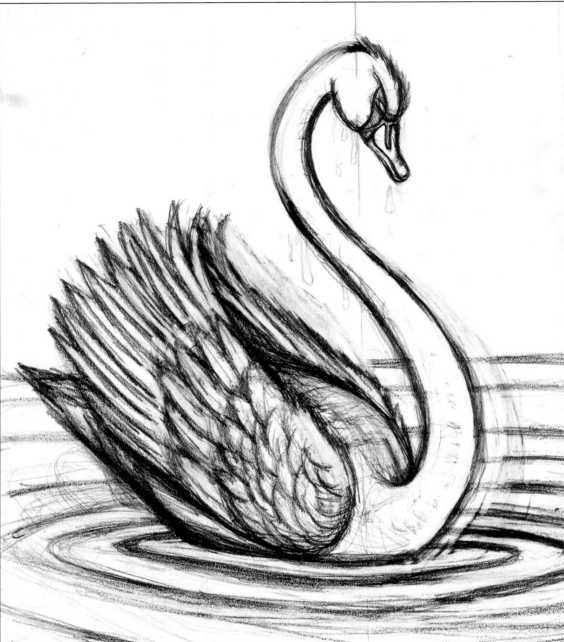

PENCIL

INK

INK

WATERCOLOR

INK

A *black swan* is a term used to describe an unforeseeable event, something no one could have predicted. It's been referenced a lot recently to account for the systemic failure taking place within the global economy. It seems to be conveniently raised by those in power—those who are behind the wheel when the failures occur—in a way that absolves them of any sort of responsibility for their "mistakes." *What could we do? It's a black swan, no one could have seen it coming.*

But what if there are no black swans, only white swans that have been painted black to create the illusion? Manufactured black swans. That way, you can present a contrived problem as something that just happened by unforeseeable chance, seemingly out of anyone's control. Then you can offer the contrived solution.

Since this show was taking place in the UK, home of the Round Table Group Black Swan Manufacturing Co., it seemed appropriate . . .

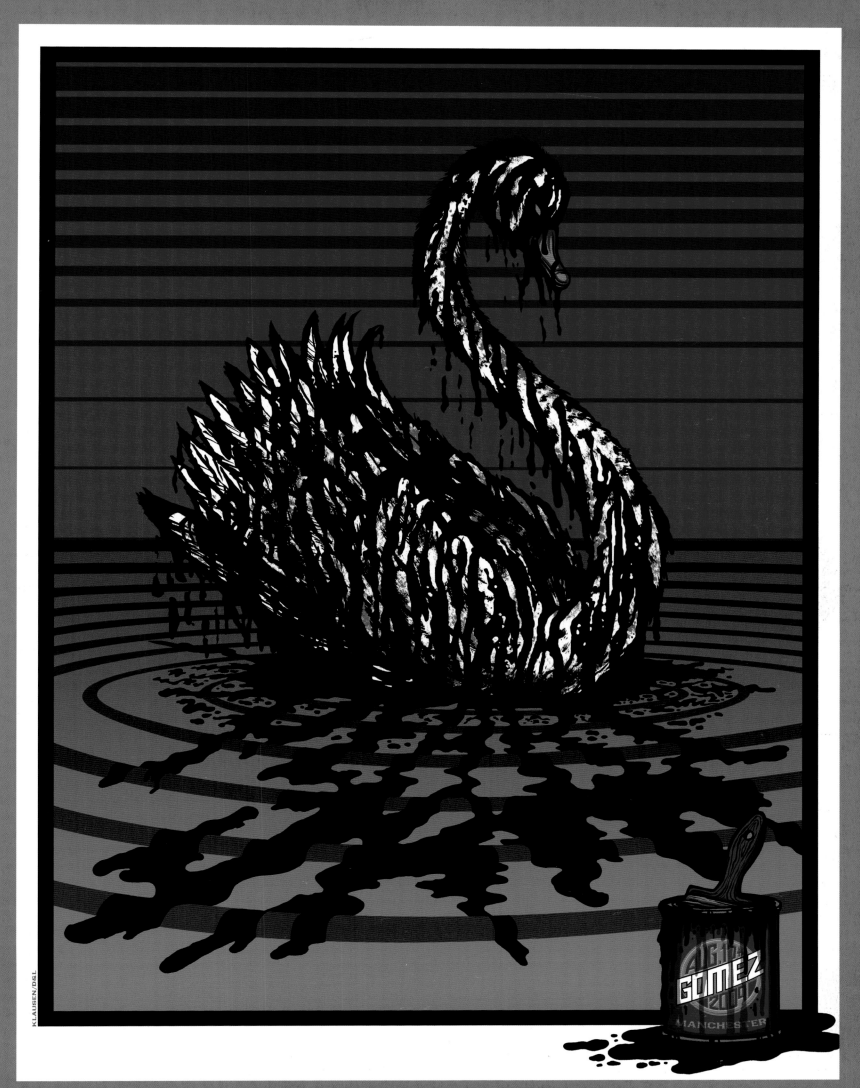

KLAUSEN/DGL

INK

INK AND PENCIL

PENCIL

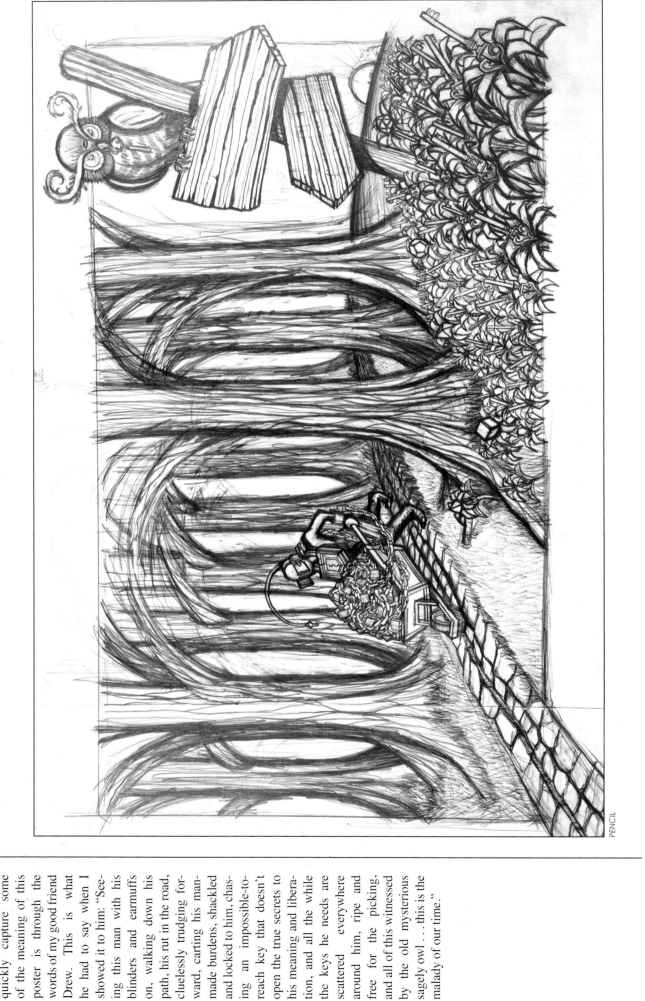

PENCIL

There's not nearly enough room to write about the inspiration for this poster. Despite popular belief, it's not based on the lyrics to "Given to Fly." A few days after I finished this poster, as I was walking my dogs through the park, an owl swooped down out of thin air and landed on a branch just above us. Ever since then, owls seem to keep appearing.

The best way to quickly capture some of the meaning of this poster is through the words of my good friend Drew. This is what he had to say when I showed it to him: "Seeing this man with his blinders and earmuffs on, walking down his path, his rut in the road, cluelessly trudging forward, carting his manmade burdens, shackled and locked to him, chasing an impossible-to-reach key that doesn't open the true secrets to his meaning and liberation, and all the while the keys he needs are scattered everywhere around him, ripe and free for the picking, and all of this witnessed by the old mysterious sagely owl . . . this is the malady of our time."

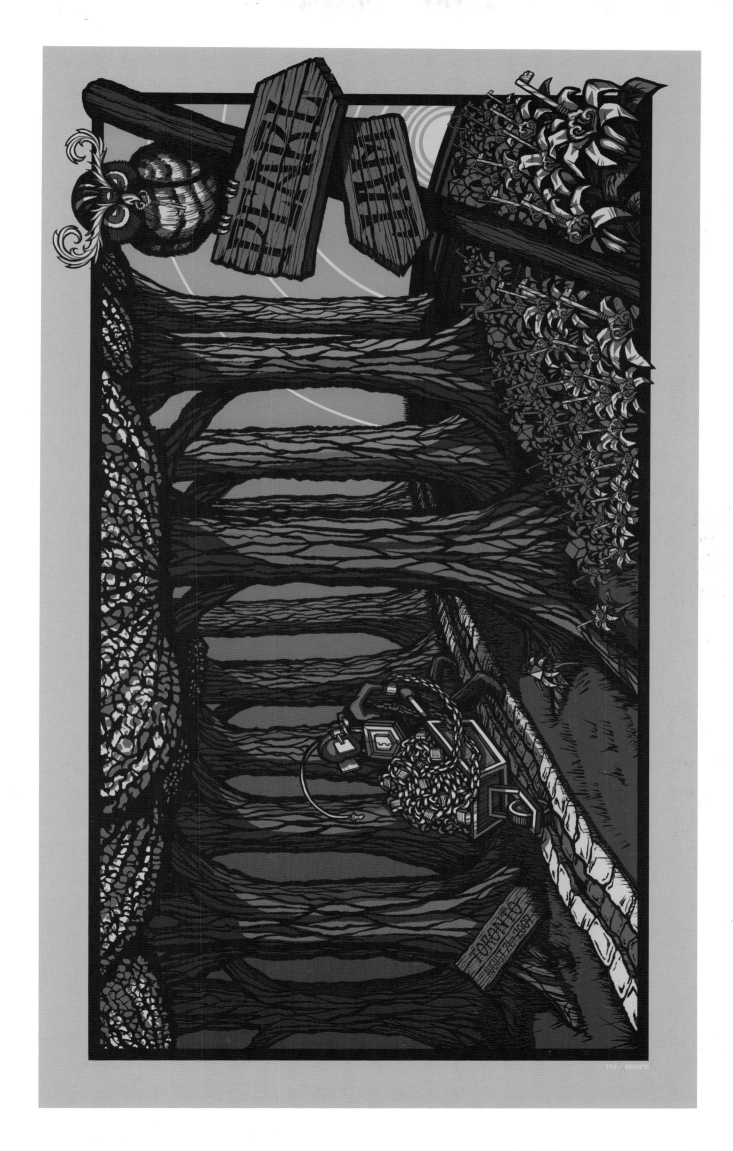

117

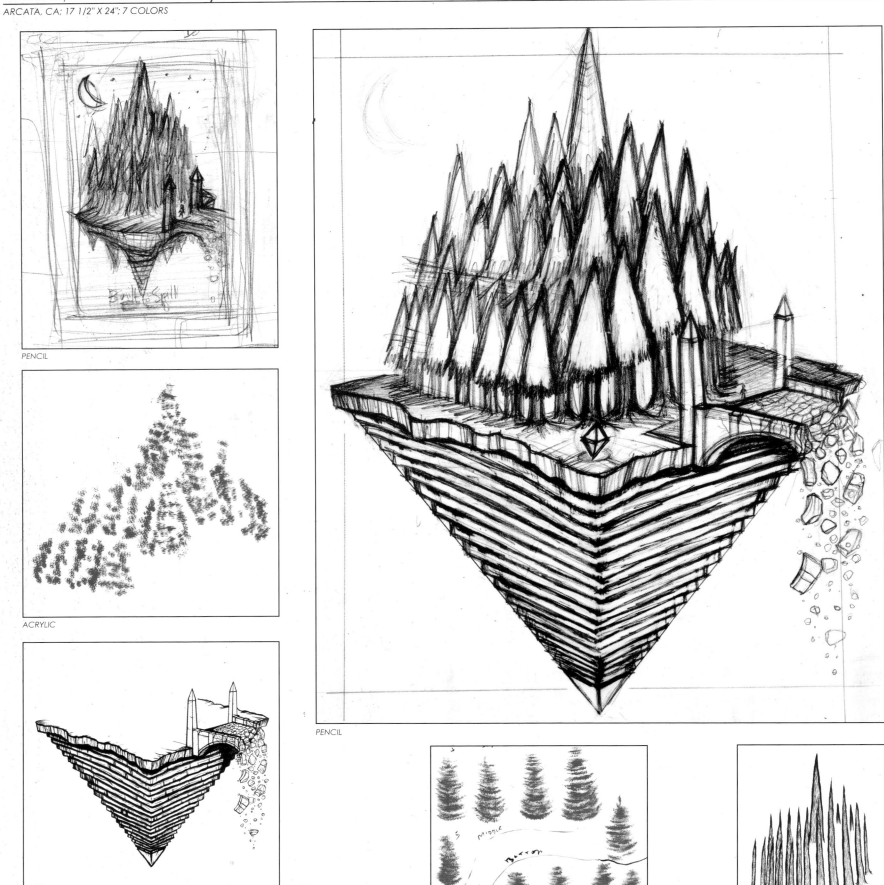

PENCIL

ACRYLIC

INK

PENCIL

ACRYLIC

INK

Near the end of the summer of 2008, a couple of things took place that seemed unconnected but were both crucial elements for my own personal development as an artist and as a person. The first was I started working for myself, from my own home. The second was that my dog Zoe, after about twelve years of going to parks to play frisbee, had to retire from the game. So instead of finding open fields to play in, we started going on long walks through wooded parks near the house.

These walks became an integral part of my creative process, giving me the time to think that I formerly had when playing frisbee under the stars with Zoe. Eventually I started to see the woods as a cathedral, and began referring to these walks as "going to church."

This show took place in Arcata, California. If the park near my house is a cathedral, then Northern California is like Vatican City.

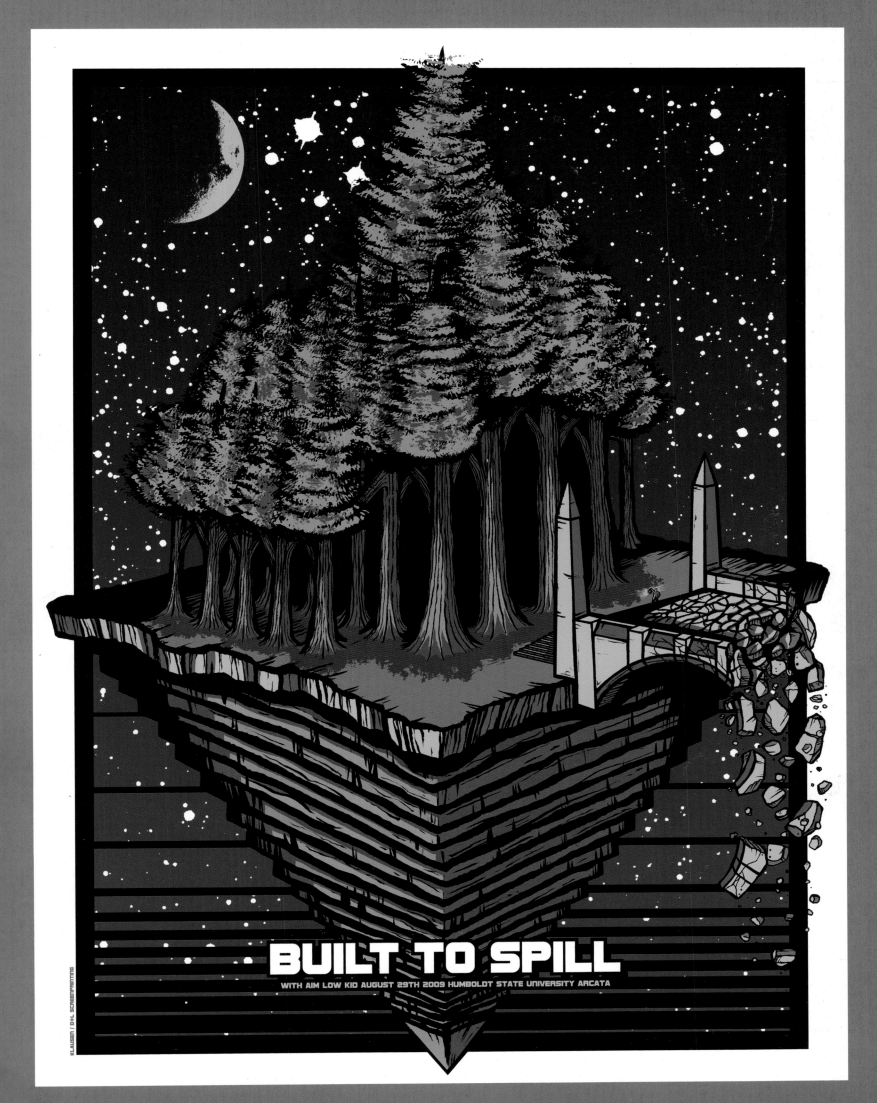

PENCIL

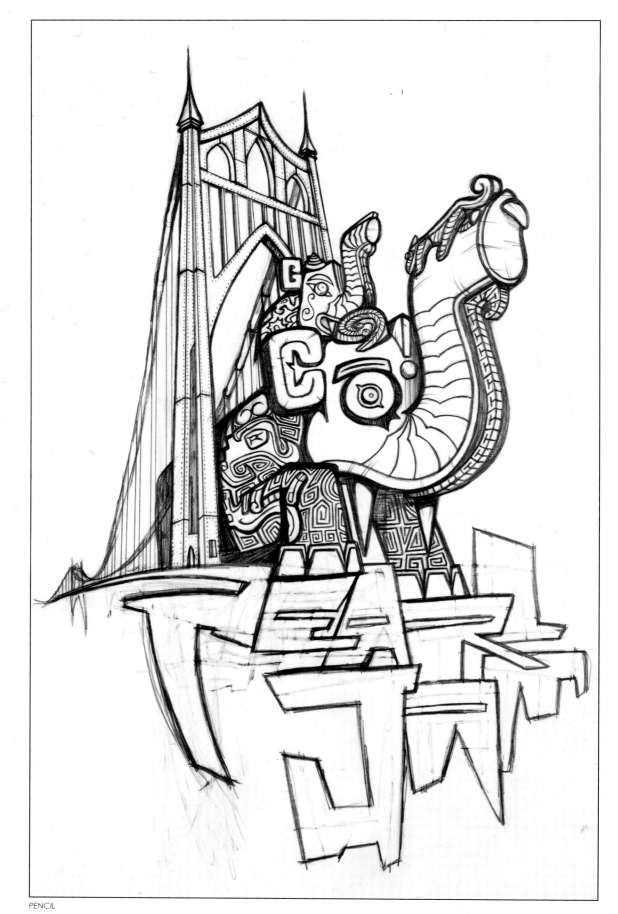

PENCIL

There's a statue in Portland that I absolutely love. *Da Tung and Xi'an Bao Bao* is an enlarged replica of a wine pitcher from the late Shang Dynasty (circa 1200–1100 BC). The baby elephant standing on its father's back symbolizes healthy and prosperous offspring. I didn't know any of that until I sat down to draw this poster. All I knew was that I always look forward to seeing this statue each time I visit Portland.

There's not a lot of movement in the statue, so when it came time to draw the figures, I wanted to at least try to give them a chance to move around. So I led them on a walk across the St. John's Bridge in Portland. The "gates" of the bridge have a large arched opening, with a smaller entrance sitting above. It mirrors the arrangement of the large and small elephants, and was a perfect fit.

120

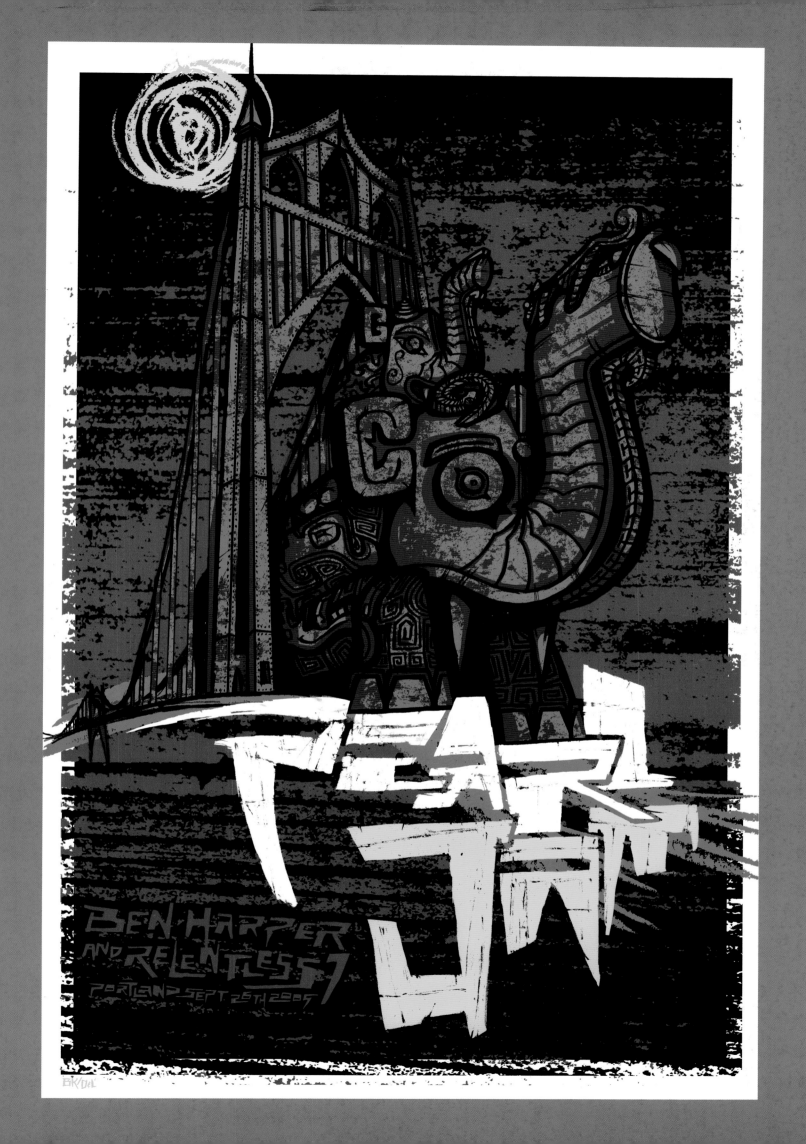

SALT LAKE CITY, UT; 18" X 24"; 4 COLORS

PENCIL

PENCIL

INK

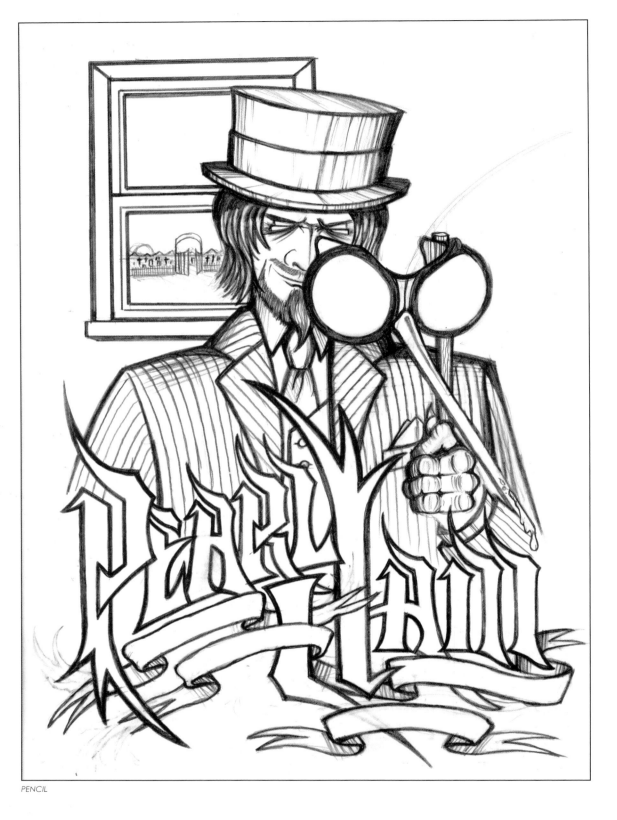

PENCIL

"Watched from the window, with a red mosquito / I was not allowed to leave the room / I saw the sun go down, and now it's coming up / Somewhere in the time between / I was bitten, must have been the devil / He was just paying me / A little visit, reminding me of his presence / Letting me know, he's a-waiting . . ."
—Pearl Jam, "Red Mosquito"

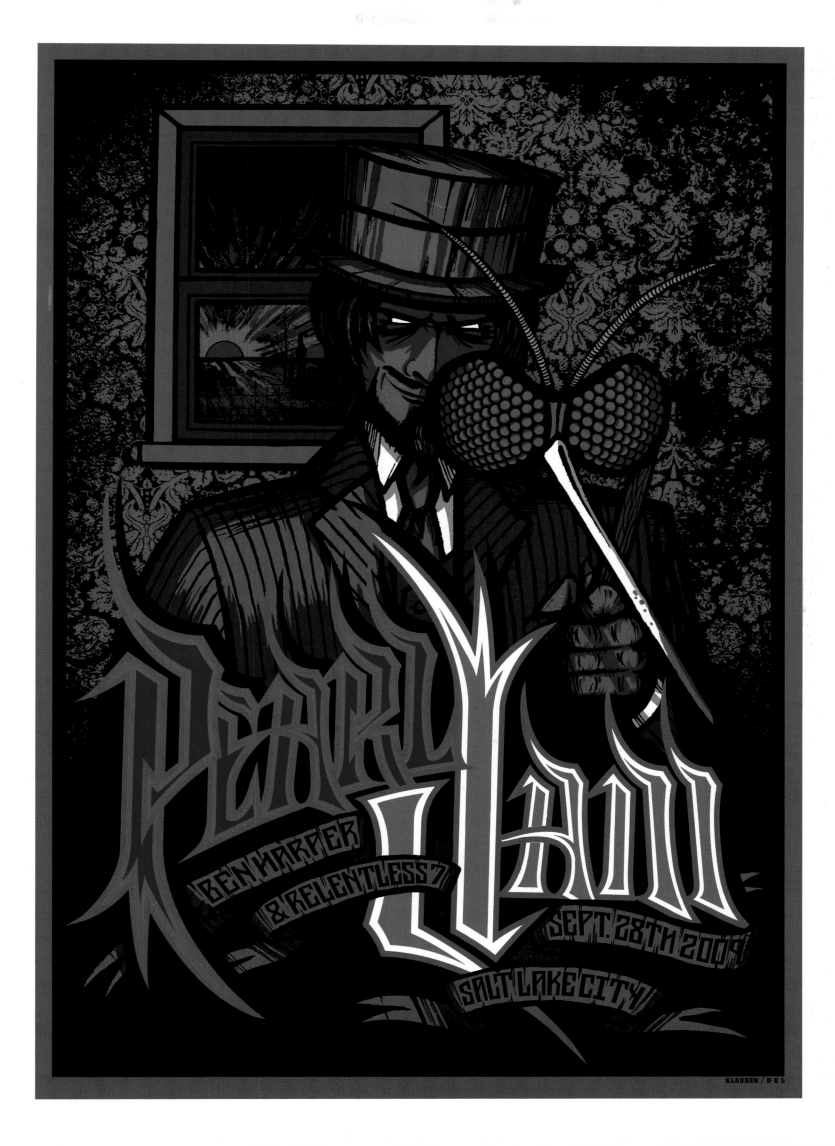

18" X 24"; 4 COLORS

PENCIL

INK

PENCIL

Within the Zohar, the primary Kabbalist text, it says: "The narratives of the Doctrine are its cloak. The simple look only at the garment—that is, upon the narrative of the Doctrine; more they know not. The instructed, however, see not merely the cloak, but what the cloak covers."

The folks at Faded Line Clothing asked me to join their roster of artists and wanted to use pieces of art from older posters for some shirts and other projects.

In particular, they wanted to use the reaper from the Pearl Jam DC poster. At this point in time, I no longer wanted to focus on this aspect of my creative energy, but it would give me a chance to fix the DC image. I had always felt that the poster seemed unfinished or flat, like all the colors hadn't been printed yet. So I was pleased for a chance to go back and revisit the piece. A simple layer of shading makes a big difference.

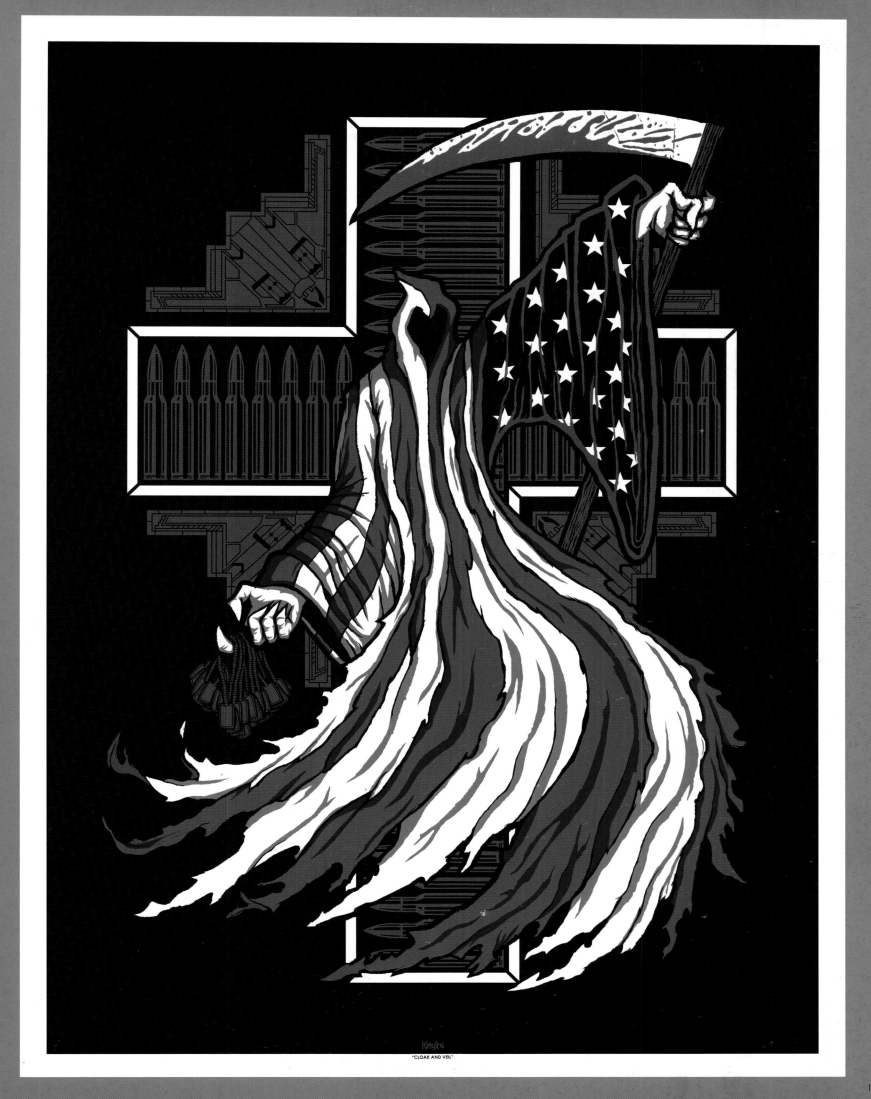

KLAUSEN

"CLOAK AND VEIL"

PENCIL

PENCIL

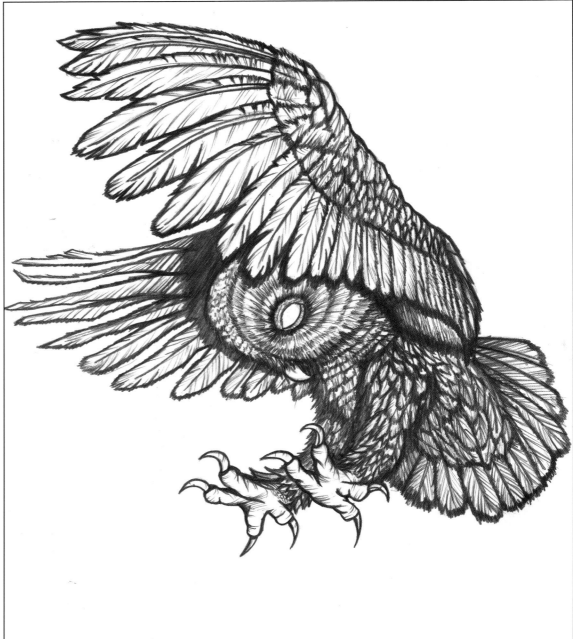

PENCIL

INK

PENCIL

Ever since I drew an owl on the Pearl Jam Toronto '09 poster, owls started to appear in my life—and I've become absolutely smitten with them. If it's not raining, I try to go out at dusk specifically to find them. During my evening searches, I've come to appreciate the wonderful energy that happens during the transition between night and day. Being that there is a lot of folklore around owls, which are sometimes thought of as omens of death, it seemed like a good image for a Monster of Folk.

In the summer of 2009, I lived near Woodlawn Park and started spotting owls in the trees. By the end of the summer we had to move, but luckily not far from the much larger Discovery Park, where I now go to watch owls hunt over the tall grass . . . It's a scene almost identical to this poster I drew the previous autumn.

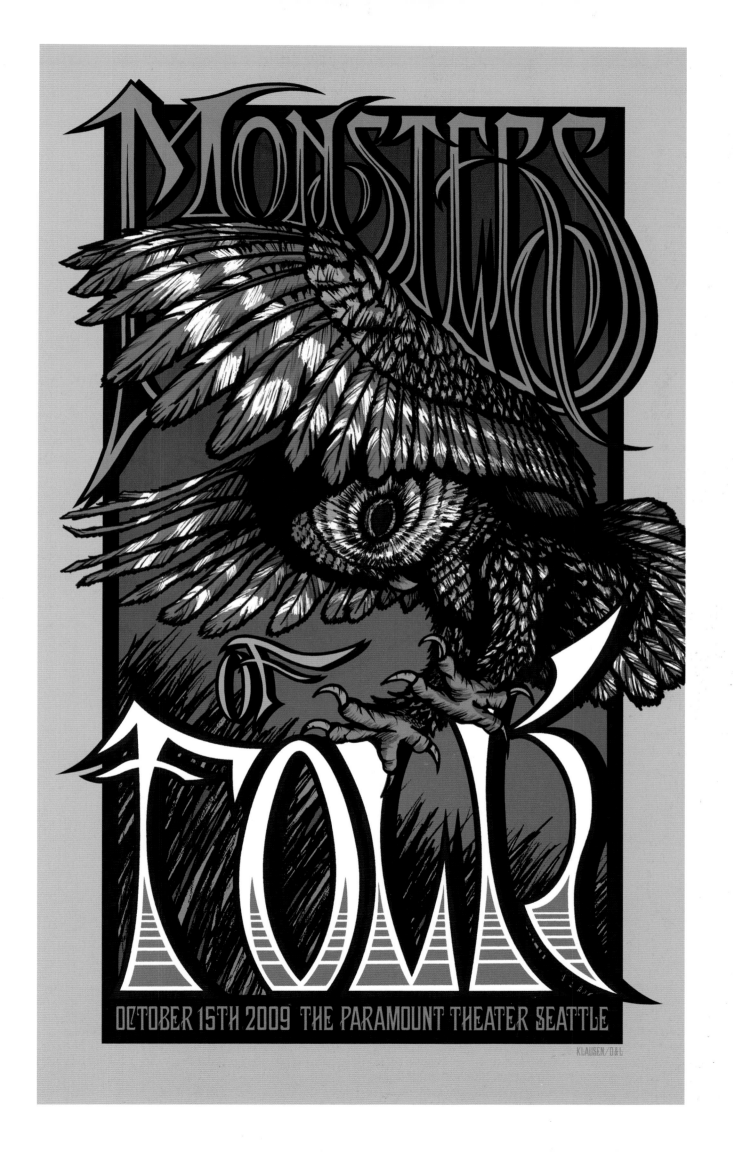

PENCIL

PENCIL

PENCIL

PENCIL ON PRINTOUT

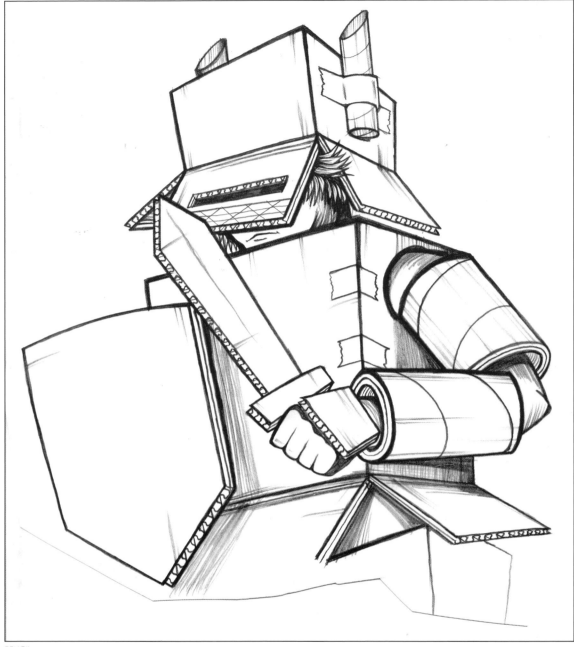

PENCIL

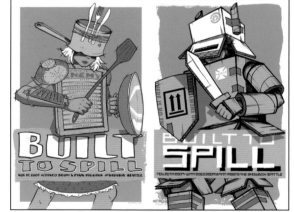

NOVEMBER 19 POSTER BY KRISTIN SUMMERS

PENCIL

Kristin Summers is one of the most talented, gifted people I know. She excels at everything she does and is a constant source of inspiration. For a while I had been trying to figure out a way to get her to design a poster. Luckily, that opportunity finally arrived when I asked Built to Spill if I could do a couple posters for them. They were playing two nights at the Showbox, so this was the perfect chance to get Kristin to design something. She could do one night and I could do the next.

When working on posters for multiple nights at one venue, I always want to try and make the posters a set . . . if I can. Sometimes it works out and sometimes it doesn't. It worked out well this time; Kristin handled the pots-and-pans girl and I took the cardboard-box boy. Every time I see these two posters, it makes me smile.

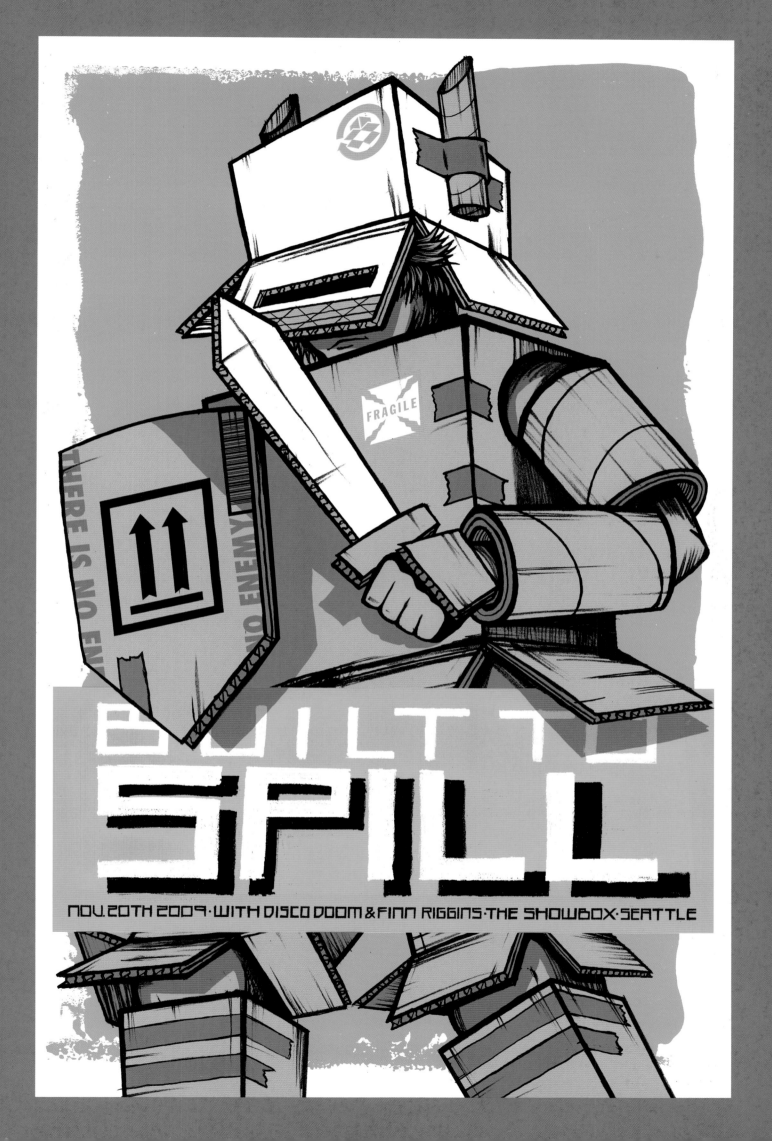

BALTIMORE, MD; 14 3/4" X 24"; 5 COLORS

PENCIL

PENCIL

INK STAMP

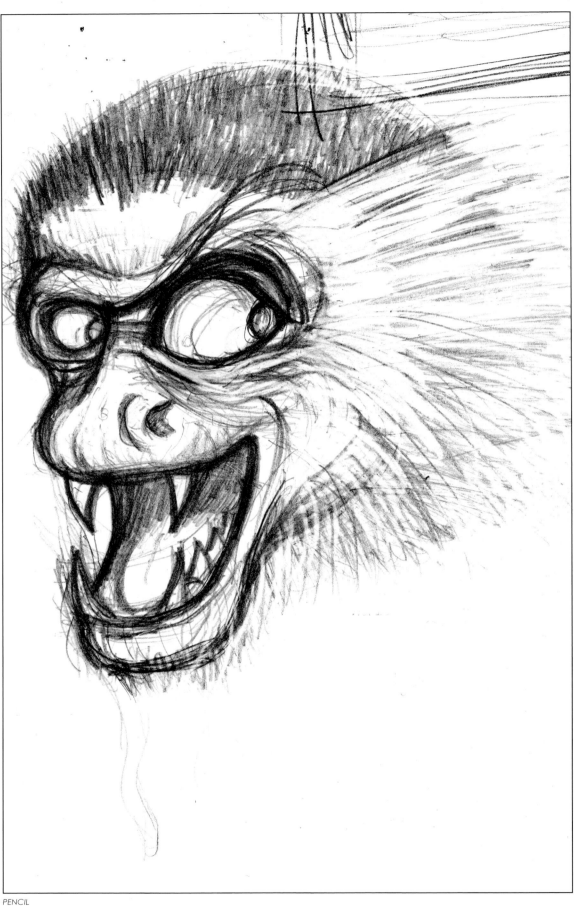

PENCIL

David Yow, singer of the Jesus Lizard, always makes me think of a crazed monkey on acid spewing poetry. He treads a fine line between madman and genius, and the lyrics and his delivery of them on stage remind me of the rantings of a lunatic on the corner. At first you might be a bit startled or frightened, but the more you listen, the more you get drawn in. The more you want to listen and try to decipher the message.

The original idea for this one involved our crazed monkey busting through the door of a cage and devouring the bird, depicting the end scene of a moment of chaos and madness. Unfortunately, I wasn't into the scale of the characters in my composition, and this was an instance where I couldn't successfully translate the image in my head onto the paper. While I liked the monkey face I had drawn enough to think it might work on its own, I still wish I had figured out the cage scene . . .

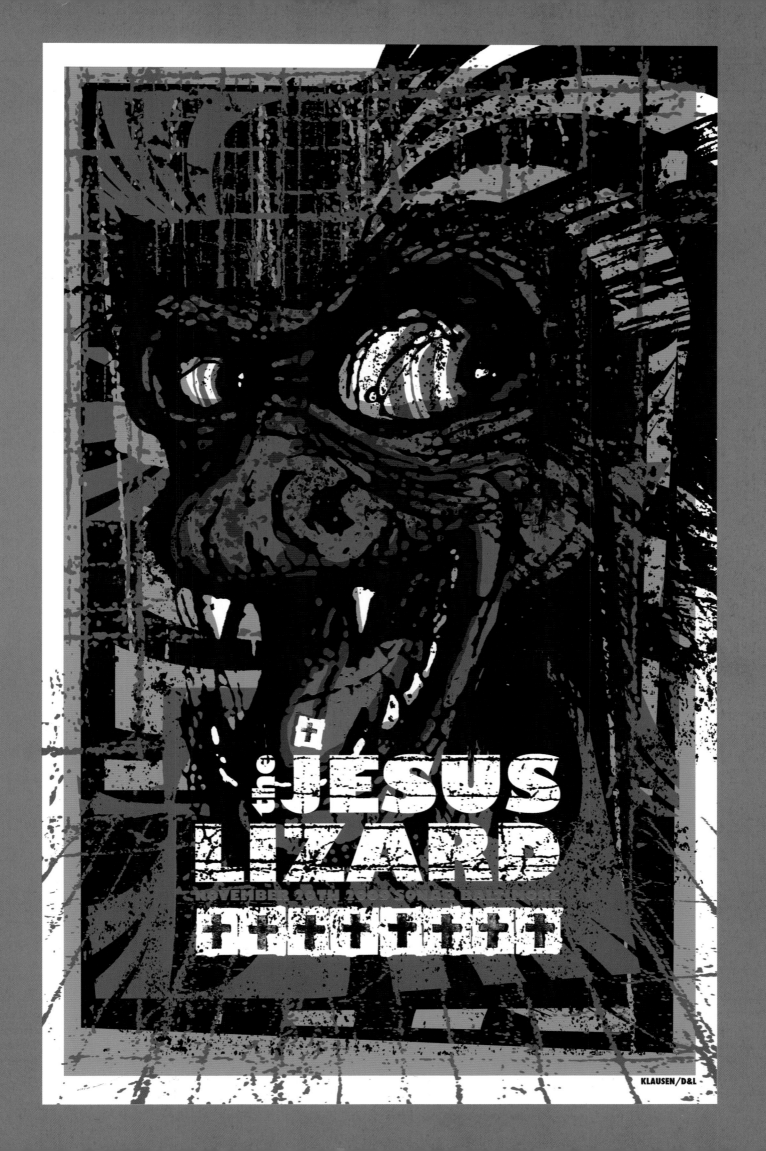

PENCIL

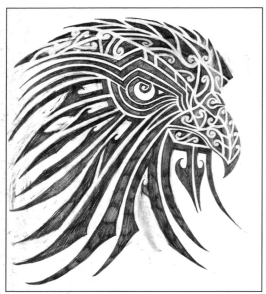

PENCIL

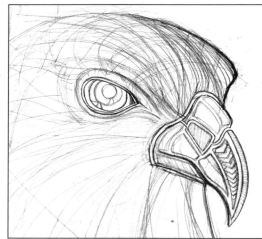

PENCIL

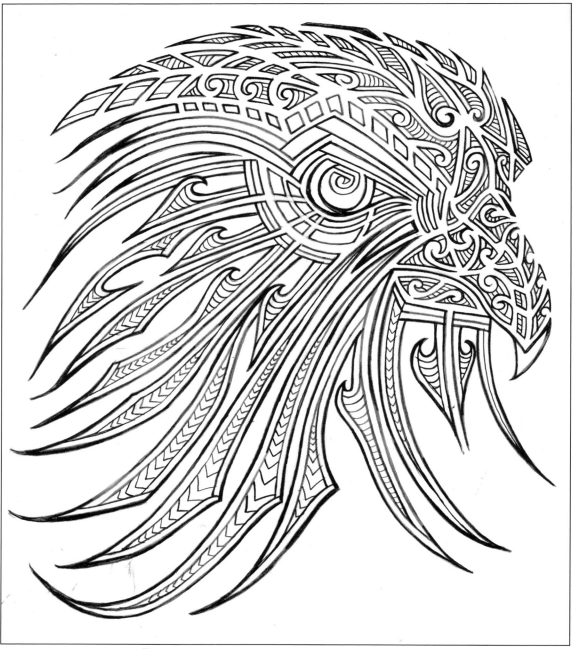

PENCIL

When I first started making posters, I would occasionally reference the city of the show in my compositions. Over time I started to realize that part of the challenge involved making an image relevant to people of that immediate area; it just gives the poster that much more meaning to those who attend the show.

I've always found the designs of Maori tattoo art to be quite compelling. So when it came time to do a poster for New Zealand, I wanted to pay my respects to the native Maori. Birds are often thought of as the messengers of the gods, given their ability to land on earth and fly to the heavens. The bird depicted is the harrier hawk, or Kahu, as it's known in Maori. Behind the hawk is the *Tino Rangatiratanga* flag of the Maori. It not only symbolizes the balance of the forces of nature, but also the independence of the Maori people.

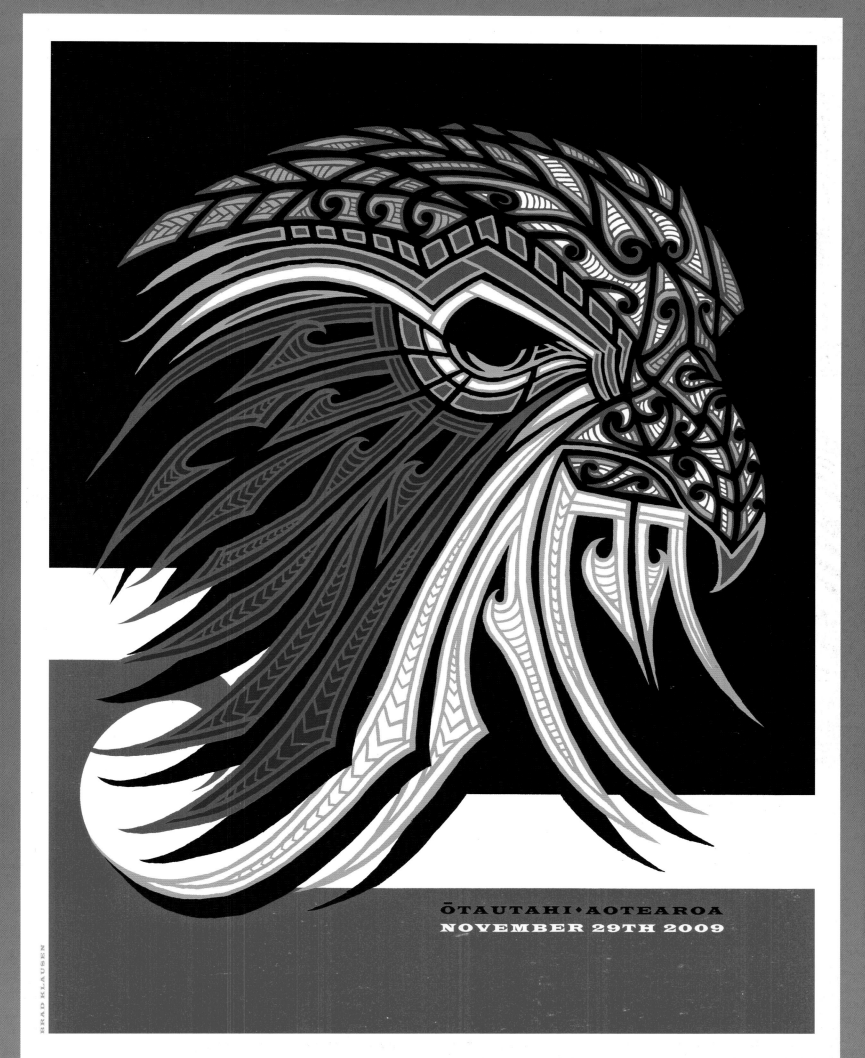

ŌTAUTAHI ✦ AOTEAROA
NOVEMBER 29TH 2009

BRAD KLAUSEN

ATLANTA, GA; 15" X 24"; 7 COLORS

PENCIL

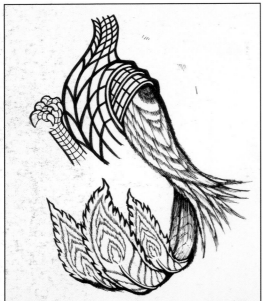

PENCIL

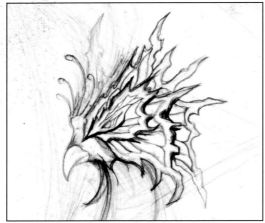

PENCIL

PENCIL

This design is all about rebirth and wormholes. There is an esoteric belief that through the philosophy of fire, one can transmute the lead of human existence into the gold of the eternal soul. From the calcined ashes rises the reborn phoenix, free from the impurities of matter, strengthened by the release of its true essence.

Once this state has been achieved, when the moon and the sun have been wed together, one can enter the field of MFKZT, as the ancient Egyptians believed. The cosmic phoenix, transcending space and time.

Widespread Panic always makes me think of my two friends named Brad: Flinn and Niederman. They are both big fans of the band, and are the reason I am even familiar with their music. Whenever I work on posters for Panic, it reminds me of their friendship, which is one of the reasons why I enjoy making these posters.

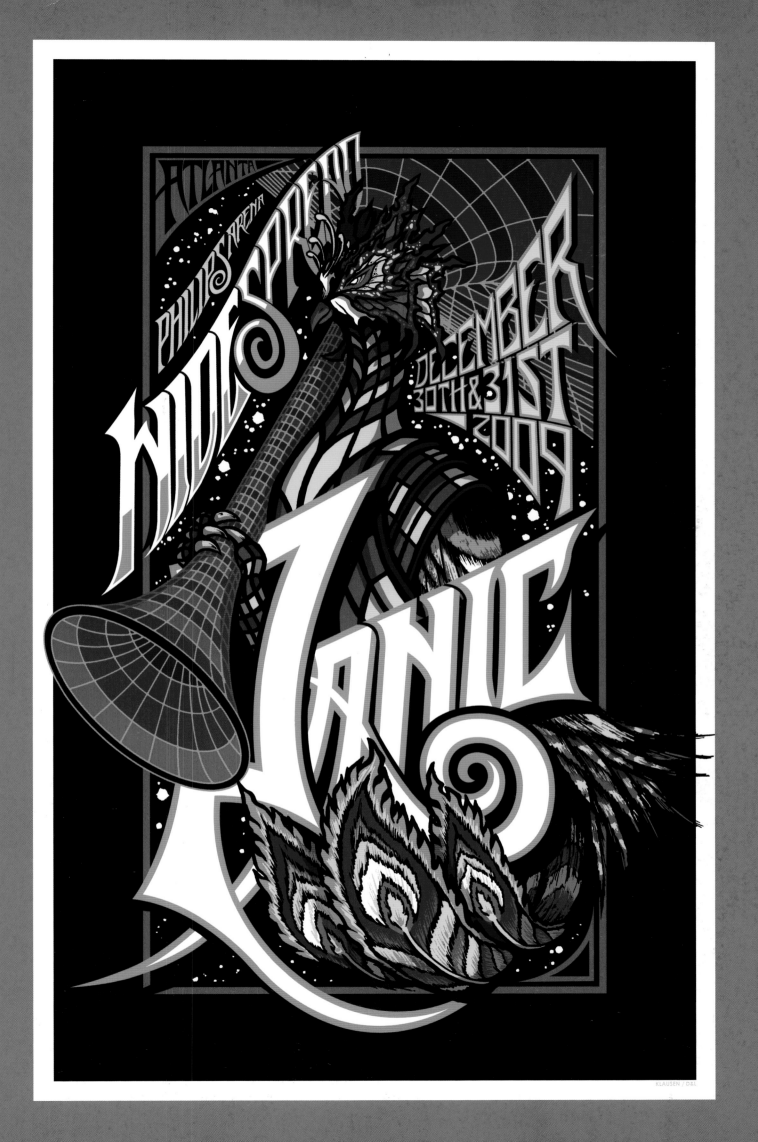

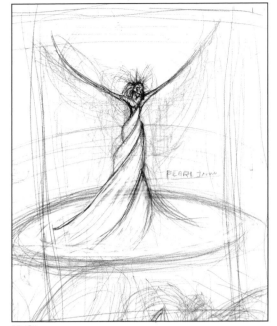

PENCIL

PENCIL

INK

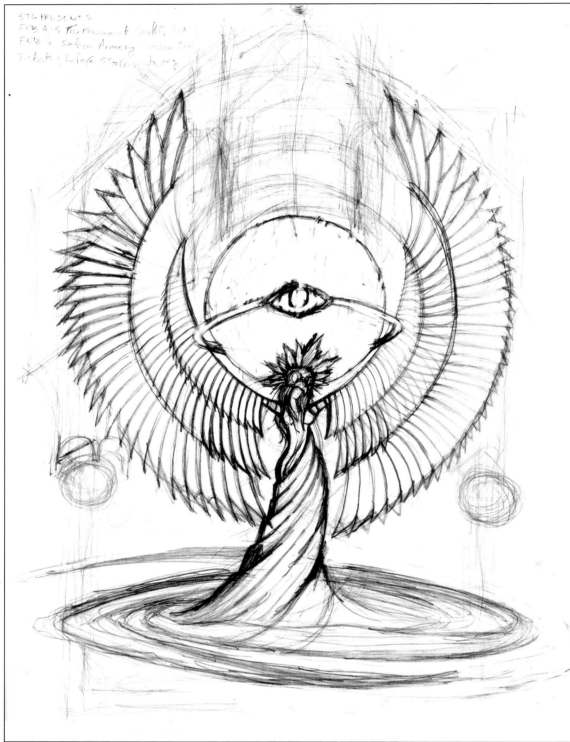

PENCIL

INK

I worked on this poster a few weeks before traveling to Egypt. With the country on my brain, I decided to compose an ode to the goddess Isis. Isis has many titles, but the two I wanted to reflect in this image were "Protector of the Dead" and "Queen of the Heavens." Protector of the Dead for obvious reasons; and her dress is meant to symbolize the spiraling arms of the galaxy, or the heavens, as she spins forth, rising out of the center as Queen of the Heavens.

While I had initially planned on using this sketch of a woman spiraling out of water for a Pearl Jam poster, it ultimately felt like it would make a much better Alice in Chains image—the border is supposed to allude to chains.

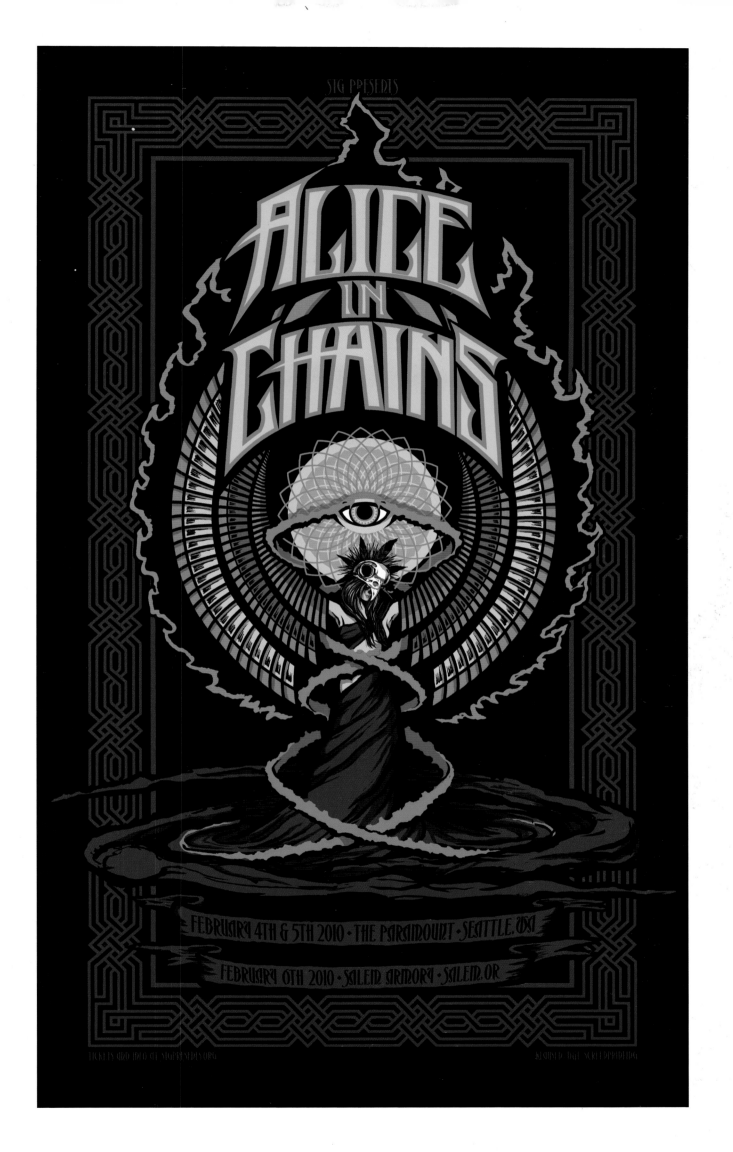

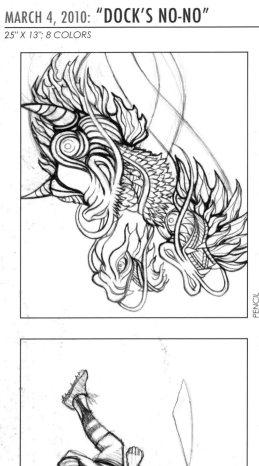

PENCIL

PENCIL

PENCIL

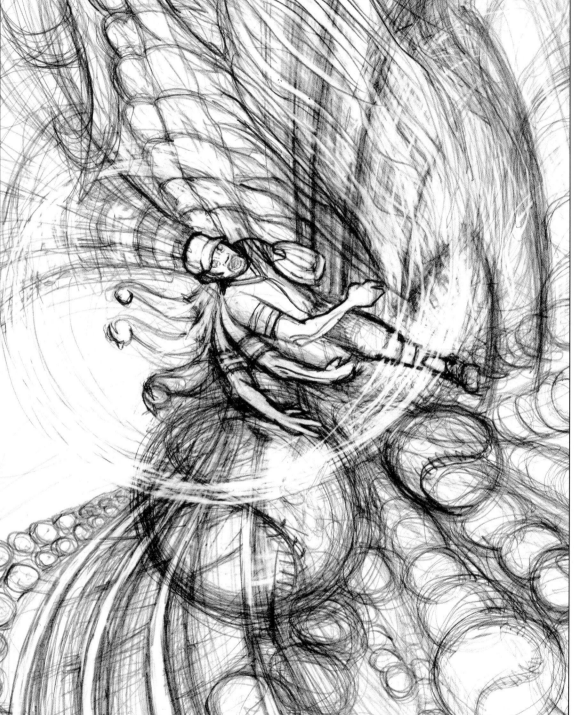

PENCIL

On June 12, 1970, Pittsburgh Pirates pitcher Dock Ellis, high on LSD, pitched a no-hitter against the San Diego Padres. Gallery 1988 in LA had a show entitled "The Greatest Moments in Sports History," and they asked me to contribute a piece. From my point of view, Dock's no-no was hands down the greatest moment in sports history. It takes some serious swagger to walk out to a major league pitcher's mound with a head full of acid. And then to pitch a no-hitter—granted, it wasn't the prettiest no-hitter on record, but a no-hitter nonetheless.

While I really liked my original sketch, it became a challenge to figure out how this was all going to screenprint. A painting would've been fine, but the more I worked on the sketch, the more I realized I was going to have a very hard time setting this drawing up for a screenprint.

As you can see in the sketch, there's a dragon morphing out of the left side of Dock. Like I mentioned with the Pearl Jam Toronto '06 poster, I've always had this idea in my mind that acid is a portal for dragons. So I figured that since I couldn't get the first sketch to work out right, I might as well instead go with another dose of acid dragons.

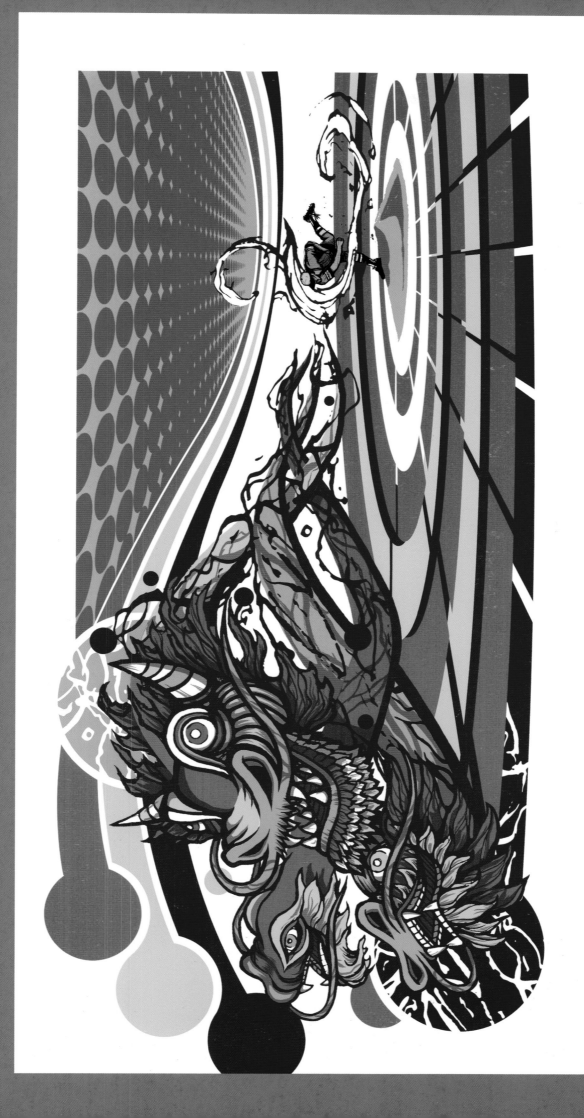

PENCIL

INK

ACRYLIC

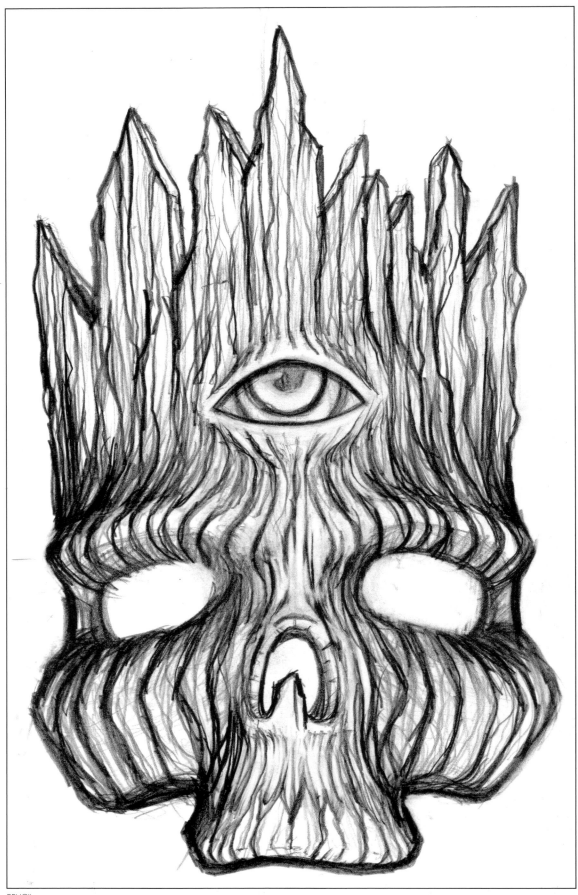

PENCIL

I had been hoping the day would come when I might get a chance to make a Soundgarden poster. I planted a seed with their drummer, Matt Cameron, awhile back that if for some reason they ever reunited, I'd love to do a poster. And much to my surprise, that day arrived.

The concept is all about the reawakening of the slumbering kings of the woods of the Northwest. When you walk through the woods around dusk and into the eve-ning, there is a wonderfully eerie feeling. Once you get past the fear of it, you realize there is nothing to fear at all—in fact it's quite welcoming, and there's a power in the darkness. It's the same feeling I have about the heavier Seattle bands. I feel like the slow, dirgey Seattle sound was born out of the dark forests of the Pacific Northwest. It's out there, in the roots . . .

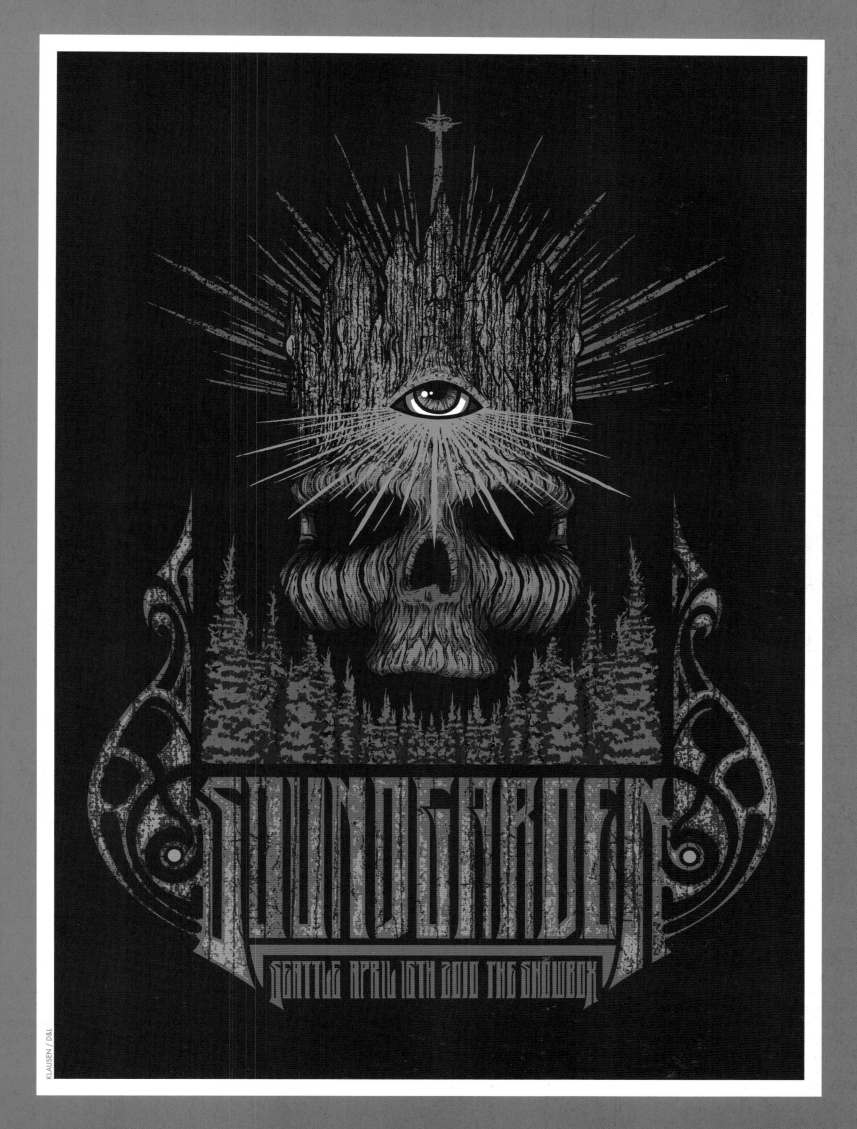

PENCIL

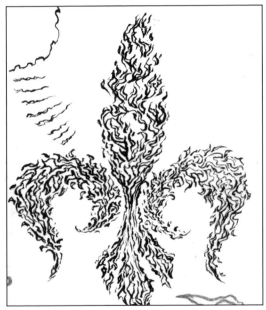

INK

PENCIL

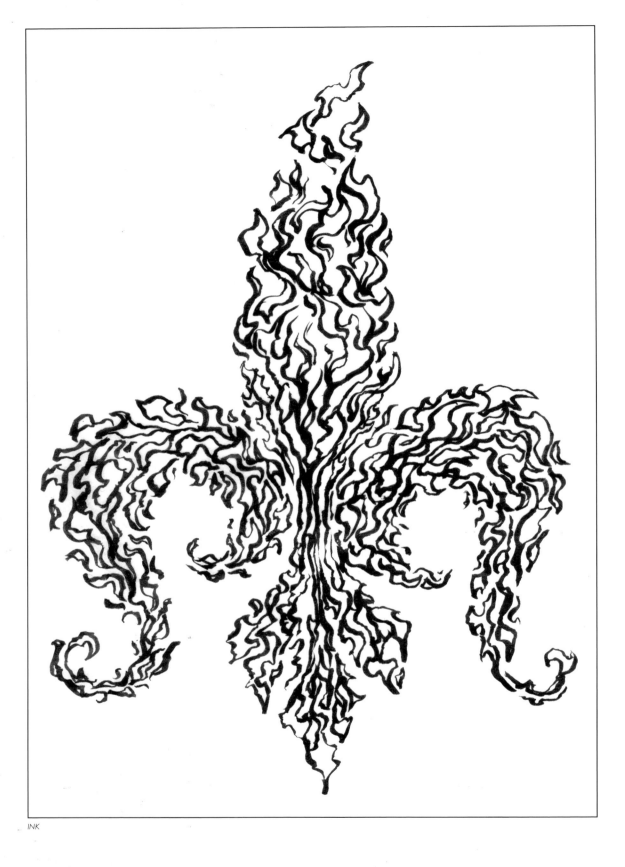

INK

I had four posters to design for Pearl Jam's 2010 tour, so I decided to see if there was a way to somehow tie them all together. I've been quite intrigued with alchemy lately, and one of its main components revolves around the four elements: earth, air, fire, and water. I decided to base each poster off one of the four elements, while also relating each design to aspects of the city of the show.

I had hopes for the rebirth of New Orleans after Katrina. Being that the phoenix is the quintessential symbol of rebirth, fire was the obvious elemental choice for New Orleans. Sadly, a few weeks after I finished the poster, the BP oil spill occurred in the Gulf of Mexico, and my hopes for New Orleans's quick rebirth were cut short.

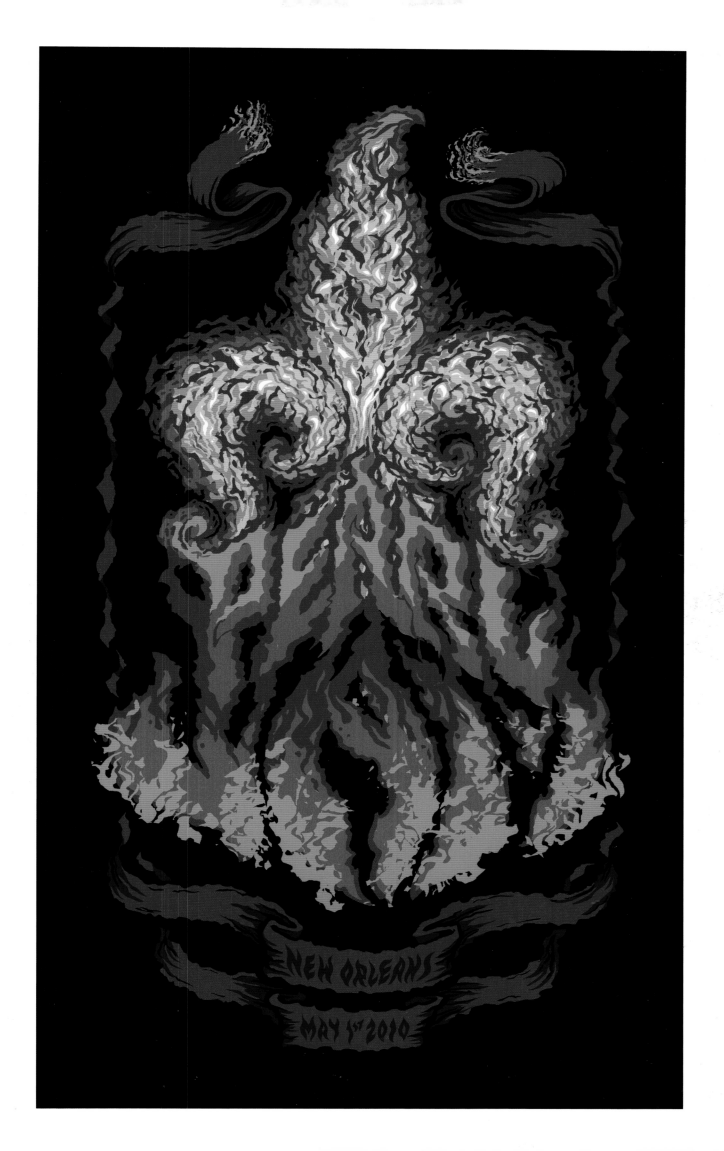

PENCIL

PENCIL

PENCIL

PENCIL

Trees are one of the symbols for the earth element, and I'd been wanting to create a poster based on the song "In My Tree" for a while. It fit perfectly for a show in Ireland, where the ancient Celts venerated trees as symbols of wisdom and knowledge. Which goes right with the lyric, "Let's say knowledge is a tree." When I went back to listen to the song as I was working on this concept, I started to develop a new impression: for the first time, I heard the song as a meditative mantra. It seemed to be describing inward contemplation, going into one's tree, where your friends can't see you and you aren't bothered by the headlines of newspapers. "Up here so high the sky I scrape" perhaps alludes to a heightened level of consciousness. Over the years, and more so recently, I've been on many walks through the woods with my dogs. The more I am around trees in the woods, the more I get the feeling of being in the presence of wise elders, of being in the presence of knowledge.

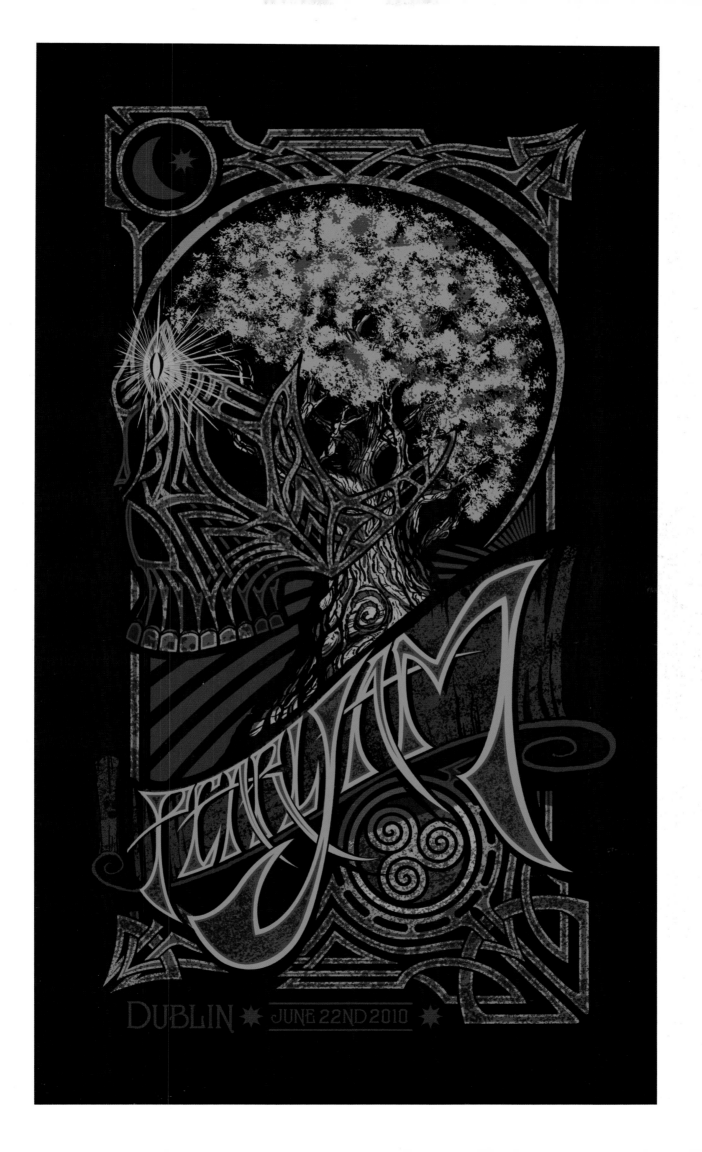

PENCIL ON PRINTOUT

PENCIL

INK

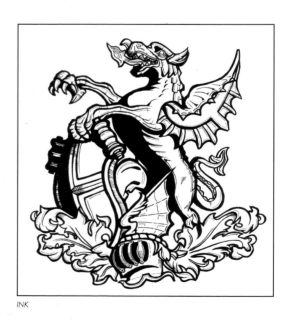

INK

Griffins and dragons are symbols for the air element, and it just so happens that throughout the city of London you can find dragon statues. The dragons mark the boundaries of the Square Mile of Old London, guarding the entrances to the financial capital of the world, and can also be found perched on certain buildings. The dragons hold shields bearing the cross of St. George, which became not only the flag of England but also the cross of the Knights Templar. The gateway into the

city was originally through the Temple Bar Memorial on Fleet Street. There, out in front of the Royal Courts of Justice, is where you will find the fiercest dragon of them all.

The financial capital of the world was owned by the Knights Templar. In order to practice law in their courts, lawyers had to pass through the barred gateway of the Temple Bar. Once through the guarded gate, you had "passed the bar."

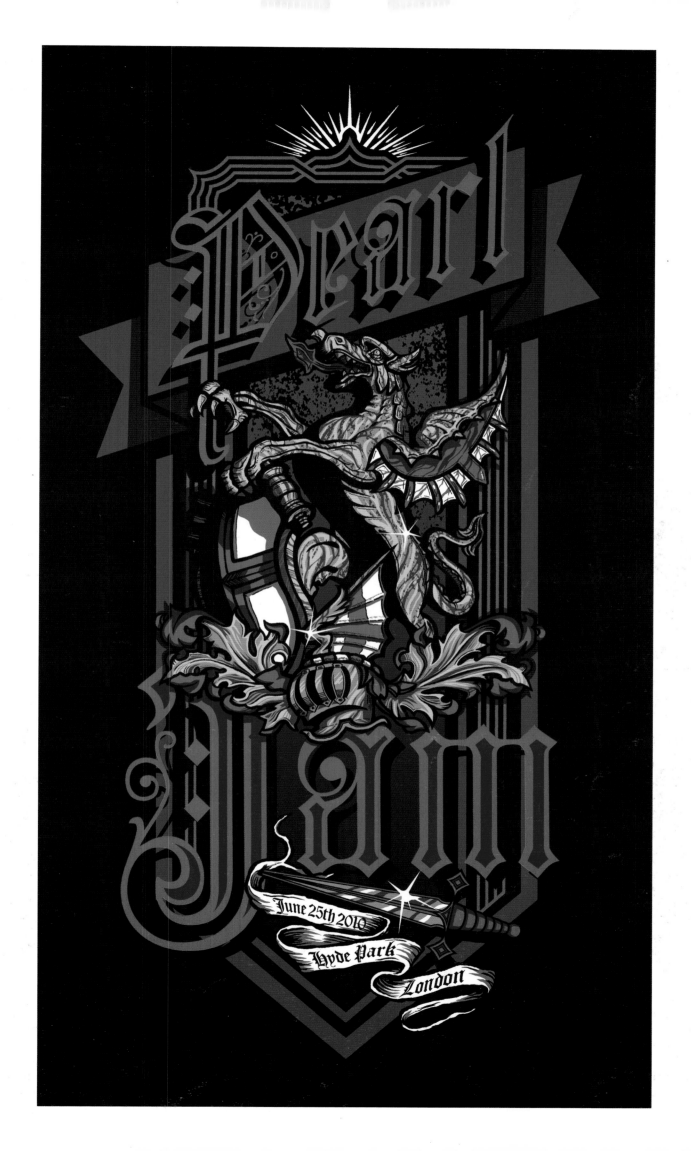

147

GDYNIA, POLAND; 14" X 24"; 8 COLORS

PENCIL

PENCIL

PENCIL

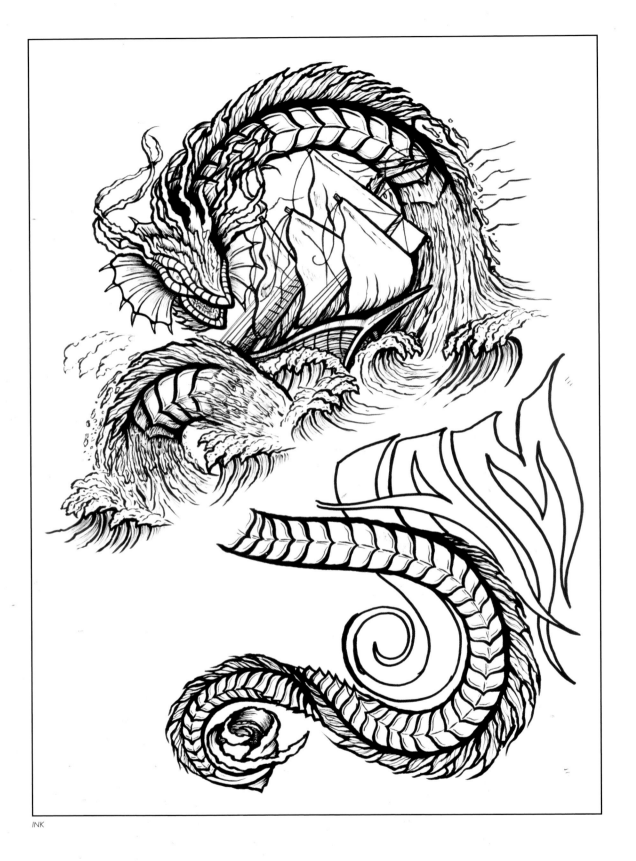

INK

Sea monsters are one of the symbols for the water element. Given that Gdynia is a seaport town, it seemed like an appropriate fit. Also, Gdynia has hosted four out of six of Poland's tall ships races over the past few decades, so why not have a sea monster attacking a tall ship?

For a while I'd been wanting to do a poster depicting an above-water/below-water scene. Something where below the surface it seems calm, even though up above it's chaos. I am a big Katsushika Hokusai fan, and have always loved how he was able to stylize the movements of nature, particularly water, in his famous *The Great Wave off Kanagawa*. When working on this piece, as well as "Escape From Absurdia: Day 7," I was doing my best to find my own Hokusai-esque version of stylized waves.

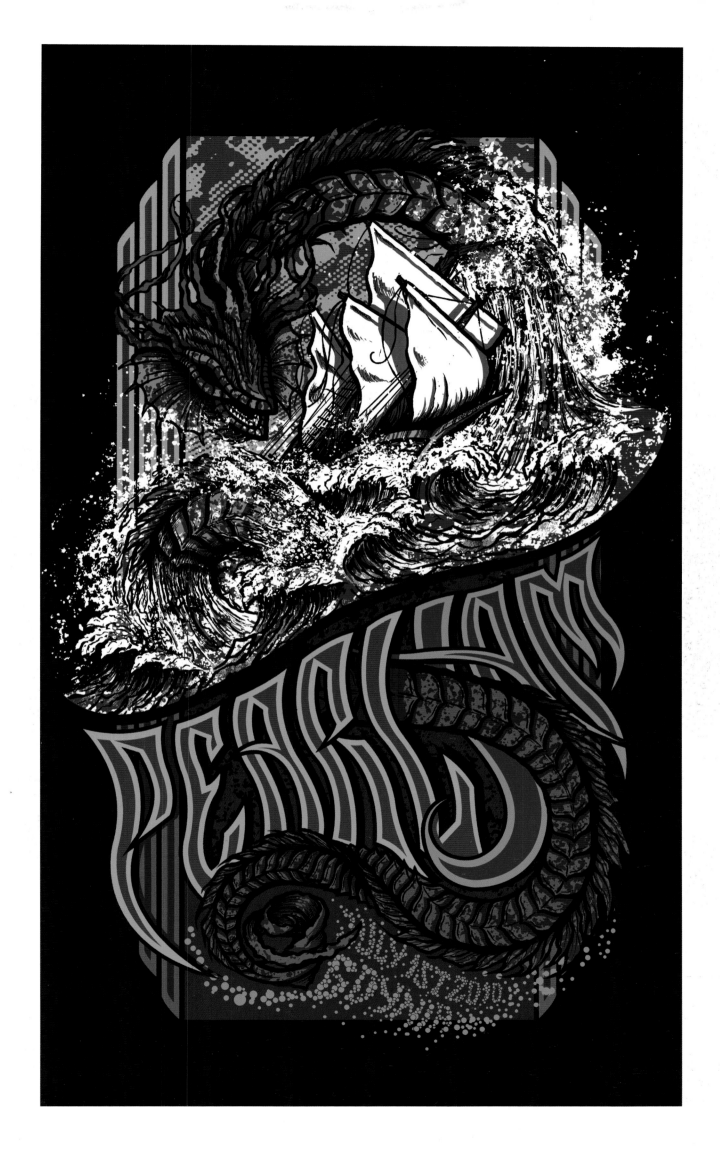

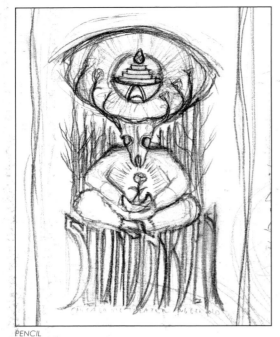

PENCIL

INK

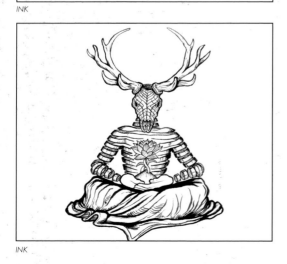

INK

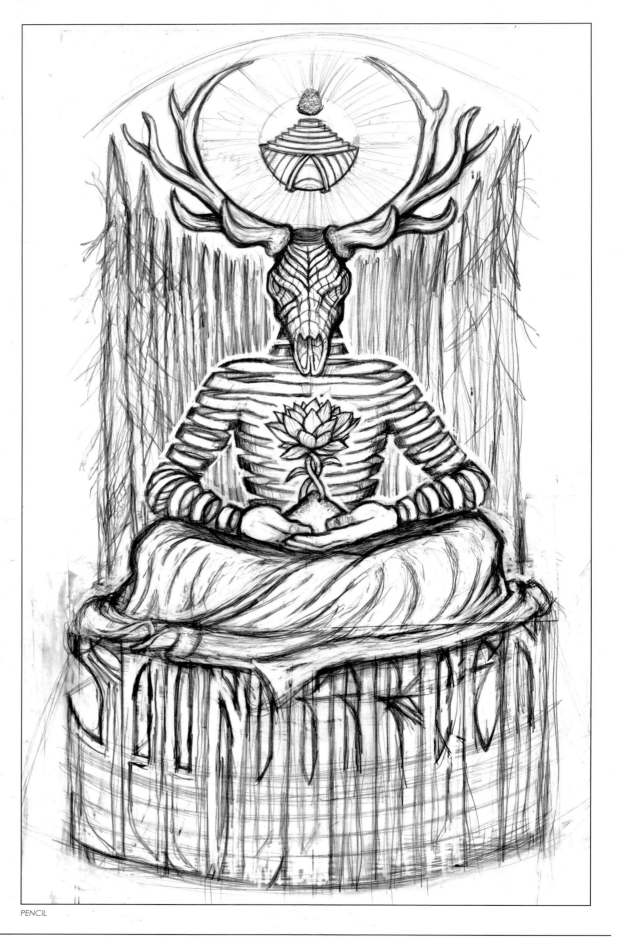

PENCIL

"Searching with My Good Eye Closed" is one of my favorite Soundgarden songs. The title reminds me of the struggle of our modern civilization blindly stumbling through a spiritually devoid world, unable to find any real truth in the physical reality we've been conditioned to cling to. The image refers to the activation of the third eye, or pineal gland. Descartes referred to the pineal gland as "the seat of the soul." There is a belief that it's through the pineal gland that we are able to connect with our higher self, with our true spirit. Some have suggested that the ancient Egyptians knew this and used the blue lotus flower as a key ingredient in alchemical elixirs to attain spiritual enlightenment and higher states of consciousness. Along with the blue lotus, there is speculation that through alchemically creating white-powdered gold, or MFKZT, as the Egyptians called it, they could open doorways to other realms of existence, to other dimensions of spirituality.

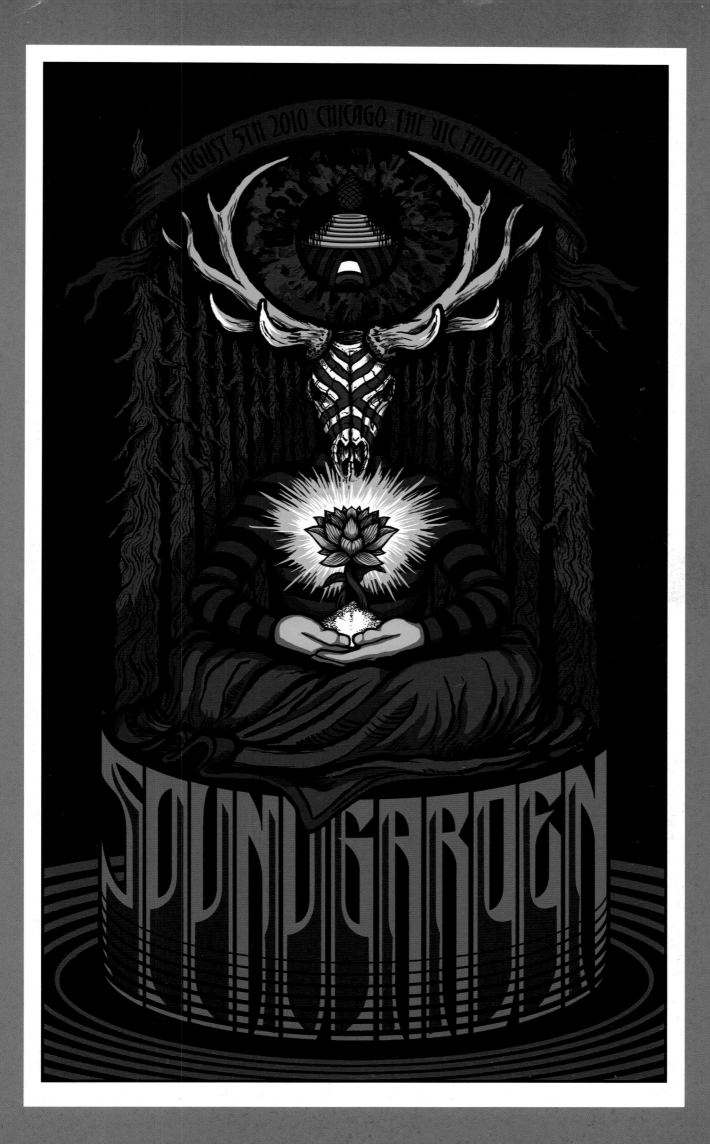

151

PENCIL

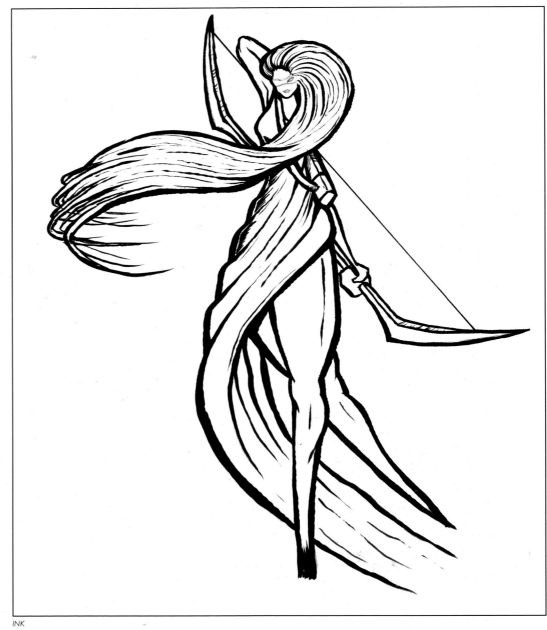

PENCIL

INK

ILLUSTRATOR

INK

I love the Black Keys. Gritty, bluesy, raw, catchy songs that thump and move. They are one of those bands that share my love for oversaturated, distorted, fuzzed-out guitar tones. The kind that swell and sustain forever and make you think there might be something wrong with the amp. The way guitars should sound.

As much as I love that aspect of the band, I also dig the slower, more sultry, sexy grooves they can achieve. Since the band is steeped in the blues, a lot of the songs seem to deal with women and heartache, especially on their latest album, *Brothers*. With that in mind, I wanted to convey the concept of the power of the feminine to seduce and lure the masculine, only to crush it and leave it broken and in pieces. The goddess with pinpoint accuracy to strike and pierce the heart as she gracefully glides in and then out of your life.

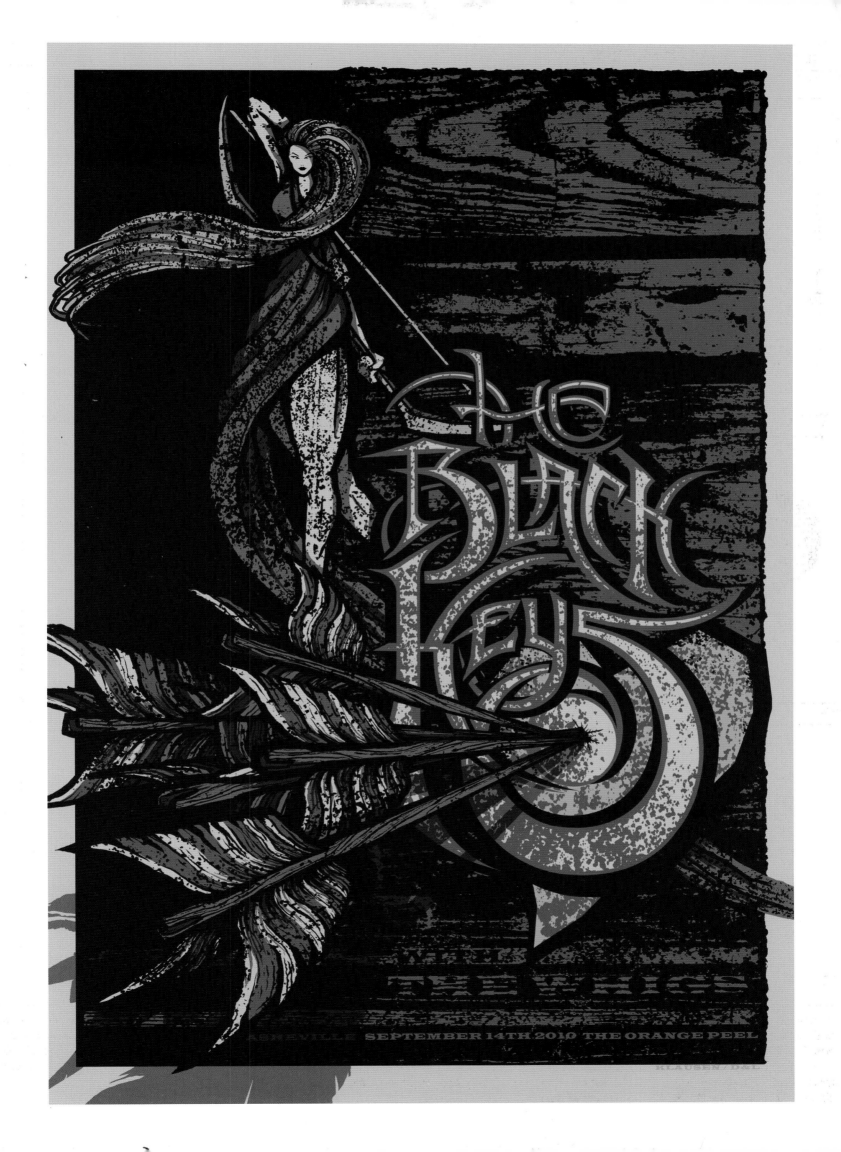

FROM A HOSPITAL IN SANTA MONICA

I was born on February 29, 1976, in Santa Monica, California. The earliest memories I have are of rummaging around under the bleachers of ice-skating rinks, before the sun was even up, looking for hockey pucks and broken sticks. I was dragged along to all my sister's early-morning figure-skating practices, so the rinks of Southern California were my day care. Once I had collected enough pucks and had outgrown the adventure of it all, I spent many a wasted quarter in the countless arcade games that either accompanied the skating rinks or were in the restaurants or malls next door. *Elevator Action*, *Time Pilot*, *Dragon's Lair*, *Space Ace*, *Joust*, *Tron* . . . these games, along with cherry Icees and Orange Juliuses and the B. Dalton bookstore, were the soil of my early years.

Living in Southern California, I spent the majority of the first half of my life sitting in a never-ending sea of slowly creeping metal, rubber, exhaust, and smog that stretched as far as the eye could see across twisting clogged concrete arteries, continually praying that if an earthquake were to strike, it would wait until I was safely out from under three tiers of traffic. I went to the same school from kindergarten through twelfth grade in North Hollywood, but lived in a town called Newhall, which is a part of Santa Clarita and about forty-five minutes north of LA. But in LA, everything is "about forty-five minutes away."

I existed on a healthy diet of peanut butter and jelly sandwiches, hot dogs, pizza, Winchell's donuts, Chipwiches, and In-N-Out. I was a rail-thin, six-foot-four, lanky, awkward kid who had delusions of being Wayne Gretzky. My Uncle Doug referred to me as "The Flexy Straw."

Come my senior year of high school, I couldn't wait to get as far away from LA as possible. I had hopes of going to school on the East Coast, just so I could be on the opposite end of the country. I only made it as far as Denver, which proved to be just as good. It was someplace other than LA. I learned a lot about life and myself in Denver, most of which I don't remember. But I know it was fun. I think.

Not having any money after college, and eager to get a design job in the music world, I bit the bullet and moved back home. After driving all over the place and handing my portfolio to completely uninterested receptionists at every record label in Southern California who, without even looking, annoyingly shoved it into a drawer crammed full of other portfolios no one would ever look at, I started to realize getting a design job in the music world was probably not a reality. Eventually I landed an entry-level job at a broadcast design firm in Hollywood, where my excitement quickly turned into apathy as the reality of having to live and work in LA started setting in more and more each day. I had been there less than a year when they rightfully fired me. I remember driving home feeling unbelievably relieved and happy.

A few months prior to being fired, I had spent time on the job working on a poster/résumé that I sent to Pearl Jam's fan club. I had just seen one of their newsletters and it was exactly the type of design work I wanted to do. Having no idea of the existence of the Ames Bros, and that they were the ones who designed the newsletter, I naïvely sent off my poster/résumé, letting them know that if they needed anyone to design posters for shows or album art, I would love to do it. They literally wrote back: *Thanks, but no thanks*. I wasn't all that surprised by this response, and figured you can't get in if you don't knock.

Eight months later, much to my surprise, they contacted me. Turns out they were looking to hire an in-house graphic designer, and my poster/résumé with my phone number on it just happened to be on their wall. They flew me up for an interview and asked if I'd be willing to move to Seattle.

I was the in-house designer for Pearl Jam for nine years, until I left in August of 2008, when I decided it was time to try and focus more on making posters and art on my own. I learned a lot about life and myself in those nine years, most of which I don't remember. But I know it was fun. I think.